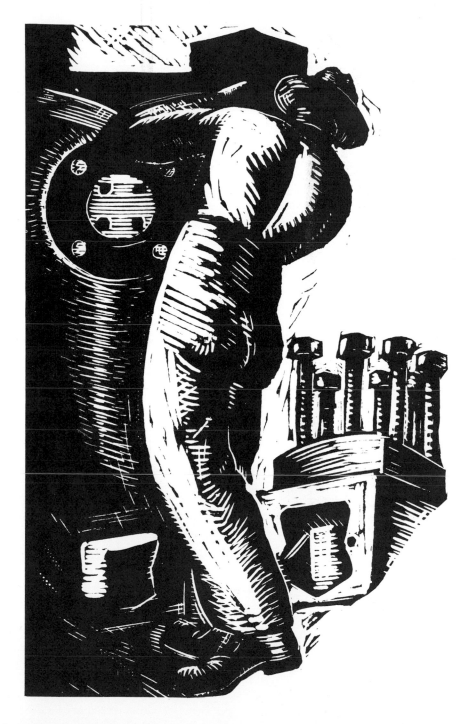

ARTISTS FOR VICTORY

An Exhibition Catalog

by Ellen G. Landau

Library of Congress Washington 1983

Library of Congress Cataloging in Publication Data

Main entry under title:

Artists for victory.

Bibliography: p.
Supt. of Docs. no.: LC 1.12/2:Ar7
1. Prints, American—Exhibitions. 2. Prints—20th century—United States—Exhibitions. 3. World War, 1939–1945, in art—Exhibitions. 4. Artists for Victory, Inc.—Exhibitions. I. Landau, Ellen G. II. Library of Congress.
NE508.A77 1983 769'.4'99405373 83-600117
ISBN 0-8444-0432-2

Cover: *War Bulletins,* by Leo John Meissner (see p. 79).
Title Page: Detail from *Labor in a Diesel Plant,* by Letterio Calapai (see p. 25).

Note:
All works illustrated in this catalog are from the collections of the Library of Congress. Measurements given in captions are in centimeters, and height precedes width. Many of the prints are not dated, either in pencil or on the plate. The majority were done in 1942 or 1943, specifically for the "America in the War" exhibition.

Catalog for an exhibition at the Library of Congress

Washington, D.C.
February 2–July 31, 1983

Also exhibited by:

THE CENTRAL INTELLIGENCE AGENCY FINE ARTS COMMISSION
McLean, Virginia
August 7–September 4, 1983

THE U.S. ARMY AIR DEFENSE MUSEUM
Fort Bliss, Texas
September 25–October 23, 1983

MATHER GALLERY
CASE WESTERN RESERVE UNIVERSITY
Cleveland, Ohio
November 1–December 11, 1983

THE LYNDON BAINES JOHNSON LIBRARY AND MUSEUM
Austin, Texas
February 19–March 18, 1984

THE PRESIDENTIAL MUSEUM
Odessa, Texas
April 8–May 6, 1984

Contents

Acknowledgments

I would especially like to acknowledge the use of the following sources in preparing the essay "America in the War" and artists' biographies: the Artists for Victory "Bulletin to Members" series, which appeared in *Art News* from September 1944 to January 1947; the minutes of board, executive committee, and general membership meetings of the Artists for Victory organization—a gift of Helen Treadwell, in 1965, to the Archives of American Art, Smithsonian Institution, Washington, D.C.—the papers of Forbes Watson, Samuel Golden, and Charles Keller, also in the Archives of American Art; and the papers of Albert M. Reese, in the archives, and Reese's book, *American Prize Prints of the Twentieth Century* (New York: American Artist's Group, 1949). Many of the artists involved in "America in the War" wrote to Golden and Reese concerning their careers and, in some cases, discussed the particular prints actually in the "America in the War" show.

I would like to thank the following artists from "America in the War" for their generous cooperation in answering my questions about their participation in the show: Will Barnet, Riva Helfond Barrett, Fiske Boyd, Letterio Calapai, Minna Citron, Richard Floethe, Robert Gwathmey, Hans Jelinek, Misch Kohn, Alicia Legg, J. Jay McVicker, Jack Markow, Seymour Nydorf, Phil Paradise, Dorothy Rutka Kennon Porter, Leonard Pytlak, Charles F. Quest, Karl Schrag, Henry Simon, Burr Singer, Raphael Soyer, Prentiss Taylor, Joseph Trovato, Sylvia Wald, Charles Banks Wilson, and Lumen Martin Winter. I would like to extend special thanks to Hilda Katz, for sending me an original copy of the prospectus for the exhibition, and to Isabel Bishop, Evelyn Lazzari, and Eleanor Patrick Melugin for providing information on Gladys Mock, Pietro Lazzari, and James H. Patrick, respectively. Libraries and museums all over the country, too numerous to mention by name, helped with clippings and biographical data on the artists.

Finally, I would like to thank Henry Simon for providing a new impression of *The Three Horsemen,* and the National Museum of American Art, Smithsonian Institution, Washington, D.C., for lending Louis Lozowick's *Granaries of Democracy,* as well as Karen Beall, of the Prints and Photographs Division of the Library of Congress, for her help and advice.

Ellen G. Landau
Case Western Reserve University

Artists for Victory

America in the War

The worst military disaster in the history of the United States, the bombing of Pearl Harbor on December 7, 1941, shocked this nation into sudden, all-out mobilization for a war to protect the American way of life. Overnight, the entire country became war-minded, and people in all walks of life began to ask what they could do to help defeat the Axis powers. Every resource this nation could muster was desperately needed. Among those who immediately answered the call to action were artists.

One of the primary concerns of the previous decade had been the social utility of art. During the depression, the government-sponsored Works Progress Administration (W.P.A.) Fine Arts Projects had emphasized the utilitarian. The style known as "Social Realism," so prominent in the 1930s, dictated that the artist put his conscience to work, using art as a means of communicating important ideas, rather than dwelling on purely formal problems.

This humanistic approach was given further credence by the great master of the School of Paris, Pablo Picasso, when in 1937 he painted *Guernica*. This painting, the artist's response to the total annihilation of a town's innocent population in the Spanish Civil War, revalidated content and made contemporary the age-old phenomenon of war as a stimulus for creativity.

Not only has war been one of the principal occupations of civilized human beings but it has been an incentive for aesthetic activity from a time before recorded history. Mesolithic rock paintings found in the Sahara desert, the first to show human figures, depict scenes of belligerence. Early civilizations exalted the military prowess of their rulers, which was equated with the triumphs of their gods. Classical vase painting, sculpture, and epical poetry glorified the valor of war heroes, and this exalted approach by artists to war continued more or less constant, even into modern times. To cite just a few examples, Louis XIV's exploits became the subjects for Grand Style monumental decorative cycles by Le Brun; Napoleon was portrayed as a messianic figure by the Baron Gros; and the virile nationalistic symbolism of Leutze's *Washington Crossing the Delaware* still stimulates intense patriotic feeling. Most

of the American artists of the First World War perpetuated this approach by emphasizing the pomp, pageantry, flag-waving, and thrill of going off to battle or returning home victorious. In December 1942, American artist Guy Pène du Bois, writing on the occasion of a New York Gallery exhibition of 1915–20 vintage paintings, noted how out-of-spirit the romantic illusions of this interpretation of war were, however, with the deadly seriousness of the current struggle.

Artists of the forties felt a closer kinship, for instance, with seventeenth-century printmaker Jacques Callot, who had depicted not the glories but the miseries of the Thirty Years' War. Or with Francisco Goya, whose *Disasters of War* series of 1863 broke with tradition to focus on the personal implications of war, condemning its cruelty and inhumanity rather than lauding it. In addition to Picasso, several other twentieth-century European artists, such as Kaethe Kollwitz, George Grosz, and Otto Dix presented examples of antiwar sentiment in their works.

The very magnitude of the Second World War, coupled with the fact that it was not being fought on American soil, intensified the need for American artists to use whatever powers they had at their disposal to help clarify the issues and marshal both the spiritual and the material resources of the country. Francis Brennan, chief of the Office of War Information, observed that the American people needed their artists to express their anger, their grief, their fear, and their greatness more than ever in such a perilous time. In the words of printmaker Rockwell Kent, American artists of the period had an obligation to be "spokesmen of the nation's will to victory."

Less than two weeks after Pearl Harbor, the Division of Information of the Office of Emergency Management issued a bulletin announcing a competition for artists to submit defense and war pictures. The Graphics Division of the Office of Facts and Figures (which was under the direction of Archibald MacLeish, simultaneously Librarian of Congress) soon also became a sponsor for war-related art projects, as did the W.P.A., until its demise, and the U.S. Treasury Department's Section of Painting and Sculpture.

Inspired by the British example in World War I, the public relations

departments of the army, navy, and other service branches began to commission artists to prepare camouflage, illustrate training manuals, design recruiting posters, and make a limited on-the-spot record of the war. The works of these armed forces artists—which, by dictate, emphasized objective reporting over subjective interpretation—were shown to the public in a number of exhibitions at such prestigious museums as the National Gallery of Art in Washington, D.C., the Chicago Art Institute, and the Metropolitan Museum of Art in New York City. In addition to *Life* magazine, which contracted with civilian artists to do war subjects, Abbott Laboratories of Chicago, Standard Oil of New Jersey, the Chrysler Corporation, and other leading firms in the business community also commissioned artists to document preparations for war and defense in paintings.

Many of the artists not associated with such projects began to feel the need to mobilize formally themselves. As early as 1940, the Society of Illustrators and Writers Guild of New York had formed a National Defense Committee to analyze what the artist could do in the event of U.S. involvement in the war in Europe. In June 1941, a group of radical artists and writers convened a congress in New York in defense of art against the threat of Fascism. That year, also, the Museum of Modern Art presented an exhibition, "Britain at War," to demonstrate to American artists how their talents could be used for the national good.

In England, the leading art societies had banded together to form the Central Institute of Art and Design to more effectively help their government with war-related art projects. Following the British example, the National Art Council for Defense and the Artists Societies for Defense were formed in late 1941 in New York. Representatives from major U.S. art groups of the day joined the organizations, which together included members from twenty-one different art societies. Complying with the federal government's request that there be one central organization of artists during the war, the two merged in January 1942, renaming themselves Artists for Victory, Inc.

The stated purpose of Artists for Victory was "to render effective the talents and abilities of artists in the prosecution of World War II and the protection of this country." Hobart Nichols of the National Academy of Design, in accepting the presidency of the new association, commented:

As I interpret our purpose in forming this organization, it is, first, that we are a very large group of loyal American citizens who want to help win this war, and secondly, we are a very large group of artists who believe that by virtue of our special training and ability we can be useful to that end.

The artists who united in Artists for Victory did so in the sincere belief that their highly developed qualities of imagination and their technical abilities could be of service to the U.S. government on both the military and home fronts. President Roosevelt agreed. He wrote to Nichols in late 1942, "The very name of your organization is symbolic of the determination of every man and woman in every activity of life throughout the nation to enlist in the cause to which our country is dedicated."

By the beginning of 1943, Artists for Victory had a national individual membership of over ten thousand painters, sculptors, designers, and printmakers. A nonprofit organization with headquarters at 101 Park Avenue in New York, their capital was, in their own words, "largely enthusiasm and very little else." Taking as their symbol the Winged Victory of Samothrace and, as a basis for their philosophy, Roosevelt's State of the Union message of January 6, 1942, in which the president emphasized the Four Freedoms as a moral foundation for our nation's role in world affairs, Artists for Victory, Inc., pledged a minimum of five million man-hours to the war effort and launched an active program.

One of their main thrusts was to function as a liaison between individual artists and the federal, state, and local government agencies and private industries and businesses needing artistic jobs done for war purposes. Artists all over the country were classified and cross-indexed according to their training and capabilities, and matches were made with available job openings. Artists for Victory also acted as a clearinghouse for temporary studio space for servicemen stationed in New York, sent artists to do portrait sketching or work as recreational instructors in service hospitals, and sent muralists to decorate U.S.O. centers and service mess halls.

In order to encourage aesthetic activity in a time when cultural values were not foremost in people's minds, Artists for Victory held weekly radio shows, for a time, on station WINS in New York and published a bimonthly bulletin to its members, printed without charge by *Art News* magazine. For even more visibility, they began to sponsor competitive exhibitions. The first and largest of these opened on the first anniversary of Pearl Harbor Day, December 7, 1942, at the Metropolitan Museum of Art in New York, the result of an open competition held with the general aim of keeping the arts alive during the war. Manny Farber, a writer for *Magazine of Art* who reviewed the show (which comprised 1,500 works in all media) noted, "It is interesting how few of these [artists] were influenced by the war . . . yet nothing else is so constantly on our minds or in our feelings."

This could not be said, however, of Artists for Victory's second major undertaking, announced in May 1943. The group had decided to launch

its own special Four Freedoms Campaign in conjunction with the upcoming national observation of Four Freedoms Days designated for September 12–19. They sought to interest patriotic, educational, manufacturing, financial, business, and other groups in their programs, as well as to bring about a closer cooperation between artists and the community in an all-out effort to win the war. Part of this objective was to be achieved by holding a competition limited to printmakers.

Devised by the head of Artists for Victory's Graphics Committee, Joseph LeBoit, this competition was announced in 3,000 circulars, as well as in all of the leading art publications. To be titled "America in the War," the exhibition was to consist of 100 prints and to include examples from the four major types of graphic media: intaglio (etching and engraving), relief (woodcut and linoleum block), stencil (silkscreen, or serigraphy), and planographic (lithography).

In the prospectus for the show, LeBoit wrote:

Artists for Victory invites all artists to participate in this national graphic arts exhibition which promises to be a dramatic event in the world of art. The theme, "America in the War," should be interpreted in its broadest sense, so that the exhibition when assembled becomes a picture of America in 1943, of a country and a people in their second year of war.

Each artist competing was free to submit three different works, by the first week in August, to a jury composed of noted painter and graphic artist William Gropper, printmaker Armin Landeck, and curator of the Philadelphia Museum of Art Print Department Carl Zigrosser. Editions were to be limited to 100.

The presentation was planned for October, when the exhibit would be shown simultaneously in twenty-six museums across the United States—the first such synchronized showing of its kind in America. Each artist chosen would have to submit twenty-five impressions in addition to the one judged. By this unique arrangement, Artists for Victory explained, the graphic message of these artists would be delivered over a national network. All prints would be offered for sale and, in addition, twelve prizes were to be awarded, totaling $800 in war bonds. There would be four first prizes of a $100 bond in each technical category, four second prizes of a $50 bond, four $50 third prize bonds, and four honorable mentions.

LeBoit emphasized that any print that conveyed the impact of the war on the life of the American people was eligible. For those wishing to do new work, Artists for Victory suggested five subject categories that might be considered as themes: Heroes of the Fighting Front, Action on the Fighting Front, Heroes of the Home Front, The Enemy, and The Victory and Peace to Follow.

On October 20, 1943, "America in the War" opened as planned, as a contemporaneous presentation all over the country. *Art News* printed the official catalog and price list of the exhibition in its October 1–14 issue, headlined with a silkscreen by Richard Floethe, *The Liberator* (fig. 12), which spelled out the Four Freedoms. Famed etcher John Taylor Arms wrote a lengthy article on printmaking processes, illustrated by works from the show.

In the prospectus, the raison d'être for "America in the War" had been explained this way:

At all times the print has been an art form most expressive of contemporary life. The times in which we live should call forth renewed activity in this historical medium—the medium of Durer, Goya, and Daumier. The artist who today interprets the emotions and experiences of the American people serves not only a cultural, but a patriotic purpose.

After the exhibition opened, *Art News* published a letter from one of the artists involved in the project, Karl Schrag, which attempted to gauge the success of this call for social commitment. Schrag wrote, "The exhibition 'America in the War' proves again . . . that the graphic arts can be like a magic mirror in which the essence of the time is reflected. . . . Mural or easel painting cannot express it. Photographs lack human feeling and concentrated expression."

Many of the printmakers who submitted their work to "America in the War" were new to the exhibition scene. Almost one-third of them were women. From all over the country, they grappled with the issues of the day both using contemporary techniques—such as abstract patternization, emphatic distortion, and transposition—and updating such age-old interpretive tools as parody, satire, polemic, rhetoric, literary and religious allusion, symbolism, and anecdote. The influence of political cartoons and war posters was clear in the immediacy and intensity of many of the works, which sought to move and shock and to create an emotional identification on the part of the observer.

"Heroes of the Home Front" subjects were the most numerous among those prints chosen by the judges for the "America in the War" show. Thirty-four of the works follow closely the description in the announcement which had suggested that this category include the soldiers of production, the merchant marine, farmers, women in industry, and people in the volunteer services, victory gardens, and so on.

There were a number of award winners in this group, including first prize in serigraphy to Robert Gwathmey, whose flat-color *Rural Home Front* (fig. 14) is an interesting composite aimed at showing the total war effort of farm people, including children. *Labor in a Diesel Plant* (fig. 7), by Letterio Calapai, a prizewinner in relief, is also a compound image, which was inspired by the artist's personal experience doing defense work at the American Locomotive Company in Auburn, N.Y. He even included in the lower left corner a portrait of himself rolling an oil drum. Honorable mention in intaglio was awarded Will Barnet for an aquatint showing a black tailor at work in Harlem, sewing endlessly into the night. Working on the swing shift was a popular subject in the prints on this theme.

The surprise choice of the judges for first prize in intaglio was the etching of a virtually unknown woman artist from Tulsa, Oklahoma. Margot Holt Bostick's *Portrait of a Soldier,* the depiction of an arc welder, was commended by critics as an example of outstanding brilliance, texture, and design. A wood engraving by Chicago artist Mara Schroetter juxtaposed a welder and a fighting infantryman to make even clearer the point that both were equally needed for victory.

Helen West Heller and Jolan Gross-Bettelheim both used a semi-abstract approach to augment the impact of their works. Heller, in a powerful, strongly designed woodcut, *Magnesium Bomb* (fig. 15), showed two women air raid wardens operating a backyard stirrup pump, wearing the familiar white helmut and armbands of the Office of Civilian Defense. Gross-Bettelheim's *Home Front* (fig. 13), reminiscent of the boldly rhythmic compositions done by British artist C.R.W. Nevinson during World War I, expressed formally the dynamic beauty of a perfectly paced defense plant assembly line.

Another stunning print, a lithograph by New Orleans artist Caroline Durieux, (fig. 10), set up a dramatic repoussoir with the expressively caricatured faces and elaborately upswept hairdos of two mulatto jazz singers entertaining servicemen on Bourbon Street. Several of the artists in the show were particularly interested in the role and situation of black Americans on the home front. Most notable, besides the Durieux, are Julius Bloch's sensitive portrait, *Sheet Metal Worker* (fig. 2), of a black youth too young to fight but clearly intent on doing his part at home, Sylvia Wald's huddled group, *The Boys,* and Helen Johann's *Next of Kin* (fig. 17), depicting an elderly black woman, her face lined and weary, gripping a Detroit newspaper. Its two clearly readable headlines, "Race Riots" and "Allies Take Base," juxtapose rather ironically the cause all Americans were fighting for with the domestic tensions exacerbated by the war, which forced President Roosevelt to send in troops to put down

a racial flare-up over housing shortages in the city of Detroit in 1942. Johann does not make it clear whether this woman is more affected by the battle at home or the war abroad.

Twenty-one of the artists chosen focused on the subject of "Action on the Fighting Front." There was only one award-winner in this group, however. Sol Wilson's winning serigraph, *The Twelfth Day* (fig. 41), was suggested by news reports of sailors floating adrift at sea on a raft for almost two weeks after their ship was destroyed.

Perhaps not surprisingly, a number of artists in this category had some form of close personal contact with the prosecution of the war. Hawaiian-based artist Alexander Samuel MacLeod was one of the first eyewitnesses on the site of Pearl Harbor, arriving there with his watercolors as quickly as the first photographers. MacLeod later grouped works like the print he exhibited in this show, *Havoc in Hawaii* (fig. (fig. 20), in a book depicting the Japanese attack. James Hollins Patrick, represented by a lithograph, *This Is Our Enemy* (fig. 27), was a civilian camouflage expert on the West Coast who helped train bombardiers such as those shown in his print. Harry F. Tepker, who exhibited *Mountain Mortar Firing* (fig. 38), was a private first class in the U.S. Marines. He later also exhibited in a showing of paintings related to the Pacific theater, "The War against Japan," sponsored by the U.S. Treasury Department. Marine combat artists, like Tepker, were expected to pass the same rigorous tests and share the same hardships and dangers as other fighting members of the corps. Tepker, Corporal John Ward McClellan, and U.S. Navy Lieutenant Commander Jack Frank Bowling are probably the only artists included in the "America in the War" show who knew from experience the full meaning of being involved in combat action.

One of the most interesting "Action on the Fighting Front" prints was *Freedom's Warrior* (fig. 40), a lithograph by Charles Banks Wilson, who had grown up on a multitribe Indian reservation in Oklahoma. *Freedom's Warrior* was originally drawn by Wilson to illustrate an article he wrote for the January 10, 1943, issue of the New York Herald Tribune syndicate's *This Week* magazine on the role Native Americans were playing in the Second World War. Flanked by Indians in ceremonial dress, a young brave in uniform is seen charging forward, carrying the American flag, to do his part in defending his country.

The next subject division, "Heroes of the Fighting Front," was envisioned in the prospectus as dealing with known personalities, such as General Eisenhower and General MacArthur. Only one printmaker in the show portrayed a specific soldier-hero, however. Hoyt Howard entered a print entitled *Johnny Rivers at Guadalcanal,* but for the most part the

fifteen artists in this group were more sympathetic toward the anonymous, unsung fighting man. For example, Leonard Pytlak's *They Serve on All Fronts* (fig. 28) delineates the heroic role of the doctors and nurses of mobile medical units. In Phil Paradise's *Inductees,* a group of raw recruits get their first glimpse of an army base. And Raphael Soyer's *Farewell* (fig. 34) evokes the very common, but nonetheless moving, scene of soldiers bidding their loved ones goodbye. All of these prints were chosen for prizes by the jury.

Minna Citron, a New York artist who had three sons in the armed services, showed, in a miniature etching, her son Tom departing for the Pacific campaign as an amphibian engineer. As Tom would have liked, Citron tucked his dog, Curley, into the knapsack on his back (fig. 8). A companion print Citron later made showed Tom returning to Curley. In an expansion of the concept of "Heroes of the Fighting Front," Margaret Lowengrund created a lithograph in which the barely visible, tiny figures of Roosevelt and Churchill, meeting on a yacht off the coast of Newfoundland to draft the Atlantic Charter, are seen to cast impressive metaphorical shadows on the world.

The theme described as "The Nature of the Enemy" elicited a response from nineteen of the chosen artists. Many of these concentrated on the victims of Fascist repression. The most savage and venomous expressions of the show were reserved for depictions of the Axis leaders, such as Harry Sternberg's serigraph, *Fascism* (fig. 36), in which a three-headed monster—having the features of Hitler, Mussolini, and Hirohito—is seen stomping on symbols of the achievements of civilization—books, religious symbols, a compass and triangle. Henry Simon also showed the Axis partners, but in the guise of the biblical Horsemen of the Apocalpse (fig. 32). Beatrice Levy portrayed Hitler surrounded with corpses floating in a river of blood. Nazis were depicted as brutal, debauched drunkards by exhibition director Joseph LeBoit, and as death-heads by Seymour Nydorf. Fascism was personified in the form of a creature from the horror shows by Cleveland artist Joseph Haber.

Hans Jelinek, an Austrian immigrant who won first prize in the relief category, showed *The Last Walk* (fig. 16), one of the impressions from a twelve-print wood-engraving series which he did after reading news reports of the total rape and destruction by the Nazis of the Czech village of Lidice. The hard-edged angularity of his composition visually reinforces the mad brutality of the bayonet-wielding Germans seen rounding up the innocent Jews. The same story also inspired another first-prize winner, Benton Spruance of Philadelphia. By depicting three of the townspeople yoked or nailed to crosses, Spruance, in his *Souvenir of Lidice* (fig. 35), compared their suffering with the martyrdom of Christ.

Religious allusions were popular in this group. To cite two other examples, Prentiss Taylor's *Uprooted Stalk* (fig. 37) was a Pietà, and Karl Scrag's *Persecution* (fig. 30) an Ecce Homo. The isolated, dignified figure in the latter, being shown, like Christ, to the ugly, almost monstrous crowd by the German soldiers, represents everything of moral and spiritual value that had to be saved from total destruction. More contemporary in context, Pittsburgh artist Helen King Boyer's print *Rumor* (fig. 6) reminded viewers of "America in the War" that the perfidy of the enemy could be found everywhere, by depicting a "Tokyo Rose" figure.

Eleven of the selected printmakers chose to elaborate the theme "Victory and Peace to Follow," a category which Artists for Victory had recommended be directly concerned with the impetus behind the exhibition: Roosevelt's plans for postwar world harmony. Some, like Lawrence Barrett and William Gropper (one of the judges), envisioned soldiers and displaced persons returning to their homes, newly liberated, after the war. Charles Keller, an artist active on peace committees, showed a meeting of like-minded men and women. William Soles, in his award-winning *The Freedoms Conquer* (fig. 33), translated into graphically expressionistic terms his fervent belief in the ability of the Allies to vanquish the Axis powers, an ability not yet fully demonstrated in 1942–43, the bleakest years of the war. Several artists, such as Ralph Fabri and Richard Floethe, spelled out in specific terms the liberties Americans were fighting to protect (figs. 11 and 12).

After its initial showing, the "America in the War" exhibition continued, for several years, to circulate intact or in smaller versions to U.S.O. centers and army camps, as well as to additional museums, such as the National Gallery of Canada. Artists for Victory followed its success with a national war poster competition, to disseminate slogans adopted by the U.S. government Office of Facts and Figures; a greeting card design competition, cosponsored in 1943 with the American Artists Group, to interpret the spirit of the Christmas season in terms of hopes for global peace; several "Portrait of America" exhibitions, on which Artists for Victory collaborated with the Pepsi- Cola Company; and a British-American Goodwill Exhibition, organized in cooperation with the Central Institute of Art and Design, which toured on both sides of the Atlantic.

Artists for Victory's service to the nation was praised not only by President Roosevelt but also by the U.S. Congress, and the group received a medal of commendation for services rendered to the U.S. Army. In late 1945, with the war drawing to a successful conclusion, the leaders of the group considered restructuring to continue as a peacetime organization. Response from the membership, however, indicated lack of interest, and the corporation phased itself out of existence as of February 1946.

In October 1945 the executive secretary of Artists for Victory sent out letters to all of the participants in "America in the War," asking if they would agree to donate copies of their prints to the Library of Congress, which had expressed an interest in acquiring a complete set of the works making up the original exhibition to become part of the nation's permanent record of the war. The gift was received in April 1946, and the Library of Congress is now the only place where the complete collection of prints from the show exists intact.

Putting these prints together again for the first time in almost forty years recreates an extraordinary sociological and artistic event. No precedent exists for Artists for Victory, Inc., in any previous war fought by this country. The prints from "America in the War," although more imaginative than factual, demonstrate what Americans thought and felt and show how they lived during World War II. For the most part, the prints exhibit an expressiveness, a vivid intensity, and a power of synthesis and interpretation that combine to provide an extraordinary understanding of the modern reaction to war. They suggest something about the spirit of the American people in a crucial period of the nation's history.

Similar visual material on the Korean and Vietnam wars is almost nonexistent. The main images from these conflicts are journalistic photographs, movie newsreels, and television videotapes, which provide a completely different kind of experience for the viewer. The ability of artists to personalize and convey the experience of war through the interpretive tools at their disposal creates a picture of the feelings and emotions aroused by war very different from the literal documentation of the camera.

A June 11, 1982, editorial in the *Washington Post* newspaper began, "There is a strange, even chilling, split-screen aspect to the war talk filling the air these days." In the current climate of increased debate over defense spending and military preparedness, "America in the War" suddenly takes on a renewed pertinence. Those who remember World War II as well as those who have never personally experienced a war with such clear-cut issues can enjoy and learn from this opportunity to reexamine and reevaluate this important collection of prints.

Selected Bibliography

Artists for Victory, Inc.
A chronological list of contemporary sources about the artists' organization.

"National Art Council for Defense; Artist's War Measure for the Attention of All Art Societies and All Who Work in the Visual Arts." *Art Digest* 16 (December 15, 1941): 33.

"Artists Council for Victory." *Magazine of Art* 35 (January 1942).

"Artists Council for Victory." *Art Digest* 16 (February 1, 1942): 32–33.

"Organization." *Magazine of Art* 35 (February 1942).

"10,000 Artists Unite for Victory." *Art Digest* 16 (February 1, 1942): 17.

Durney, H. "National Art Council for Defense Organized." *Design* 43 (February 1942): 25.

"Organization." *American Artist* 6 (March 1942).

"Organization." *Architectural Record* 91 (March 1942): 12.

"Artists for Victory." *Art Digest* 16 (August 1, 1942): 28.

"Artists for Victory Exhibition Issue." *Art News* 41 (January 1–14, 1943).

"Workshop Plans." *Art News* 42 (February 15, 1943): 27.

"Artists for Victory Week." *Art News* 42 (April 15, 1943): 26.

"Five Million Man-Hours Was Pledged to the War Effort." *Art News* 42 (May 1, 1943): 27.

"A Summing Up." *Art News* 42 (October 1–14, 1943): 28.

"Whither Victory?" *Art Digest* 18 (January 15, 1944): 10.

"Bulletin to Members." *Art News* (September 1944–January 15, 1946).

"Artists for Victory Plans Now." *Art Digest* 19 (December 15, 1944).

Boswell, Peyton. "Disband." *Art Digest* 20 (January 15, 1946): 3.

"America in the War"
A chronological list of contemporary sources on the exhibition.

"America in the War; Graphic Competition." *Art News* 42 (May 15, 1943): 24.

"National Hook-up for Prints on the War." *Art Digest* 17 (June 1943): 8.

"Prints on Tour." *Art News* 42 (June–July 1943).

"America at War: 100 Contemporary Prints, Now on Exhibit (and on Sale) in 26 American Museums and Galleries." *Magazine of Art* 36 (October 1943): 224–25.

"Prize-winners of National Graphic Arts Exhibition." *American Artist* 7 (October 1943): 24–25.

"America in the War; Prints at Kennedy Galleries." *Art Digest* 18 (October 1, 1943): 5, 24.

Arms, John Taylor. "Printmakers' Processes and a Militant Show: 'America in the War.'" *Art News* 42 (October 1–14, 1943): 8–15.

Millier, Arthur. "Synthetic Venom in Prints for Victory Exhibition." *Art Digest* 18 (October 15, 1943): 24.

Schrag, Karl. Letter to the editor. *Art News* 42 (November 1–14, 1943).

"The Print Show." *Art News* 42 (November 15–30, 1943).

"Touring Print Show. 'America in the War.'" *Art News* 44 (October 1, 1945): 36.

Note: According to Artists for Victory's publicity committee report of January 31, 1944, fifty newspapers, nine magazines, and three radio stations covered the exhibition.

The Artists and Their Works

Albert Abramovitz
(1879–1963)
Woodcut: *Letter from Overseas*

Albert Abramovitz was born in Riga, Russia, on January 24, 1879. He studied art at the Imperial Art School in Odessa and at the Grande Chaumière in Paris. While in Paris, he became a member of the Salon in 1911 and, in 1913, a member of its jury. Also in 1911 he was awarded a medal at Clichy and the Grand Prize at the Universal Exhibition in Rome and Turin, Italy.

In 1916 Abramovitz came to America. His first solo show in this country took place in 1921 at the Civic Club in New York City, where in the 1940s he had one-man exhibitions at the Bonestell and New-Age galleries. During that decade he lived in Brooklyn and was active in the American Artists Congress and the Artists League of America. He took part in such politically oriented exhibitions as the June 1941 "In Defense of Culture" show, which was mounted in passionate opposition to the rising threat of Fascism and jointly sponsored by the American Writers and Artists Congresses, and the June 1942 showing at the A.C.A. Gallery, "Artists in the War."

His work is included in such public collections as the New York Public Library and the Metropolitan Museum of Art.

Sources

"Exhibition, New-Age Gallery." *Pictures on Exhibit* 8 (March 1946): 31.

Obituary. *New York Times,* July 14, 1963.

Who's Who in American Art: 1940–47, 1953.

Beatrice Harper Banning
(1885–1960)
Drypoint: *Black Out*

Beatrice Harper was born December 5, 1885, in Staten Island, New York. She studied at the Cooper Union Art School, the Art Students League, the National Academy of Design, and several European art schools as well.

At the time of her submission to "America in the War," Beatrice Harper was married to Waldo Banning and was living in Old Lyme, Connecticut, where she remained active as a painter and printmaker until her death. Throughout the 1940s, she actively exhibited with many organizations, such as the Society of American Etchers, the Old Lyme Art Association, and the Connecticut Academy of Fine Arts (which awarded her a prize in 1944). She also showed at the Women's International Exhibition in London in 1946.

Public collections in which Banning's work may be seen include the New York Public Library and the Metropolitan Museum of Art.

Sources

Who's Who in American Art: 1940–47, 1953, 1959.

Will Barnet

(b. 1911)

Aquatint: *Swing Shift*

Will Barnet was born on May 25, 1911, in Beverly, Massachusetts. He studied at the School of the Boston Museum of Fine Arts with Philip Hale from 1927 to 1930 and, on scholarship, at the Art Students League in New York, where he was a special student of Charles Locke from 1930 to 1933. Barnet made his first lithograph in 1932 and had his premier one-man showing in 1935. This exhibition, at the Eighth Street Playhouse in New York, presented social themes and New York scenes in a style influenced by Daumier.

In 1935, Barnet succeeded Locke as official lithographic printer at the Art Students League. In this capacity, he printed stones for artists such as Raphael Soyer, Jose Clement Orozco, and Adolph Dehn, through 1946. In 1936, Barnet was hired by the W.P.A. Graphics Project not only as a printmaker but also as a technical adviser to improve the quality of W.P.A. prints.

In 1937, Will Barnet joined the faculty of the Art Students League, where he is today. After doing technical work and research in printing at the New School for Social Research for several years, he was appointed instructor there in 1941, and he began to teach in 1945 at the Cooper Union, where he was made full professor twenty years later. Barnet has been guest professor or visiting critic at such institutions as Yale University (1952–53), the University of Wisconsin (Madison), the Munson-Williams-Proctor Institute, the School of the Boston Museum of Fine Arts, and Cornell University (1968–69). He has taught summers at universities in Canada, Montana, Iowa, Washington, Minnesota, and Pennsylvania. In 1964, he was given a Ford Foundation grant to be artist-in-residence at the Virginia Museum of Fine Arts in Richmond and, in 1967, he began also teaching at the Pennsylvania Academy of the Fine Arts (PAFA). Since 1954, he has been associated as well with the Famous Artists School.

Will Barnet has shown extensively since 1935. In the 1940s he had one-man exhibitions at a number of galleries in New York, such as Bertha Schaefer and Galerie St. Etienne. In 1943, he won honorable mention in the intaglio division of the "America in the War" competition for an aquatint depicting a tailor in Harlem working the night shift.

He became a member of the vanguard group, the American Abstract Artists, in the late 1940s. By this time, his characteristic "clear-edged" style, which although abstract is still figurative, had coalesced. Even though he concentrated more on painting in this decade, he wrote a number of articles on printmaking for the *League* magazine.

Since the late 1950s, a number of retrospectives of both Barnet's painting and prints have been organized. These include shows at the Tweed Gallery, University of Minnesota (1958), the Institute of Contemporary Art, Boston (1961), the Albany Institute of History and Art (1962), the Brooklyn Museum (1965), the Virginia Museum of Fine Arts, Richmond (1964), Associated American Artists (1972), the Jane Haslem Gallery, Washington, D.C. (1977), the Roy E. Neuberger Museum in Purchase, New York (1979), and the Ringling Museum in Sarasota, Florida (1980).

Recently, Barnet has won many prestigious prizes, including, among others, awards from the Pennsylvania Academy of the Fine Arts, the Corcoran Gallery of Art, and the National Academy of Design. Important monographs on his art were published in 1950 and in 1965, the latter by the Brooklyn Museum. In 1972, Associated American Artists issued a catalogue raisonné of his graphics since 1932. Barnet's work may be seen in such major collections as the Museum of Modern Art, the National Gallery of Art, the New York Public Library, the Metropolitan Museum of Art, the Fogg Museum at Harvard University, and the Los Angeles County Museum of Art.

Sources

"Barnet Preaches No 'Angry Propaganda,'" *Art Digest* 14 (December 1938): 17.

Reese, Albert M. *American Prize Prints of the 10th Century.* New York: American Artists Group, 1949.

Farrell, James T. *The Paintings of Will Barnet: A Selection of 36 Paintings Completed during the Decade 1939–1949.* New York: Press Eight, 1950.

Seckler, Dorothy G. "Will Barnet Makes a Lithograph (*Fine Friends*)." *Art News* 51 (April 1952): 38–40, 62–64.

Will Barnet: A Retrospective Exhibition. Text by Orazio Fumagalli. University of Minnesota: Tweed Gallery, 1958.

Will Barnet Retrospective. Foreword by Thomas M. Messer. Boston: Institute of Contemporary Art, 1961.

Will Barnet Prints, 1932–1964. Text by Una E. Johnson and Jo Miller. New York: Brooklyn Museum, 1965.

Cole, Sylvan Jr. *Will Barnet Etchings, Lithographs, Woodcuts, Serigraphs 1932–1972, Catalogue Raisonné.* New York: Associated American Artists Group, 1972.

Will Barnet: 27 Master Prints. New York: Harry N. Abrams, 1979.

Who's Who in American Art: 1940–80.

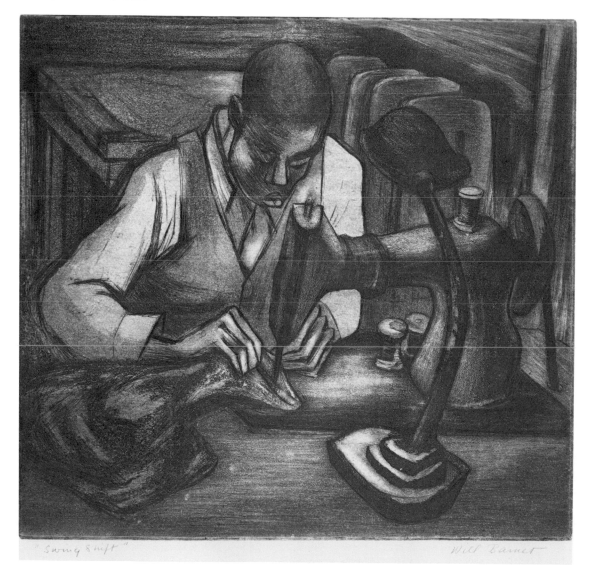

Fig. 1
Swing Shift

Will Barnet, b. 1911

Aquatint, not dated (25 x 27.2 cm)
Signed in pencil

"This was a period in my life when I spent a great deal of time 'street sketching.' It was also a period when I was very interested in the working conditions of small shops. This led to a series of etchings, including Swing Shift. *I was impressed to find the black man in Harlem was working under the same conditions as his white counterpart. Both have a strong personal dignity. This latter person inspired me to make many sketches and etchings.* Swing Shift *remains the culmination of all the work with this Harlem tailor."* The artist hoped to show *"someone who is working endlessly into the night. This was a time when there were no eight-hour workdays, and more often than not workers had to work a day well beyond ten or twelve hours."* (Will Barnet to Ellen Landau, April 14, 1982)

Fine Prints Collection
Prints and Photographs Division
Library of Congress

Lawrence Lorus Barrett

(b. 2897)

Lithograph: *The Return*

Lawrence Barrett was born on December 11, 1897, in Guthrie, Oklahoma. He intended to become a banker; but changing directions, he decided to study art at the Broadmoor Academy and at the Colorado Springs Fine Arts Center, whose faculty he eventually joined in 1936. That same year, Barrett first took up lithography. Originally taught to print by Charles Locke, Barrett was introduced by Adolf Dehn to the many and varied technical possibilities of planographic printmaking, especially with reference to the achievement of textural and tonal effects.

In 1940, Lawrence Barrett was awarded a Guggenheim Fellowship to do experimental work in lithography and, in 1950, he collaborated with Dehn on a book, *How To Draw and Print Lithographs*. By then a master printer, he was frequently called upon to process lithographic stones for other artists, especially on the West Coast. Some of the other printmakers in the "America in the War" exhibition, such as Burr Singer from California, used his services at Colorado Springs.

In the 1940s, Barrett had one-man exhibitions at the M.H. de Young Memorial Museum in San Francisco (1941), the Santa Barbara Museum (1945), and the Pasadena Museum (1946). He wrote books for children and was a member of the American Artists Group, Inc., which published his and Dehn's text, cited by *American Artist* magazine as "an important contribution to the understanding and enjoyment of the lithographic print."

Barrett's work can be seen in the collections of the Metropolitan Museum of Art.

Sources

Barrett, Lawrence, and Adolph Dehn. "How to Draw and Print Lithographs." *American Artist* 15 (May 1951): 57.

Who's Who in American Art: 1953.

Riva Helfond Barrett

(b. 1910)

Color silkscreen: *Patterns for Victory*

Riva Helfond was born on March 8, 1910, in New York City. She spent many of her childhood years in Europe, however, particularly in Russia. Returning to the United States in 1923, she studied at the Art Students League of New York with William von Schlegell, Harry Sternberg, Yasuo Kuniyoshi, Morris Kantor, and Alexander Brook. In the late 1930s she worked on the silkscreen unit of the Graphic Arts Division of the New York W.P.A. Fine Arts Project.

In 1942 Riva Helfond Barrett won two awards in an exhibition of paintings for children's rooms at the Museum of Modern Art. Other prizes awarded her in the 1940s and 1950s came from the Montclair Museum, the Library of Congress, and the Society of American Graphic Artists. She has had solo exhibitions at the Galerie Collette Allendy in Paris (1957) and, in the 1960s, at Highgate Gallery in Upper Montclair, New Jersey, Juster Gallery, New York City, and Bloomfield College, Bloomfield, New Jersey. Riva Helfond (the name she uses professionally) has also exhibited widely in both national and international group exhibitions and taught graphics at New York University, Union College in Cranford, New Jersey, and privately.

For the past twenty years or so, Helfond has owned and directed the Barrett Art Gallery in Plainfield, New Jersey. Her work may be seen there, as well as in the permanent collections of such institutions as the Metropolitan Museum of Art, the Museum of Modern Art, the Los Angeles County Museum, Cornell University, Princeton University, and the Brooklyn Museum.

Sources

Collins, J. L. *Women Artists in America, 18th Century to the Present.* Chattanooga: University of Tennessee, 1973.

Who's Who in American Art: 1940–47, 1953, 1956.

Wenonah Day Bell

(dates unknown)

Linoleum block: *Sailors in War*

Wenonah Bell was born in Trenton, South Carolina. She studied at Brenau College, at Columbia University, and at the Pennsylvania Academy of the Fine Arts (PAFA). The last institution awarded her two Cresson traveling scholarships, enabling her to take summer art classes in Capri, Italy, with Hans Hofmann, whose school was based in Munich from 1915 until 1930.

Bell was awarded the PAFA's Mary Smith prize and first prize in the Georgia-Alabama Artists Exhibition, both in 1936. In the mid-1930s, she was director of the Dickerson Art Gallery and an instructor in art at the Frances Shimer Junior College in Mt. Carroll, Illinois. By the early 1940s, she was living in New York City and teaching at the Parsons School of Design.

A painter as well as a printmaker, she has works at the John H. Vanderpoel Art Association in Chicago, the Meriwether County Court House in Greenville, Georgia, and the U.S. Department of Agriculture Buildings in Washington, D.C.

Sources

Who's Who in American Art: 1936-37, 1940-47, 1953.

Alfred Bendiner

(1899–1964)

Lithograph: *The Heroes of the Home Front—The Filter Room of the Aircraft Warning Service*

Alfred Bendiner, architect, mural painter, writer, archaeologist, printmaker, and caricaturist, was born July 23, 1899, in Pittsburgh, Pennsylvania. His parents moved to Philadelphia just a few months later. In 1917, Bendiner won a scholarship to the School of Industrial Art (now the Philadelphia College of Art). He then attended the University of Pennsylvania, where he received his bachelor of architecture degree in 1922 and a master's degree in the same field in 1927. The following year, he studied at the atelier of the American Academy in Rome and, in 1929, after working in the office of Paul P. Crèt, Bendiner opened his own architectural practice in Philadelphia.

In another facet of his career, Bendiner's caricatures appeared in various newspapers, including the *Philadelphia Evening Bulletin, Philadelphia Sunday Bulletin, Philadelphia Record,* and *Washington Times-Herald,* from 1917 through the year of his death. He wrote and illustrated two books, one whimsically satirizing some of the famous musicians associated with the Philadelphia Academy of Music, which he titled *Music to My Eyes* (1952), and the other *Bendiner's Philadelphia,* sketches of local scenes published posthumously in 1964.

Bendiner contributed articles to the *Atlantic Monthly, Harper's,* the *Journal of the American Institute of Architects,* and others. In 1937, he was the official artist for the University of Pennsylvania's archaeological expedition to Tepe Gawra and Khafaji, Iraq. Later, only four years before his death, he accompanied a similar expedition to Tikal-Tikal in Guatemala. He also did research for the American Philosophical Society and the Jewish Publication Society.

Bendiner's career as an artist included mural painting. He executed murals for Byck Brothers in Louisville, Kentucky, the Fidelity-Philadelphia Trust Company, the University of Pennsylvania Museum, and Gimbel Brothers department store in Philadelphia. Artistic prizes he won during his career included two from the Philadelphia Print Club (1938 and 1944), the popular award at the 1946 Pennsylvania Academy of the Fine Arts exhibition, the 1950 Gimbel mural competition award, a

prize from the Concord Art Association in 1954, and the Front Page Award of the Newspaper Guild in 1955.

Some of the many public collections in which Bendiner's work may be found are the Cabinet des estampes of the Bibliothèque nationale in Paris, the Uffizi Gallery in Florence, the Princeton University Library, and the National Gallery of Art in Washington, D.C.

Sources

"Alfred Bendiner, Artist, Architect." *New York Times,* March 20, 1964, 33.

Complete Catalogue, Alfred Bendiner: Lithographs. Essays by Kneeland McNulty and Ben Wolf. Philadelphia: Philadelphia Museum of Art Department of Prints and Drawings, 1965.

Who's Who in American Art: 1953.

Harriet Berger

(dates unknown)

Sugar-lift aquatint: *Wounded Soldiers*

Harriet Berger was active as an artist in Englewood, New Jersey, at the time of her submission to "America in the War."

George Albert Beyer

(b. 1900)

Color silkscreen: *Making Mess Kits*

George Albert Beyer, a painter as well as a printmaker, was born August 30, 1900, in Minneapolis, Minnesota. He studied at the Minneapolis School of Art and with Sydney Dickinson and Vaclav Vytlacil, the latter a former pupil of Hans Hofmann.

Throughout his career Beyer has remained in the Minneapolis area where, in the 1930s, he was a political and social activist who took part in demonstrations in favor of federal unemployment compensation for artists and the like. Later, as a septuagenarian, he acted as adviser to a radical group of postermakers at the University of Minnesota. This group, known as The Poster Factory, specialized in antiwar and socially oriented work.

Beyer has won awards for his art from the Museum of Modern Art, the Minneapolis State Fair (1944), the Elisabet Ney Museum (1943), and the National Serigraph Society (1941). He is represented in the permanent collection of the Ney Museum, located in Austin, Texas.

Sources

"City Man, 73, Finds Posters Means to Continue Protest." *Minneapolis Tribune,* December 1973.

Who's Who in American Art: 1953.

Julius Thiengen Bloch
(1888–1966)
Lithograph: *Sheet Metal Worker*

Julius T. Bloch, a painter and lithographer, was born in Kehl Baden, Germany, on May 12, 1888. He studied at the Philadelphia Museum of Art School, the Barnes Foundation, and the Pennsylvania Academy of the Fine Arts, where he later became an instructor.

In the early 1930s, Julius Bloch worked on the Public Works of Art Project, which preceded the W.P.A. In 1934 his painting *Unemployed Worker* was chosen by President and Mrs. Franklin Delano Roosevelt to hang in the executive offices of the White House in Washington, D.C. Bloch was among the first to extensively study the character and social conditions of black people in America through his art. His print in the "America in the War" exhibition is evidence of this interest.

Julius Bloch won many awards in Philadelphia area exhibitions throughout the 1930s, primarily for socially oriented subjects. His work is part of the permanent collection of such museums as the Metropolitan Museum of Art, the Corcoran Gallery of Art, the Philadelphia Museum of Art, and the Museum of Western Art in Moscow, USSR.

Sources

"Imported Philadelphia." *Philadelphia Art Alliance Bulletin,* April 1938, 2–3.

Reese, Albert. *American Prize Prints of the 20th Century.* New York: American Artists Group, 1949 (pp. 23, 237).

Obituary. *New York Times,* Sept. 24, 1966.

Obituary. *Washington Post,* Sept. 24, 1966.

Who's Who in American Art: 1940–47, 1953, 1966.

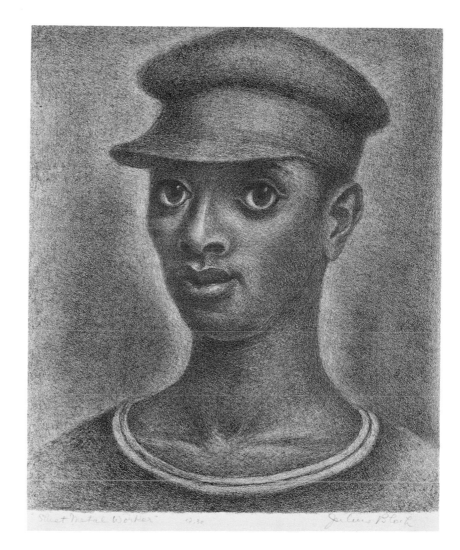

Fig. 2
Sheet Metal Worker

Julius Thiengen Bloch (1888–1966)

Lithograph, not dated
(25.7 x 20.6 cm)
Signed in pencil, edition of 30

XX B641 A2
Fine Prints Collection
Prints and Photographs Division
Library of Congress

Margot Holt Bostick
(b. 1912)
Aquatint: *Portrait of a Soldier*

Margot E. Holt was born on July 12, 1912, in Shawnee, Oklahoma. She graduated from Oklahoma A. and M. College in 1932, where she studied under Doel Reed. By the early 1940s, Margot Holt had married H. P. Bostick, who worked on defense projects at Douglas Aircraft. She herself worked as a draftsman at the Stanolind Pipe Line Company in Tulsa, Oklahoma. Her own experience and her husband's in war work probably furnished the subject for her submission to "America in the War." Her print depicts an arc welder in a defense plant. Since Bostick was relatively unknown outside Tulsa, critics were surprised when she won first prize in the intaglio division of the competition.

In the late 1930s and early 1940s, Bostick had exhibited several times on the East Coast. She showed with the National Academy of Design and with the Society of American Etchers in New York. Also, in 1944, one of her prints was chosen for the Pennell exhibition at the Library of Congress. Three years earlier, she represented Tulsa in a national sewing contest in New York.

Sources

"Tulsan's Etching Takes Top in National Contest." *The Tribune* (Tulsa, Oklahoma), October 2, 1943.

Hugh Pearce Botts
(1903–1964)
Aquatint: *Refuge '43*

Hugh P. Botts was born April 19, 1903, in New York City. He studied at Rutgers University, the National Academy of Design, the Art Students League, and the Beaux Arts Institute. His teachers included Charles Hawthorne, Charles Louis Hinton, and Charles Courtney Curran. In the 1930s, Botts worked on the Fine Arts Project of the W.P.A. and, in January 1942, he served as an alternate delegate to the Artists Council for Victory from the Society of American Etchers.

Botts exhibited extensively in print and painting exhibitions all over the United States in the thirties and forties, winning many awards. He was given one-man exhibitions at Rutgers University and by the Division of Graphic Arts of the U.S. National Museum, Smithsonian Institution (1949–50). A contributor of both illustrations and articles to many craft, technical, and trade publications, Botts served as director of the national Audobon Association Membership Committee in the late 1950s. He lived in Cranford, New Jersey, and maintained a studio on Seventy-Eighth Street in New York for the last forty-two years of his life.

His work is part of the permanent collections of many museums, including the Metropolitan Museum of Art, the New York Public Library, the Brooklyn Museum, and the Fogg Museum at Harvard University.

Sources

"Hugh Botts Dies; Painter, Lithographer." *New York Herald Tribune,* April 26, 1964.

"Hugh Botts, Etcher and Printmaker, 61." *New York Times,* April 27, 1964.

Who's Who in American Art: 1940–47, 1953, 1959.

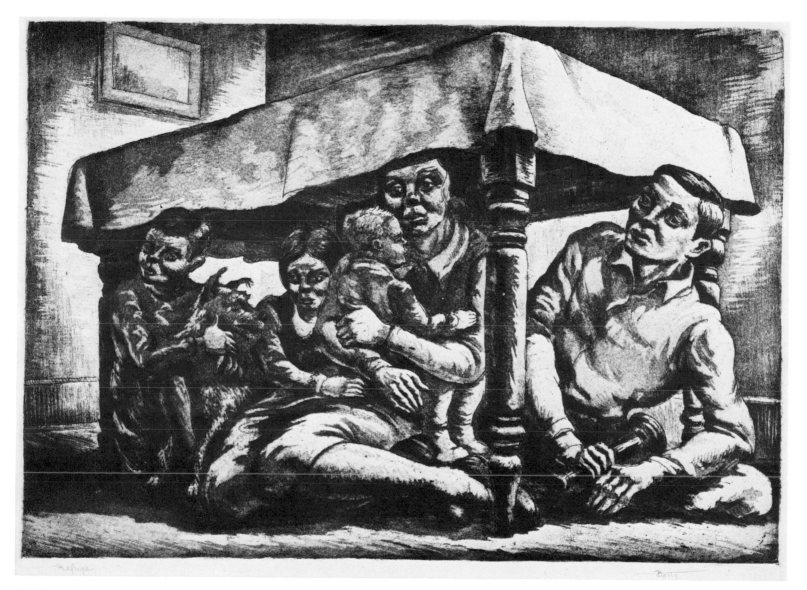

Fig. 3
Refuge '43

Hugh Pearce Botts (1903–1964)

Aquatint (soft ground etching), not
dated (18.8 x 27.1 cm)
Signed in pencil

XX B740 A45
Fine Prints Collection
Prints and Photographs Division
Library of Congress

Jack Frank Bowling

(b. 1903)

Linoleum cut: *Periscope Postmortem*

Jack Frank Bowling, an illustrator, craftsman, painter, and sculptor, was born in Bonham, Texas, on July 5, 1903. He studied at the U.S. Naval Academy and, at the time of the "America in the War" exhibition, was a lieutenant commander in the U.S. Navy. By the time of his retirement, he had attained the rank of rear admiral. Living in Hawaii in the 1930s, Bowling won the John Poole Memorial Prize in Honolulu in 1934 and exhibited with the Southern California Printmakers and Southern Printmakers Association, as well as the Honolulu Academy.

During the 1940s, Bowling had one-man exhibitions in Newport, Rhode Island; Colombo, Ceylon; Singapore; and Manila, in the Philippines. He listed his address as Hingham Centre, Massachusetts, when he entered the Artists for Victory competition; however, his address is given in art directories during the war years, and up through the early 1950s, as Washington, D.C. Later directories locate him in Philadelphia, Pennsylvania, where he operated the Two Star Studio and the Society Hill Silver Workshop after his retirement from the navy.

In the late 1950s and early 1960s, Bowling turned his attention more toward crafts, specifically religious items such as chalices, crosses, and candlesticks. He won an award in 1960 at the exhibition "Church Art Today," held at Grace Cathedral in San Francisco. Bowling has been commissioned to make many objects for churches, such as St. Columba's Episcopal Church in Washington, D.C., the Church of the Holy Trinity in Philadelphia, and Immanuel Episcopal Church in Wilmington, Delaware. He also contributed five murals to the First Baptist Church in his hometown of Bonham, Texas. Other examples of Bowling's work may be seen at the Museum of Art in Colombo, Ceylon, and the Honolulu Academy of Art. He has also illustrated several books, including *The Book of Navy Songs* and the *U.S. Naval Institute Proceedings*.

Sources

Who's Who in American Art: 1940–47, 1953, 1959, 1962.

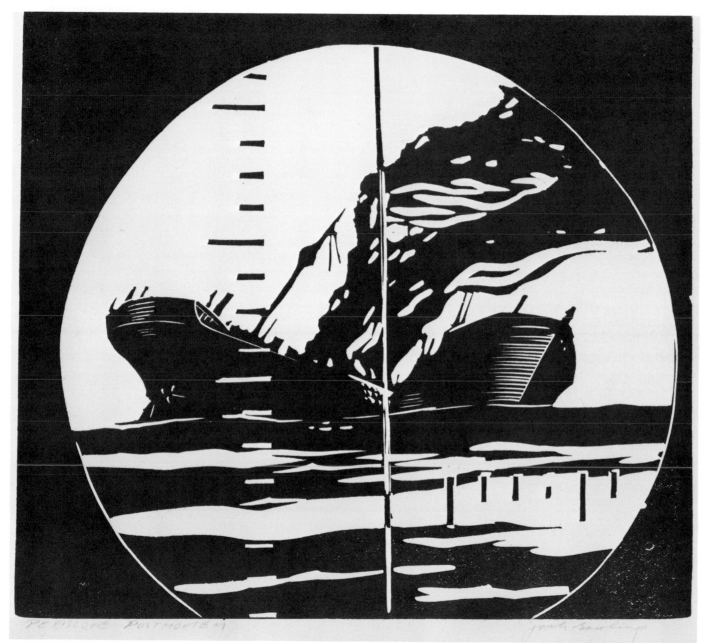

Fig. 4
Periscope Postmortem

Jack Frank Bowling, b. 1903

Linoleum cut, not dated
(17.6 x 19.9 cm)
Signed in pencil

XX B756 A1
Fine Prints Collection
Prints and Photographs Division
Library of Congress

Fiske Boyd
(1895–1975)
Woodcut: *Scarecrow of Europe*

Fiske Boyd was born in Philadelphia, Pennsylvania, on July 5, 1895, descended from several generations of fine cabinetmakers. His father, Peter K. Boyd, a master carver in wood and stone and an architectural sculptor, was an important influence on his art. Fiske Boyd studied art at the Pennsylvania Academy of the Fine Arts from 1913 to 1916, where his teachers included Garber, Breckinridge, and Pearson. He also studied sculpture there with Grafly. In 1917 Boyd attended Jay Hambidge's seminal lectures on dynamic symmetry in New York.

During World War I, Fiske Boyd served as a commissioned officer in the U.S. Naval Reserve. While a cadet at the U.S. Naval Reserve Officers Training School at Harvard University, he became friendly with author and artist Denman Ross, who was another important influence in his life. From 1921 to 1924, Boyd studied at the Art Students League with John Sloan, Boardman Robinson, and Kenneth Hayes Miller. During that time, he began exhibiting at the Daniel Gallery and, in 1928, had his first one-man show there of woodcuts he had done the previous year in Florence, Italy.

In the early 1930s, Boyd and his wife, the painter Claire Shenehon, spent their summers in the Hudson Highlands of New York and their winters in Summit, New Jersey, where Shenehon taught school. Under the auspices of the U.S. Treasury, Boyd painted a mural for the post office in Summit. During the depression years, he also worked on the Fine Arts Project of the W.P.A. and had several more one-man showings, including one at the Brownell-Lambertson Gallery, New York (1931), the Frank M. Rehn Galleries, New York (1935), and the Goodman-Walker Gallery, Boston, (1935).

In 1938, Boyd moved to Painfield, New Hampshire, and became director of the Landscape School of Pinehaven located there. He had a one-man showing at the Addison Gallery in 1940. In the following decade,

Boyd exhibited in many group shows, garnering a number of awards, most notably the John Taylor Arms Memorial Prize for creative excellence from the Society of American Graphic Artists in 1954. Recently, in 1979, the Paradox Gallery in Woodstock, New York, gave him a posthumous retrospective.

Fiske Boyd's works may be seen in the collections of the Metropolitan Museum of Art, the New York Public Library, the Baltimore Museum of Art, the Fogg Museum at Harvard University, Smith College, and others.

Sources

Cary, Elizabeth Luther. [Review], *New York Times,* April 5, 1931.

"Fiske Boyd." In *Handbook of the American Artists Group.* New York, 1935 (pp. 14–15).

Boyd, Fiske. "Tools and Materials VI: Woodcut." *American Magazine of Art* 28 (July 1935): 424–29.

Original Etchings, Lithographs and Woodcuts Published by the American Artists Group. New York, 1937 (pp. 8–10).

U.S. Treasury Department. Public Works Branch. "Fiske Boyd." *Painting and Sculpture Section Bulletin* 9 (March–May 1936): 21–22.

Reese, Albert M. *American Prize Prints of the 20th Century* New York: American Artists Group, 1949 (pp. 27, 237).

Fiske Boyd 1895–1975. Woodcuts and Drawings. Essay by R. Angeloch. Woodstock, New York: Paradox Gallery, 1979.

Who's Who in American Art: 1937, 1962.

Fig. 5
Scarecrow of Europe

Fiske Boyd (1895–1975)
Woodcut, not dated (25.3 x 16.2 cm)
33/100, signed in pencil

XX B761 A3
Fine Prints Collection
Prints and Photographs Division
Library of Congress

23

Helen King Boyer
(b. 1919)
Drypoint: *Rumor*

Helen King Boyer, the daughter of Louise Rivé-King Miller Boyer, whose work is also presented in this exhibition, was born December 16, 1919, in Pittsburgh, Pennsylvania. She studied art with Samuel Rosenberg and Boyd Hanna and lithography at the Carnegie Institute of Technology with Wilfred Readio. She had her first solo exhibition at age sixteen and a one-woman show at the Pittsburgh Arts and Crafts Center in 1951.

Just before and during the war years, Helen Boyer and her mother both worked in drypoint on experimental anodic-coated aluminum, which had the advantage of requiring no grounding or biting and allowed long editions from lightly cut passages. Her print in the "America in the War" exhibition probably reflects her experimental period. Later, both she and her mother switched to the more typical copper printing plate.

Helen Boyer exhibited throughout the 1940s with printmakers' associations all over the United States, and she received a Tiffany Foundation grant in 1949. In 1955 she executed a mural on silk for the Henning Company. By this time, she had moved to Leonia, New Jersey, and was working in New York City as a designer of tie silks and stuffed toys.

Boyer's work is part of the permanent collections of the Carnegie Institute, the Metropolitan Museum of Art, and the Miniature Print Society, for whom she executed the presentation print in 1953.

Sources

Collins, J. L. *Women Artists in America, Eighteenth Century to the Present.* Chattanooga: University of Tennessee, 1973.

Who's Who in American Art: 1953, 1962.

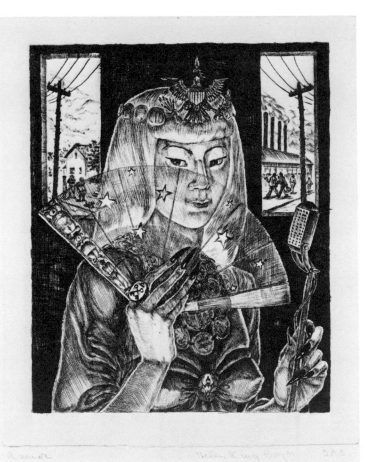

Fig. 6
Rumor

Helen King Boyer, b. 1919

Drypoint, not dated (13.8 x 11.4 cm)
Signed in pencil

XX B767 A5
Fine Prints Collection
Prints and Photographs Division
Library of Congress

Louise Rivé-King Miller Boyer

(1890–?)

Drypoint: *The Hot Mill—First Line of Defense, Aluminum Company, New Kensington, Pa.*

Louise Rivé-King Miller was born on the south side of Pittsburgh, Pennsylvania, on October 30, 1890. She studied at the Pittsburgh School of Design and the Carnegie Institute of Technology where she received a bachelor's degree. Among her teachers were Henry Keller, Arthur Sparks, and Charles Hawthorne. She married I. W. Boyer, and their daughter Helen became a printmaker also, working with her mother in drypoint on experimental plates in the late 1930s and early 1940s. In 1946, an extensive article in the *Pittsburgh Press* explained Mrs. Boyer's method of working. At that time, she was living in the Brentwood section of Pittsburgh, although she later moved to Leonia, New Jersey, with her daughter.

Louise Boyer exhibited frequently throughout the 1940s with the Society of American Graphic Artists and other printmakers' associations all across the United States. She was awarded prizes by the Pittsburgh Association of Art and the John Herron Art Institute in Indianapolis. Her work may be seen in such public and private collections as that of the Metropolitan Museum of Art, the Carnegie Institute, the Richard C. DuPont Memorial, and the Aluminum Company of America. Her print in "America in the War," *The Hot Mill,* was subtitled "First Line of Defense, Aluminum Company, New Kensington, Pa." and attests to the strong feelings Louise Boyer had about the steel industry in her native Pittsburgh and to her conviction about the importance of the work done by American industry in helping to win a global war.

Sources

"An Etcher Looks at Pittsburgh," *Pittsburgh Press,* March 17, 1946, p. 18.

Reese, Albert. *American Prize Prints of the 20th Century.* New York: American Artists Group, 1949 (pp. 28, 238).

Collins, J. L. *Women Artists in America, Eighteenth Century to the Present.* Chattanooga: University of Chattanooga, 1973.

Who's Who in American Art: 1953, 1962.

Letterio Calapai

(b. 1904)

Wood engraving: *Labor in a Diesel Plant*

Letterio Calapai, a first-generation American of Sicilian descent, was born in Boston, Massachusetts, on March 29, 1904. He studied at the Boston School of Fine Arts and Crafts and the Massachusetts School of Art, with Charles Hopkinson and Howard Giles. In 1928, he moved to New York, where he studied sculpture at the Beaux Arts Institute of Design and at the Art Students League with Robert Laurent. He also learned the fresco technique of mural painting from Ben Shahn at the American Art School. Calapai never formally studied printmaking, but he was inspired by the work of the eighteenth-century English printer Thomas Bewick.

In the 1930s, Letterio Calapai worked on the Mural Division of the W.P.A. Fine Arts Project in New York. He had his first one-man exhibition of oil paintings at the Art Center in New York City in 1933, and his second the following year at the Montross Gallery, whereupon Howard Devree, art critic of the *New York Times,* hailed him as "a new discovery in the art firmament." In 1939, Calapai worked at the New York World's Fair repairing sculpture damaged in shipping to the Italian pavilion and assisting various muralists. To do this, he had to become a member of the United Scenic Artists Brotherhood of Painters, Decorators, and Paperhangers, Local 929 of the AFL. Calapai then worked with Hugo Gellert, Anton Refregier, and Stuyvesant Van Veen of the Muralists Guild on furthering unionism in the arts and amalgamating the AFL and the CIO.

Letterio Calapai's most important mural, commissioned by the W.P.A., was a series of three panels depicting the history of military signal communication, painted for the 101st Battalion Armory in Brooklyn. Formally presented in June 1939, these panels were acquired by the U.S. Army in 1980 and were installed in late 1982 in a special room at the U.S. Army Signal Museum at Ft. Gordon, Georgia.

During the war, Calapai did defense work in Auburn, New York, at the American Locomotive Company, which was building diesels for use in the cold climate of Siberia. This experience was recorded in his wood-engraving *Labor in a Diesel Plant,* which won third prize in the relief medium category of the "America in the War" competition. Included in the lower left corner of this work is a self-portrait of Calapai rolling an

oil drum. Before this, Calapai had never submitted a print to any show. The following year, 1944, one of his works was chosen for Fifty Prints of the Year.

In 1946, Letterio Calapai met Stanley William Hayter and became associated with the innovative group of printmakers at Atelier 17, remaining there for the next three years. He was working at this time on a series of illustrations for a Negro Bible and for Thomas Wolfe's *Look Homeward, Angel,* which he exhibited at the George Binet Gallery in New York and in a one-man show sponsored by the Graphics Division of the Smithsonian Institution.

During this time, Calapai was also working as an instructor at the Riverside Museum and the Brooklyn Museum Art School. From 1949 to 1955, he taught at the University of Buffalo's Albright School of Art, where he was chairman of the department of graphics. Returning to New York City, he taught at the New School for Social Research from 1955 to 1962 and was instrumental in setting up the Contemporaries Graphic Art Center (now the Pratt Graphics Center) with Margaret Lowengrund (another of the artists involved in "America in the War"). In 1960, Calapai founded the Intaglio Workshop for Advanced Printmaking and, from 1962 to 1965, taught at New York University and at Brandeis University in Massachusetts.

In the 1950s and 1960s, Calapai participated in numerous group shows. He won a Tiffany Foundation grant in 1959 and a Rosenwald Foundation award in 1960. In 1972, the Illinois Arts Council organized a traveling retrospective of twenty years of his career. Examples of Calapai's work may be seen in numerous public and private collections all over the United States, at the Bibliothèque nationale in Paris, the Kunsthaus in Zurich, and in museums in Italy, Australia, Israel, India, and Japan.

Sources

Devree, Howard. [Review, Montross Show]. *New York Times,* December 23, 1934.

Historical Development of Military Signal Communication: A Mural by Letterio Calapai. New York: W.P.A. Federal Art Project, 1939.

Heintzelman, Arthur W. *Wood-engravings by Calapai.* Boston, 1948.

Reese, Albert M. *American Prize Prints of the 20th Century.* New York: American Artists Group, 1949 (pp. 36, 238).

"Explorer of Techniques: Letterio Calapai." *Kendall College Magazine* (Spring 1966): 27.

Long, Chester Clayton. "The Art of Letterio Calapai." In *Letterio Calapai: 20 Years of Printmaking.* Chicago: Illinois Arts Council, January 31, 1972–February 25, 1972.

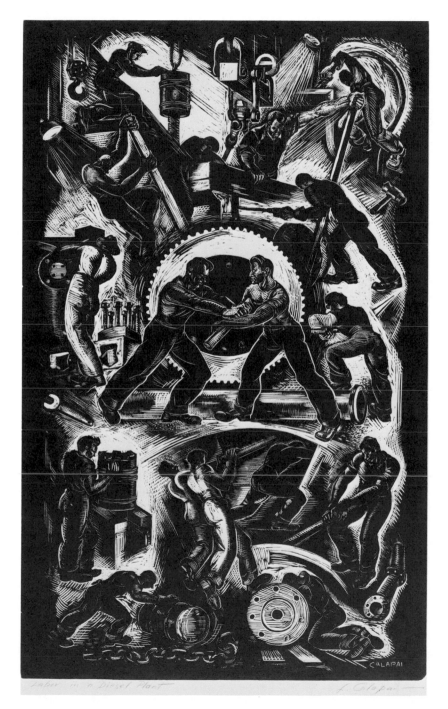

Fig. 7
Labor in a Diesel Plant

Letterio Calapai, b. 1904

*Wood engraving, not dated
(39.8 x 24.2 cm)
Signed on block and in pencil*

The artist describes how he completed this print in 1940 in Auburn, New York, where he had taken a war job at the American Locomotive Company: "As the 'Oil Man' I was stationed in the Oil House and summoned by telephone when needed immediately to serve the engineers on the main floor of the plant, where diesel engines were being built for use in Siberia. During periods in the Oil House when I was not needed, I sketched from memory what I had seen of the workmen building the various parts of the engines. From these numerous sketches I composed the design of the print and engraved it onto boxwood." (Letterio Calapai to Ellen G. Landau, 1982)

*XX C148 B1
Fine Prints Collection
Prints and Photographs Division
Library of Congress*

Minna Wright Citron

(b. 1896)

Etching and aquatint: *As Tom Goes Marching to War*

Minna Wright was born October 15, 1896, in Newark, New Jersey. She studied at the Brooklyn Model School, the Manual Training High School, the Brooklyn Institute of Arts and Sciences, the New York School of Applied Design, and City College of New York. She also took classes at the Art Students League, from 1928 to 1935 and again in 1940–42, with Kimon Nicolaides, Kenneth Hayes Miller, Reginald Marsh, John Sloan, and Charles Locke. In the mid-twenties she married Henry Citron. In 1930 she had her first solo exhibition at the New School for Social Research and in the early thirties established a studio in Union Square, an area in which she has remained active as an artist.

Citron's work in the 1930s centered around a good-humored, satirical treatment of current mores, especially with relation to women. Her one-person show in 1935 was titled "Feminanities." She first came to prominence when the Section of Painting and Sculpture of the U.S. Treasury Department commissioned her to paint two murals for the United States post office in Newport, Tennessee, on the subject of the Tennessee Valley Authority. Her show of paintings related to this project at the Art Students League in 1940, was attended by Eleanor Roosevelt. She also painted another mural for the post office in Manchester, Tennessee.

Citron was an instructor in drawing at the Brooklyn Museum from 1943 to 1946. Her 1943 Midtown Gallery exhibition was entitled "New York in Wartime." The mother of two sons in action at that time, Citron spent many hours sketching at Pennsylvania Station, the Officers Service Club of the Hotel Commodore, and other places frequented by soldiers and sailors. Her entry to "America in the War" depicts one of her sons leaving for duty.

Around this time, Minna Citron became associated with the innovative printmakers at Stanley William Hayter's Atelier 17, and she began to change from using a representational style to depict subject matter based on her observation of the milieu around her to doing first semiabstract prints and then Abstract Expressionist-influenced nonobjective works. She did her first completely abstract print in 1946. That year, she was Paris correspondent for *Iconograph* magazine and the following year she represented the United States government at the Congrès internationale d'éducation artistique in France. Citron had a number of solo showings in the 1940s, including the Isaac Delgado Museum in New Orleans, the Corcoran Gallery of Art, the Galerie Lydia Conti in Paris, Howard University, and the Division of Graphic Arts of the Smithsonian Institution.

In the 1950s, Minna Citron, at that time a director of the Pan American Women's Association, went on a South American lecture and exhibition tour, in conjunction with which the Pan American Union published a monograph on her work. This was a period of extensive experimentation for her. In 1954, a retrospective of a decade of her work went on exhibit in Philadelphia and Texas.

A Fellow of the MacDowell Colony from 1955 to 1959, Citron had a show in Yugoslavia sponsored by the U.S. Information Agency, one at the U.S. Embassy in London, and one at the American Cultural Center, in the ensuing years. She received a Ford Foundation grant to be artist-in-residence at the Roanoke Fine Arts Center in Virginia in 1965. From 1971 to 1972, she taught at Pratt Institute, and all of her work since then has been done at the Pratt Graphic Center. In 1976, the New York Public Library showed in series her graphic oeuvre from 1945 to 1975.

In addition to writing for *Iconograph*, Citron has contributed articles to such magazines as *Artist's Proof, Impression,* and the *College Art Journal,* as well as to the Brazilian publication *U.C.B.E.U.,* on such topics as how modern art communicates to the viewer. Her work may be seen in the collections of the National Museum of American Art, the White House, the U.S. Information Agency, the Museum of Modern Art, the Victoria and Albert Museum in London, the Bibliothèque nationale in Paris, and many others.

Sources

"Feminanities." *Time Magazine,* May 6, 1935.

Lilienthal, David. *Two-Murals of T.V.A. for the Post Office, Newport, Tennessee, by Minna Citron.* New York: Art Students League, October 8–19, 1940.

"Citron Rules the 'Waves.'" *The Art Digest* 17 (April 1, 1943).

"Minna Citron Reveals the Artist in Everyone." *Brooklyn Eagle* November 12, 1946.

Reese, Albert M. *American Prize Prints of the 20th Century.* New York: American Artists Group, 1949 (pp. 42, 239).

The Graphic Work of Minna Citron 1945–1950. Essay by Karl Kup. New York: The New School for Social Research, October 16–29, 1950.

Wescher, Herta. "Minna Citron—Galerie Arnaud." *Cimaise* Paris, June–August 1956.

Sixteen Years After. Minna Citron. Essay by Joseph Frank. Washington, D.C.: Howard University Gallery of Art, April 19–May 17, 1962.

Chapman, Max. *From the 80 Years of Minna Citron.* New York: Wittenborn Art Books, 1976.

Marxer, Donna. "Minna Citron: Getting Old is Just as Good." *Women Artists Newsletter* (December 1977): 2.

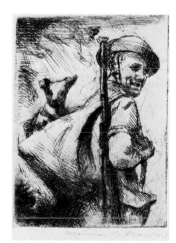

Fig. 8
As Tom Goes Marching to War

Minna Citron, b. 1896

*Etching and aquatint, 1943
(5.7 x 4.1 cm)
Signed and dated in pencil*

The artist comments that she made prints "when my son left for his Pacific campaign as an amphibian engineer, and when he returned after having served his country with honor and distinction for three years. In the first print, his dog Curley is shown tucked away in Tom's knapsack where he would have liked so much to have had him. Print two shows Tom hotfooting it home to Curley." (Minna Citron to Albert M. Reese, 1947)

*XX C581 A6
Fine Prints Collection
Prints and Photographs Division
Library of Congress*

Eleanor Coen

(b. 1916)

Color lithograph: *Reprisal*

Eleanor Coen was born in Normal, Illinois, in 1916. She studied painting at the School of the Art Institute of Chicago under Boris Anisfeld and lithography under Francis Chapin and Max Kahn, whom she later married. During 1939–40, she worked on the Federal Art Project of the W.P.A. in Chicago. Upon graduation from the Art Institute in 1941, she won the James Nelson Raymond Traveling Fellowship and used it to live and work in San Miguel de Allende, Mexico, where she painted a mural in fresco.

Some of the other prizes Coen won during her career include the San Francisco Art Association purchase prize and awards from the Print Club of Philadelphia, the Art Institute of Chicago, the Brooklyn Museum, and the Pennell purchase prize at the Library of Congress. In 1959 and again in 1967, the Fairweather-Hardin Gallery in Chicago gave her solo exhibitions. Earlier, in 1951, she collaborated in a two-person show with her husband at the College of Fine Arts of Syracuse University. Frequent subjects in her paintings and color lithographs are the couple's two children.

Eleanor Coen's work may be seen in many public collections, most notably the Art Institute of Chicago, the Museo de Arte Moderna in Sao Paulo, Brazil, the Philadelphia Museum of Art, and the National Museum, Stockholm, Sweden.

Sources

"Exhibit, Palmer House Galleries, Chicago." *Art Digest* 23 (Feb. 1, 1949): 6.

"Coen and Kahn to Show Color Lithos." *Philadelphia Art Alliance Bulletin* 30 (October 1951): 9.

Eleanor Coen Paintings—Italy and France. Chicago: Fairweather-Hardin Gallery, October 18–November 11, 1967.

Butler, Doris Lane. "Eleanor Coen Canvases Show Imaginative Talent." Clipping in Eleanor Coen and Max Kahn Papers, Archives of American Art, Washington, D.C., *n.d.*

Weigle, Edith. "Meet Eleanor Coen of City's Paintingest Family," Clipping in Eleanor Coen and Max Kahn Papers, Archives of American Art, Washington, D.C., *n.d.*

Richard Correll
(b. 1904)
Linoleum cut: *Air Raid Wardens*

Richard Correll, a painter and printmaker, was born in Springfield, Missouri, on October 22, 1904. At the time of the "America in the War" exhibition, he resided in New York City. During the war years he executed work for the Office of War Information and he showed a politically oriented piece entitled *What Are We Waiting For?* in the June 1942 A.C.A. Galleries' exhibition "Artists in the War." Throughout the late 1930s and early 1940s, he also showed at the Metropolitan Museum of Art (in 1942, probably at the large Artists for Victory-sponsored exhibition), with the Northwest Printmakers, and in Oakland, San Francisco, and Philadelphia.

Sources

Who's Who in American Art: 1940–47, 1953.

Gladys Hood Detwiler
(dates unknown)
Etching and drypoint: *They Do Their Part—The U.S. Merchant Marine*

At the time of the "America in the War" exhibition, Gladys Hood Detwiler resided in New York City, where she apparently remained through the early 1960s. The *Print Collector's Quarterly* featured one of her works in 1949.

Frederick Knecht Detwiller

(1882–1953)

Color silkscreen: *Sardines for the Army*

Frederick Knecht Detwiller was born in Easton, Pennsylvania, on December 31, 1882. He graduated from Lafayette College in 1904 and, acceding to his parents' wishes, went to the New York Law School, where he earned an LL.B. degree. After practicing law for only a short time, however, he pursued courses in art and architecture at Columbia University. He went to Paris to continue his architectural studies but turned toward painting on the advice of Victor Lalou, president of the Paris Salon, who was impressed with Detwiller's work. Detwiller then completed his art training at the Academie Colorossi in Paris and the Instituti de Belli Arti in Florence. He returned to the United States in 1914, at the outbreak of World War I, and settled in New York City.

Detwiller made his reputation in the 1930s with a series of New York scenes depicting the city's bridges and their construction, the waterfront, and the men working in these areas in the hot summer sun. He did not, however, restrict himself to the urban environment. For example, as a guest of the Canadian Pacific Railway, he spent part of the summer of 1938 painting the Nimpkesh tribe of Indians at Alert Bay, near Alaska. He later became one of the Pemaquid Group, an art colony in Maine.

In the late 1930s, Detwiller devised a system of Graphic Art Education which comprised a series of lectures and exhibitions for college students. A typescript describing his system is in the Library of Congress. He contributed articles to the *Print Connoisseur* and other magazines and wrote a book, *The Story of a Statue,* in 1943.

Frederick Detwiller served as president of numerous art organizations in the 1930s and 1940s, including the Salamagundi Club, the Allied Artists of America, and the Society of American Etchers. He was awarded an honorary doctor of humane letters degree from his alma mater, Lafayette College, in 1945, and he also received many significant prizes for his artwork.

Examples of Detwiller's work may be seen in the permanent collections of the Brooklyn Museum, the Museum of the City of New York, the Bibliotheque nationale in Paris, the Victoria and Albert Museum in London, and many other prominent institutions.

Sources

"Wooden Shipyard War Series: Etchings by Frederick Knecht Detwiller." *Print Connoisseur* 2 (December 1921): 116–21.

"Painter of Town and Country: Frederick Knecht Detwiller." *American Art News* 21 (March 10, 1923): 2.

Lord, Alice Frost. "To the Artist Belongs the Duty of Keeping Faith and Cherishing Beauty." *Lewiston* (Maine) *Journal,* magazine section, September 16, 1944.

"Frederick Knecht Detwiller Exhibition." *Pictures on Exhibit* 11 (February 1949): 23–24.

Reese, Albert M. *American Prize Prints of the 20th Century.* New York: American Artists Group, 1949 (pp. 52, 240).

Who's Who in American Art: 1940–47, 1953.

Fig. 9
Sardines for the Army

Frederick Knecht Detwiller
(1882–1953)

Color silkscreen, 1943
(45.6 x 25.5 cm)
11/42, signed and dated on screen,
signed in pencil

"The print was made from a series of
watercolor studies made in the fish
wharves in Maine. In sequence I want
to express the various stages in the
preparation of the sardines: the boats
that bring them in from the sea and
the fisher folk cleaning them on the
cutting tables. To do this I used the
diagonal relation of shapes and color
and linear perspective"
(Frederick K. Detwiller)

XX D4832 B2
Fine Prints Collection
Prints and Photographs Division
Library of Congress

Caroline Wogan Durieux

(b. 1896)

Lithograph: *Bourbon Street, New Orleans*

Caroline Wogan was born on January 22, 1896. Her mother was a Yankee and her father of French Creole ancestry. She studied art at Newcomb College of Tulane University with Ellsworth Woodward, who espoused a conservative, nineteenth-century German academic approach, under which Wogan chafed as a student. She attended the Pennsylvania Academy of the Fine Arts from 1917 to 1919, on a two-year scholarship from the New Orleans Art Association. There, under Henry McCarter and Arthur B. Carles, she encountered the tenets of modern art. Later, in 1949, she earned an M.F.A. from Louisiana State University.

In 1920, Caroline Wogan married Pierre Durieux, an exporter, and went with him to live in Havana, Cuba. During this time, she painted landscapes and flower arrangements in watercolor and oils and designed screens and furniture, in the Chinese manner, for the interior decorator Henry Bailey. In 1926, her husband was made Mexican representative for General Motors, and they moved to Mexico City, where they lived until 1937. Here she began the work in a satiric vein for which she is best known.

In 1930, Caroline Wogan Durieux took up lithography at the suggestion of Carl Zigrosser, then head of the Weyhe Gallery. On a trip to New York, she learned the technique from the printer George Miller and, back in Mexico, became affiliated with the printer Dario Mejia, at the commercial lithography establishment Lithografia Senefelder. She also worked with the lithographer Amero at the Academia S. Carlos, and her art benefited from a friendship with Diego Rivera. In the 1930s, she had a number of solo exhibitions in New Orleans, Chicago, and New York.

In 1937, the Durieux returned to New Orleans and took up residence in the Old French Quarter, and Caroline Durieux became a consultant to the W.P.A. Fine Arts Project for Louisiana. She taught at Newcomb College from 1938 to 1943 and illustrated the *New Orleans City Guide,* prepared by the local branch of the Federal Writers Project, under the editorship of Lyle Saxon.

Durieux's work of the late 1930s and early 1940s, in New Orleans, exhibits her own version of the socially conscious tendency so prevalent in art at that time. She took a sardonic, psychologically insightful look at her surroundings and the people of Louisiana. At the request of Carl Zigrosser, one of the judges, she made *Bourbon Street, New Orleans* for the "America in the War" exhibition. This work has become one of her most famous prints.

In 1941, Caroline Durieux worked for the coordinator of inter-American affairs and accompanied an exhibition organized by the Museum of Modern Art all over South America. Two years later, she joined the faculty of Louisiana State University and, in the late 1940s, illustrated a number of books on local subjects, including *Gumbo Ya Ya* (1945) and *Mardi-Gras Day* (1948).

In 1951, Durieux was given a grant to work on developing the electron and cliché-verre printing techniques. In the ensuing decade, she specialized in these methods: cliché-verre, which involves the combination of photography and graphics, and electron prints, made from drawing with ink containing radioactive isotopes, exposed to a sheet of sensitized paper, then developed like a photograph. The latter method she invented with the help of Naomi L. and Harry Z. Wheeler, under the auspices of the Louisiana State University State Council on Research. Durieux has had a number of solo exhibitions of her innovative printing methods, including two at the Louisiana State University and one at the George Washington University Library in Washington, D.C.

A guest artist at the Tamarind Lithography Workshop in the 1960s, Durieux has also won numerous other art awards. Examples of her work may be seen in such collections as the National Gallery of Art, the Museum of Modern Art, the Philadelphia Museum of Art, the Bibliothèque nationale in Paris, the Smithsonian Institution, the Louisiana State University, and the Atomic Energy Museum, Oak Ridge, Tennessee.

Sources

Rivera, Diego. "On the Work of Caroline Durieux." *Mexican Folkways* 5 (July–September 1929): 158.

"An American-Mexican Painter, Caroline Durieux." *L'Art vivant* 6 (January 15, 1930): 84, 86.

Rivera, Diego. "Caroline Durieux." *Mexican Folkways* 8 (August 1935): 89.

Salpeter, Harry. "About Caroline Durieux." *Coronet* 2 (June 1937): 50–58.

Zigrosser, Carl. *The Artist in America: 24 Close-Ups of Contemporary Print-makers*. New York: Alfred A. Knopf, 1942 (pp. 125–31).

"Caroline Durieux." *Richmond, Virginia, Museum of Fine Arts Bulletin* 4 (April 1944): 1–2.

Reese, Albert M. *American Prize Prints of the 20th Century*. New York: American Artists Group, 1949 (pp. 53, 240).

Caroline Durieux: 43 Lithographs and Drawings. Foreword by Carl Zigrosser. Baton Rouge: Louisiana State University Press, 1949.

Cox, Richard. *Caroline Durieux: Lithographs of the Thirties and Forties*. Baton Rouge: Louisiana State University Press, 1977.

Who's Who in American Art: 1940–80.

Fig. 10
Bourbon Street, New Orleans

Caroline Wogan Durieux, b. 1896

Lithograph, 1943 (27.2 x 25.3 cm)
Signed and dated in pencil

XX D910 A4
Fine Prints Collection
Prints and Photographs Division
Library of Congress

Ralph Fabri

(1894–1975)

Etching: *The Four Freedoms*

Ralph Fabri was born in Budapest, Hungary, on April 23, 1894. He studied architecture for two years at the Institute of Technology in Budapest before switching to a concentration on painting and etching at the Royal Academy of Fine Arts, from which he graduated in 1918 with a professorial degree. Fabri emigrated to the United States in 1921, at age twenty-seven, and was naturalized six years later. Awarded a prize from the American-Hungarian Cultural Federation in 1932, he had his first one-man show in this country, sponsored by the Gainesville Florida Art Association, in 1938.

In the early 1940s, Fabri was an active member of Artists for Victory. He represented the Society of American Etchers to the main organization in 1944 and he was elected head of Artists for Victory's Graphic Arts Committee in 1945. His work during these years was preoccupied with the events surrounding World War II. In 1945, critic Howard Devree of the *New York Times* pointed out that some of Fabri's prints, dating back as early as 1930, actually seemed prophetic of the war. Critics were shocked by the pessimistic attitude toward current events in Fabri's one-man show sponsored by the Division of Graphic Arts of the Smithsonian Institution in 1942. Additional solo showings in the 1940s were held at institutions in Philadelphia, Honolulu, Maine, and New York City, and at the Szalmassy Galleries in Budapest, Hungary (1946).

In the 1950s, Ralph Fabri had a large one-man exhibition at the Albany Institute of History and Art. He served as staff critic for *Pictures on Exhibit* and editor of *Today's Art,* published in Washington, D.C., by the George F. Muth Co. Fabri wrote most of the articles for that publication, on such varied topics as the illusion of depth on a two-dimensional surface, Impressionism, Cubism, and art inspired by religion. Fabri also wrote several popular books on art, including *How to Draw: A Comprehensive Handbook for Art Students and Art Lovers* (1945), *Oil Painting, How-to-Do-It* (1953), and texts on paper sculpture, painting cityscapes, and the history of the American Watercolor Society.

Ralph Fabri was also a teacher of art. During his career he was on the faculties of the Parsons School of Design, the National Academy of Design, the Newark School of Fine Arts, and the City College of New York. He served as an officer of such art organizations as the Audobon Artists, the Society of American Graphic Artists, and the National Society of Painters in Casein. He won many prizes throughout his career, and his work is in the permanent collections of such museums as the Metropolitan Museum of Art, the Museum of Fine Arts in Budapest, the Ross W. Sloniker Collection of Biblical Prints, the New York Public Library, and the Honolulu Academy of Arts.

Sources

"New York Etcher at National Museum." *Washington Star,* December 13, 1942.

"Etchings by Ralph Fabri." *Directions* (Darien, Connecticut) 7, no. 3 (1944): 16–17.

Devree, Howard. [Review]. *New York Times,* February 25, 1945.

Reese, Albert M. *American Prize Prints of the 20th Century.* New York: American Artists Group, 1949 (pp. 57, 241).

Who's Who in American Art: 1940–47, 1953, 1966.

Fig. 11
The Four Freedoms

Ralph Fabri (1894–1975)

Etching, 1943 (22.6 x 30.1 cm)
25/100, signed in pencil

XX F124 A8
Fine Prints Collection
Prints and Photographs Division
Library of Congress

Hulda Rotier Fischer
(1893–?)
Zinc lithograph: *Chaos, 1942*

Hulda Rotier Fischer, a painter and teacher as well as a graphic artist, was born in Milwaukee, Wisconsin, on July 28, 1893. She studied at the Milwaukee School of Art, at the Milwaukee Art Institute, at the Art Institute of Chicago, and with Morris Davidson, Armin Hanson, and Robert von Neumann. For many years she taught art at the Shorewood, Wisconsin, High School.

Fischer took part in many group exhibitions in the Midwest and West in the 1930s and 1940s, including the Wisconsin State Fair (1938–44), the Women Painters of America exhibition in Wichita, Kansas (1938), and shows at the Oklahoma Art Center (1939–41). She had three solo exhibitions between 1938 and 1961.

Fischer's work is in the permanent collections of such museums as the Milwaukee Art Institute and the John Herron Institute. Examples may also be seen at the Winneconni School in Wisconsin, the Merrill Wise High School, the Boys' Therapeutic School, Iron Mountain, Wisconsin, the Shorewood, Wisconsin, North Shore Bank, and the Woods, Wisconsin, Veterans Hospital.

Sources

Collins, J. L. *Women Artists in America, 18th Century to the Present.* Chattanooga: University of Tennessee, 1973.

Who's Who in American Art: 1953, 1962.

Richard Floethe
(b. 1901)
Color silkscreen: *The Liberator*

Richard Floethe was born September 2, 1901, in Essen, Germany. He studied in Europe at the Realschule Pyrmont and the Pedagogium Oberrealschule in Giessen, and learned the rudiments of the graphic arts at the Academy of Applied Art in Munich and Dortmund, under Willie Geiger and Edward Ege. He next became a student at the Bauhaus in Weimar, where he took courses with Paul Klee, Wassily Kandinsky, and Laszlo Moholy-Nagy. Before coming to this country in 1928, he executed a large historical mural for the International Exposition in Cologne.

During the Depression in New York, Floethe worked as an art director on the W.P.A. Federal Art Project (1936–39) and, from 1942–43, he served in a similar capacity with the New York City War Services. He taught commercial design at the Cooper Union (1941–42) and serigraphy at the Ringling School of Art in Sarasota, Florida (1955–67). Floethe has had exhibitions at Pynson Printers, New York (1937), the Philadelphia Art Alliance (1944), and the Sarasota Art Association (1955).

Richard Floethe gained great fame as a cover designer and illustrator of adult's and children's books. He began, in the 1930s, doing work of this type for the Limited Editions Club and won awards for his *Tyl Ulenspiegl* and *Pinocchio* illustrations in this series. In 1950, he won the American Institute of Graphic Arts award for *English Is Our Language.* Floethe wrote on illustrating picture books for the *Horn Book* magazine. In 1939, his book *Summer Holiday,* a story told in color and line, was published by the Brookdale Press.

Floethe's print, *The Liberator,* was chosen by *Art News* as the cover for the October 1–14, 1943, issue, in which the "America in the War" official catalog was published. Later the print was sent to the Soviet Union and shown at the Kalinin Galleries in Moscow.

Other examples of Floethe's work may be seen in the collections of the Metropolitan Museum of Art, the Philadelphia Museum of Art, the Kerlan Collection at the University of Minnesota, and the Spencer Collection at the Fifth Avenue Library, New York.

Sources

Floethe, Ronald K. *Kid Stuff.* Gordon Kerckhoff Productions, 1970.

Bielschowsky, Ludwig. "Richard Floethe, a German-American Illustrator." *Illustration* 63 (1974).

Who's Who in American Art: 1940–47 through 1980.

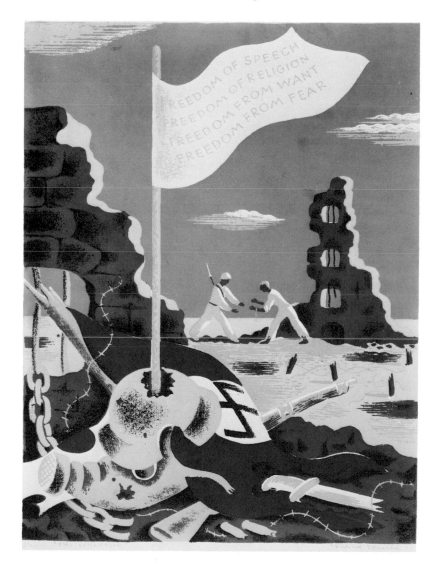

Fig. 12
The Liberator

Richard Floethe, b. 1901

Color silkscreen, 1943
(30.1 x 40.2 cm)
7/35, signed and dated in pencil

"My print, The Liberator, *was created at an emotional time when all our minds were concentrated on the war's outcome," the artist said in 1982 about this work. In October 1945 Floethe's print was included in an exhibit sent to the Soviet Union, where it was singled out as "a very striking piece."*

XX F628 B1
Fine Prints Collection
Prints and Photographs Division
Library of Congress

Jean Eda Francksen
(b. 1914)
Lithograph: *The Final Exam*

Jean Eda Francksen was born in Philadelphia, Pennsylvania, on May 9, 1914. She studied at the University of Pennsylvania, where she received a B.F.A. in education, and she took art courses at the Philadelphia Museum School of Industrial Art and the Barnes Foundation. Her teachers included Benton Spruance, Arthur B. Carles, and Stanley William Hayter of Atelier 17. Francksen herself taught in the late 1930s and early 1940s, at Beaver College in Jenkintown, Pennsylvania, the Philadelphia Museum School of Industrial Art, and Swarthmore College. She exhibited extensively in Philadelphia from 1938 through 1952, at the Museum of New Mexico in Santa Fe (1941), and at the Library of Congress (1943–44).

Early in her career, Jean Francksen did illustrations for such books as *Fog on the Mountain* (1937) and *It's Fun to Listen* (1939). She has executed murals for St. Joseph's Hospital in Carbondale, Pennsylvania, the Einstein Memorial Hospital, the Riverview Home for the Aged, and the Children's Reception Center, all in Philadelphia. Other buildings in which her wall paintings may be seen are Medill Blair High School in Fairless Hills and the Jewish Community Center in Scranton, Pennsylvania. Her work is also in the collection of the Philadelphis Museum of Art.

Sources

Collins, J. L. *Women Artists in America, 18th Century to the Present.* Chattanooga: University of Tennessee, 1973.

Who's Who in American Art: 1940–47, 1953, 1962.

Samuel Greenburg
(b. 1905)
Color woodcut: *For Freedom*

Samuel Greenburg was born in Russia, at Uman, in the Ukraine, on June 23, 1905. He received both a bachelor and master of arts degree at the University of Chicago and also studied art abroad. He held positions as instructor of art at Tuley High School in Chicago and supervisor of art for the Chicago Board of Jewish Education (1949–51). In 1947 Greenburg wrote a textbook, *Making Lino Cuts* and, in 1952, he was coauthor of *Arts and Crafts in the Jewish School.*

One-man exhibitions of Samuel Greenburg's graphics and paintings were held at the Delphic Studios in New York City (1934), the Chicago Women's Aid (1939), the Art Institute of Chicago (1947), and the Creative Gallery (1951). The AIC awarded him a prize in 1942. During the decade of the "America in the War" exhibition, he took part in numerous other group shows in Philadelphia, Chicago, New York, Pittsburgh, and Washington, D.C., at the Library of Congress. His work is in the permanent collection of the Museum of Modern Art in Tel Aviv, Israel.

Sources

Who's Who in American Art: 1940–47, 1953.

William Gropper

(1897–1977)

Lithograph: *Liberated Village*

William Gropper was born December 3, 1897, on the Lower East Side of New York, the son of poor Jewish immigrants from the Ukraine and Romania. Working odd jobs by day, he attended art school at night in his teenage years. From 1912 to 1915, he took classes with George Bellows and Robert Henri at the Ferrer School. He was dismissed from the National Academy of Design, after only two weeks, when he protested against having to draw from casts. Gropper also studied at the Chase School with Howard Giles and, from 1915 to 1918, at the New York School of Fine and Applied Arts.

From 1917 to 1919, William Gropper worked as staff artist for the *New York Tribune*. He left this job after being radicalized, as the result of an assignment to cover a Justice Department raid on the anarchist International Workers of the World, to whose ideas he realized he was sympathetic. After a short stint as seaman and construction foreman in Cuba (1922), he returned to New York and became a free-lance magazine illustrator and cartoonist for such publications as *New Masses,* the *Liberator, Vogue,* the *New Yorker,* and H. L. Mencken's *Smart Set.* He won the Collier prize for illustration in 1918 and became the staff cartoonist for the Yiddish Communist daily paper *Freiheit,* in 1924. Later, he drew also for the *Sunday Daily Worker* and was appointed to the editorial board of *New Masses.* Some of Gropper's best work was done for these periodicals, which were dedicated to the social problems of the working classes.

Although he was never a member of the Communist party, William Gropper was chosen as a delegate to the Tenth Anniversary of the October Revolution in Russia in 1927, along with Theodore Dreiser and Sinclair Lewis. While there, he drew for Russian periodicals, and he published a book of drawings of the USSR upon his return to the States in 1929. The following year, he went back to Russia as a delegate to the Kharkov Conference. These experiences were to contribute, much later, to his being blacklisted by the McCarthy Committee (1953). In retaliation, he created one of his most famous series of prints, his *Caprichos,* inspired by Goya.

In the 1930s, Gropper painted murals for the Schenley Corporation,

the Hotel Taft, the Department of the Interior Building in Washington, D.C., and post offices in Michigan and Long Island. He began a series of one-man shows at the A.C.A. Gallery. His savage caricature of Hirohito pulling the Nobel Peace Prize in a rickshaw, published in *Vanity Fair,* had international political repercussions, involving the U.S. State Department. In 1937, Gropper's one-man show at A.C.A. was dedicated to the defenders of democracy in Spain, and a Guggenheim Fellowship that year led to a series of prints on the problems of the Dust Bowl. His 1940 one-man show at A.C.A. celebrated the twentieth anniversary of his resignation from the *New York Tribune* and the beginning of his social awareness.

During World War II, William Gropper painted war bond posters for the Abbott Laboratories. *Vogue* magazine assigned him to do a series of caricatures of the Supreme Court in the style of Daumier. Gropper won a first prize in the Artists for Victory exhibition at the Metropolitan Museum of Art in December 1942, and he served on the jury of the "America in the War" exhibition, as well as showing a print of a village in Eastern Europe being liberated by the combined forces of the United Nations. In 1945, he served as fourth vice-president of Artists for Victory.

A pamphlet, entitled "Lidice," that Gropper prepared in 1942 for the Office of War Information was rejected because of its extremely graphic portrayal of Nazi atrocities. (It was eventually published in South America.) After being assigned to North Africa as an artist-correspondent, Gropper was refused permission to go by the War Department. After the war, in 1948, he traveled to Europe to see the remains of the Warsaw Ghetto firsthand and began his *Lest We Forget* series in memory of what happened there.

In the 1950s and 1960s, despite his blacklisted status, William Gropper continued to exhibit in the United States, primarily at A.C.A. Gallery in New York, and abroad (in London, Mexico City, Rome, and Israel). A Ford Foundation grant in 1967 led to his first color prints, made at the Tamarind Institute Workshop in California. In 1968, 1971–72, and 1976, he was given three retrospectives: one at the University of Miami, Florida, one organized by A.C.A. (which traveled to Ohio,

Texas, and upstate New York), and one at the Maryland Institute of Art in Baltimore. The American Academy and Institute of Arts and Letters gave Gropper a memorial show in 1978.

William Gropper wrote and illustrated a number of books, including *Alay Oop* (1930), *American Folklore* (1951), *The Little Tailor* (1954), and *The Shtetl* (1970). His work may be seen in numerous public collections. A partial list includes the Art Institute of Chicago, the Biro-Bidjan Museum, the Hirshhorn Museum and Sculpture Garden, the Kharkov Museum (USSR), the National Gallery of Prague, and the Tel Aviv Museum.

Sources

Shipley, Joseph T. "'Knowing a Man through His Face': The Art of William Gropper." *Guardian,* November 1924, 11–15.

Brace, Ernest. "William Gropper." *Magazine of Art* 30 (August 1937): 467–71.

Salpeter, Harry. "William Gropper, Proletarian." *Esquire,* September 1937.

William Gropper: Etchings. New York: Associated American Artists, 1965.

William Gropper Retrospective. Essay by August L. Freundlich. Coral Gables, Florida: Joe and Emily Lowe Art Gallery, University of Miami, 1968.

Gahn, J. Anthony. "William Gropper—A Radical Cartoonist." *New York Historical Society Quarterly* (April 1970).

William Gropper: Fifty Years of Drawing, 1921–1971. Text by Louis Lozowick. New York: A.C.A. Gallery, 1971.

William Gropper. Essay by Wahneta T. Robinson. Long Beach, California: Long Beach Museum of Art, 1972.

William Gropper: Works on Paper 1914–1974. Baltimore, Md: Decker Gallery of the Maryland Institute College of Art, 1976.

"William Gropper, Artist, 79, Dies; Well-known Left-wing Cartoonist." *New York Times,* January 8, 1977.

Jolan Gross-Bettelheim
(b. 1900)
Lithograph: *Home Front*

Jolan Gross-Bettelheim was born in Nitra, Czechoslovakia, on January 27, 1900. She studied at the Royal Hungarian Academy of Fine Arts, the State Academy of Fine Arts in Berlin, in Vienna, at the Grande Chaumière in Paris, and at the Cleveland School of Art. The artists Orlik and Hofer were important to her education. Gross-Bettelheim came to the United States in 1925, moving to New York City in 1938. At the time of the "America in the War" exhibition, she resided in Jackson Heights, Long Island, an address which remained constant through the early 1960s.

Jolan Gross-Bettelheim worked as an artist in various media, primarily concentrating her attention on lithography, drypoint, and pastels. Her only solo showing, in 1945 at the Durand-Ruel Gallery in New York, comprised works in pastels. Throughout the 1930s, she exhibited regularly in group shows at the Art Institute of Chicago and the Pennsylvania Academy of the Fine Arts. In January 1939 her work was included in the W.P.A. Fine Arts Project show "Prints for the People," and she was included in a process portfolio compiled by Kalman Kubinyi, print supervisor for the Ohio W.P.A. Project. In the 1940s her work was included in various group exhibitions all over the United States.

Gross-Bettelheim's work is in many permanent collections including, most notably, the Cleveland Museum of Art, the Seattle Art Museum, the Munson-Williams-Proctor Institute, and the Museum of Western Art in Moscow, USSR.

Sources

"Pastels by Gross-Bettelheim." *Pictures on Exhibit* 7 (October 1945): 24, 33.

Reese, Albert M. *American Prize Prints of the Twentieth Century.* New York: American Artists Group, 1949 (pp. 71, 242).

Who's Who in American Art: 1940–47, 1953, 1959, 1962

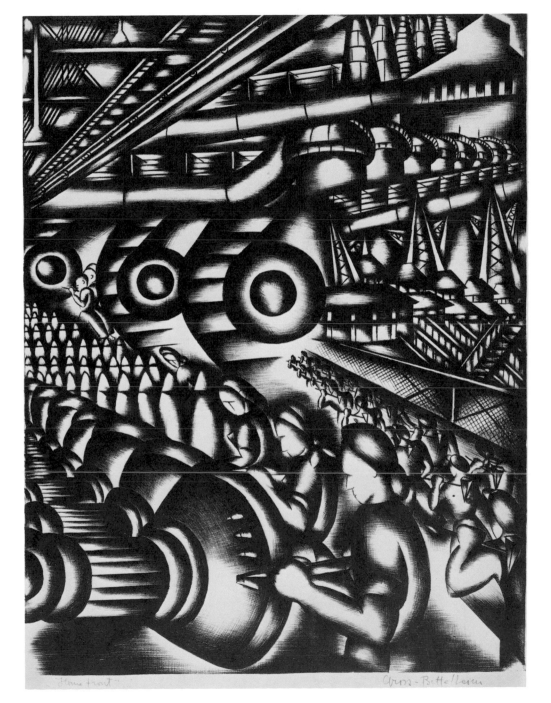

Fig. 13
Home Front

Jolan Gross-Bettelheim, b. 1900

Lithograph, not dated
(40.4 x 30.3 cm)
Signed in pencil

XX B550 B3
Fine Prints Collection
Prints and Photographs Division
Library of Congress

43

Robert Gwathmey

(b. 1903)

Color silkscreen: *Rural Home Front*

Robert Gwathmey was born in Richmond, Virginia, on January 24, 1903. His childhood in the South provided much of the material for his art, which has always exhibited a close identification with white share-croppers and blacks in rural areas and social awareness of the conditions of their lives. Gwathmey studied at the North Carolina State College of Agriculture and Engineering (1924–25), the Maryland Institute in Baltimore (1925–26), and the Pennsylvania Academy of the Fine Arts (1926–30). Teachers who influenced his work include George Harding, Daniel Garber, and Franklin Watkins.

During the 1930s, Gwathmey taught at Beaver College, in Jenkintown, Pennsylvania, several days a week, spending the rest of his time in New York City, where he was an active member of the Artists Union, serving for a time as its vice-president. From 1938 to 1942, he taught at Carnegie Tech in Pittsburgh, and, from 1942 to 1968, he was on the faculty of the Cooper Union in New York City.

In 1939, Robert Gwathmey was a winner in the U.S. government's "48 States Mural Competition," which resulted in his decorating the U.S. post office in Eutaw, Alabama. In 1940, he took the prize in *PM* magazine's "Artist as Reporter" competition and that same year was chosen the winner of the fourth contest sponsored by the American Artists Congress for a first New York show. This took place in 1941 at the A.C.A. Gallery. Two subsequent solos by Gwathmey were held there, in 1946 and 1949.

Robert Gwathmey took part in numerous war-related art activities in the early 1940s. He was one of the signers of a call to American artists and writers to convene in defense of culture against Fascism. He exhibited in the A.C.A. Gallery's "Artists in the War" group show. And he served as recording secretary of Artists for Victory in 1944. Gwathmey exhibited in Artists for Victory's British–American Goodwill Exhibition, as well as in "America in the War." His multicolor silkscreen, *Rural Home Front,* a composite design showing the efforts of rural Americans

with respect to war activities, was awarded first place in the latter's serigraphy division. In 1946, Gwathmey was chosen to receive the second prize in the Pepsi-Cola Annual and also received a prestigious grant from the American Academy of Arts and Letters.

Throughout the 1950s and through the 1970s, Robert Gwathmey continued to win prizes in group exhibitions and to show his work in a series of one-man exhibitions, primarily at the Terry Dintenfass Gallery in New York City. A visiting professorship at Boston University in 1968 led to a complete retrospective there the following year. One of his most recent solo showings, organized by St. Mary's College of Maryland in 1976, was partially funded by the American Revolution Bicentennial Commission. Examples of Gwathmey's work may be seen in many museums all over the United States.

Sources

Robert Gwathmey. Essay by Paul Robeson. New York: A.C.A. Gallery, January 21–February 9, 1946.

Reese, Albert M. *American Prize Prints of the 20th Century.* New York: American Artists Group, 1949 (pp. 73, 242).

Colt, Thomas C. "Robert Gwathmey." *Richmond, Virginia, Museum of Fine Arts Virginia Artists Series,* no. 28, n.d.

Robert Gwathmey. New York: American Contemporary Arts Heritage Gallery, September 30–October 19, 1957.

Robert Gwathmey. Essay by Jonathan Ingersoll. St. Mary's City, Maryland: St. Mary's College of Maryland and New York; Terry Dintenfass Inc., 1976.

Who's Who in American Art: 1940–80.

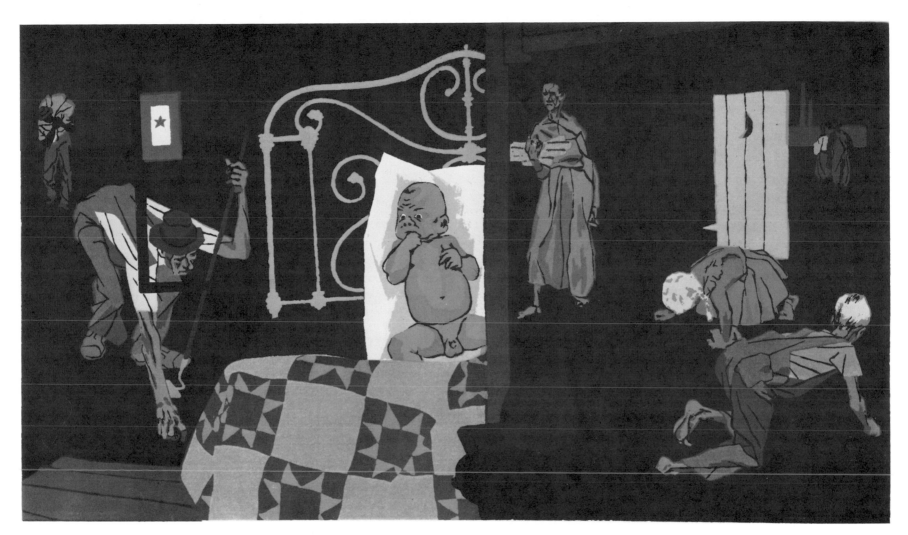

Fig. 14
Rural Home Front

Robert Gwathmey, b. 1903

Color silkscreen, not dated
(25.9 x 46.3 cm)
Signed in ink

"I've simply taken various rural images and combined them in a composite picture, showing the total effort of farm people, including the children. I've used ten flat colors and have been particularly aware of the two-dimensional space." (Robert Gwathmey to Albert M. Reese, August 30, 1947)

Joseph Haber
(b. ca. 1902)
Wood engraving: *Choose*

Joseph Haber was born in the Cleveland, Ohio, area about 1902. When seven months old, he was stricken with infantile paralysis, which left him crippled for life. He attended East Tech in Cleveland (because it had an elevator), the Cleveland School of Art, and the John Huntington Polytechnic Institute.

In 1929, at age twenty-seven, Haber executed the Higbee Department Store special Christmas windows. Despite his physical handicaps, he was a very socially and politically active artist in the 1940s. Around this time he served as executive secretary of the Artists Union in Cleveland, a CIO affiliate whose aim was to promote art for the masses and make the artist a leader in progressive social thought.

Joseph Haber worked on the W.P.A. in Cleveland, and the *Cleveland Press,* in 1940, dubbed him the Ohio W.P.A. Art Project's "New Ideas Man," as a result of his development of a method of making decorative relief panels out of plastic. He made two such panels to represent the joint development of mind and body in education for the Bratenahl School's combined gymnasium and auditorium. He also executed a plastic plaque with power tools for the 1939–40 New York World's Fair. A writer for the *Cleveland Press* noted, in 1940, that Haber's physical handicaps, far from hindering him, had resulted in a sharpening of his artistic sense.

Sources

"'Promise Me No Sympathy' Says Crippled Artist." *Cleveland Plain Dealer,* November 14, 1929.

"Clevelander Creates Mural Art with Plastics." *Cleveland Press,* April 13, 1940.

"C.I.O. Artists Work to Take Art to Masses. Joe Haber's an Inspiration to Small, New Group of Craftsmen." *Cleveland Press,* September 20, 1941.

Edward Hagedorn
(b. 1902)
Drypoint: *Life Boats*

Edward Hagedorn was born in San Francisco, California, in 1902. A self-taught artist, he worked in oils, watercolors, lithography, and block-printing. Beginning in 1937, he specialized primarily in etching, and in 1952 he published a limited edition portfolio of ten nudes for the San Francisco-based Peregrine Press. In the late 1930s, Hagedorn worked on the W.P.A. in California.

Hagedorn participated in many group exhibitions throughout his career, including shows sponsored by the Library of Congress, the Art Institute of Chicago, the Society of American Etchers, the San Francisco Museum of Art, and the Philadelphia Art Alliance. He won several prizes in the early 1940s, including the Artist Fund prize at the Graphic Annual of the San Francisco Art Association in 1941. He won an honorable mention at the Fifteenth Annual Exhibition of American Etchings at the Philadelphia Print Club in 1942 for a naval war subject.

Sources

"Sinking of the Rawalpindi Awarded Artist Fund Prize at Graphic Annual." *San Francisco Art Association Bulletin* 7 (February 1941): 43.

Charles Edward Heaney

(b. 1897)

Soft ground and aquatint: *Mark of the Enemy*

Charles Edward Heaney was born on August 22, 1897, in Oconto Falls, Wisconsin. In 1913 he moved to Portland, Oregon. In 1917 he apprenticed himself to a jewelry engraver, learning a trade at which he continued to work part-time until his retirement in 1962. He also enrolled in 1917 at the Portland Museum Art School and the University of Oregon Extension Division to study, in his spare time, drawing and design. He chiefly worked under Harry Wentz, dean of the Museum Art School. Another strong influence was the painter C. S. Price.

In 1922 Heaney began an approximately twenty-year period during which his chief interest was printmaking. He studied etching with William Givler, 1937–41, and specialized in aquatint from 1941 to 1946. About 1932–40, Heaney worked on federal government art projects in Oregon as a painter and art instructor. During this period, he made annual sketching and painting expeditions to the fossil beds and badlands of the John Day Country in eastern Oregon and Nevada. In 1942, he began to create his "fossil pictures," with heavily textured and sculptured surfaces simulating the cracked, scraped, and crackled appearance of rocks which have undergone natural processes of aging.

Most of Heaney's paintings are done in a realist style, similar to the Regionalist painting of Thomas Hart Benton, Grant Wood, and John Steuart Curry as well as that of his mentor C. S. Price. Heaney has participated in a large number of group shows since the 1930s, winning many awards. He has also had numerous one-man exhibitions of both his paintings and his prints, in places ranging from Seattle to Scranton, Pennsylvania, Utica, New York, and his native Portland. The Portland Art Museum gave him a complete retrospective in 1952. Heaney was one of a few Oregon artists chosen for "Art of the Pacific Northwest," a special regional invitational exhibition, organized by the Smithsonian Institution in 1974. His work figures in the permanent collections of most of the prominent Northwest museums.

Sources

Charles Heaney, Portland Painter and Printer: A Retrospective Exhibition. Essays by Priscilla Colt and William H. Givler. Portland, Oregon: Portland Art Museum, 1952.

"Biographical Notes. Charles Heaney." Salem, Oregon: Bush Barn Gallery, April 1967.

Who's Who in American Art: 1937.

Helen West Heller

(1885–1955)

Woodcut: *Magnesium Bomb*

Helen West Heller was born of pioneer stock on a farm in Rushville, Illinois, in Spoon River Country, in 1885. She began to paint and carve in wood as a very young child. As a teenager, she did hand illumination on vellum, as well as hand bookbinding. After briefly studying art in New York, she returned to Illinois and worked on a farm with her husband. After his death, she did factory work and sold in a dry goods store by day, painting by night. Heller made her first wood-block in 1923, never having had any lessons in this technique.

By the mid-1920s, Helen West Heller established herself as an artist in Chicago. In 1930 a writer for the *Chicago Daily News* called her "the woman who had to paint." She had a series of solo exhibitions in that city in the late 1920s and published a book of her own poetry, in which she herself cut the text by the intaglio method and cut each separate illustration on a different wood-block. This volume, *Migratory Urge,* exhibited her typical decorative, semiabstract, and highly patternized style. The poems had first been published in the *Chicago Evening Post* under the Japanese pseudonym "Tarika."

In 1932, Helen West Heller left Chicago for New York, according to the papers, "to seek a wider public." She worked on the Public Works of Art Project and the Fine Arts Project of the W.P.A., designing murals and mosaics. In 1933, she exhibited at the Roosevelt Hotel with an avant-garde group of thirty-five artists who called themselves the "Independent Independents," and she also had a solo showing at Philosophy Hall, on the campus of Columbia University.

In the February 1937 issue of *Art Front,* an organ of the radical Artists Union, Heller was featured in an article reprinting her answers to a questionnaire sent out to artists in the Mural Division of the New York W.P.A. concerning their theory, philosophy of art education, and techniques. She painted murals for the Neponsit Hospital in Brooklyn and spoke on mural painting at a symposium held in conjunction with the A.C.A. Gallery's 1942 exhibition "Artists in the War." She was also one of the signers of a call to artists and writers to convene in defense of culture against Fascism.

In the 1940s, Heller had several solo exhibitions in New York, including one sponsored by the Artists League of America in 1948. The following year, the Division of Graphic Arts of the Smithsonian Institution presented thirty-two of her wood-engravings. In 1947, she published the book *Woodcuts, U.S.A.,* with an introduction by John Taylor Arms.

Heller also exhibited in a number of group shows throughout her career, including several in Europe: at the Hagenbund in Vienna, the Salon d'Automne in Paris, and The Meatyards in London. Her work may now be seen in numerous public collections at such institutions as Bryn Mawr College, the Brooklyn Museum, the New York Public Library, and the Smithsonian Institution. An artist who generated much excitement and publicity in her day, Helen West Heller was receiving assistance from the New York Department of Welfare when she died in 1955.

Sources

"Exhibition in New York." *Revue du vrai et du beau* 4 (March 1925): 20–21.

"The Woman Who Had to Paint." *Chicago Daily News,* August 13, 1930.

"Helen Heller Leaves to Seek Wider Public." *Chicago Daily News,* February 25, 1932.

"Modernist at 60." *New York Evening Post,* April 1933.

"Question and Answer: Helen West Heller." *Art Front,* February 1937, pp. 12–13.

Harms, Dr. Ernest. "Helen West Heller: The Woodcutter." *Print Collectors Quarterly* 29 (1942): 250–71.

Reese, Albert M. *American Prize Prints of the 20th Century.* New York: American Artists Group, 1949 (pp. 81, 243).

Obituary. *New York Herald Tribune,* November 30, 1955.

Obituary. *New York Times,* November 30, 1955.

Who's Who in American Art: 1940–47, 1953.

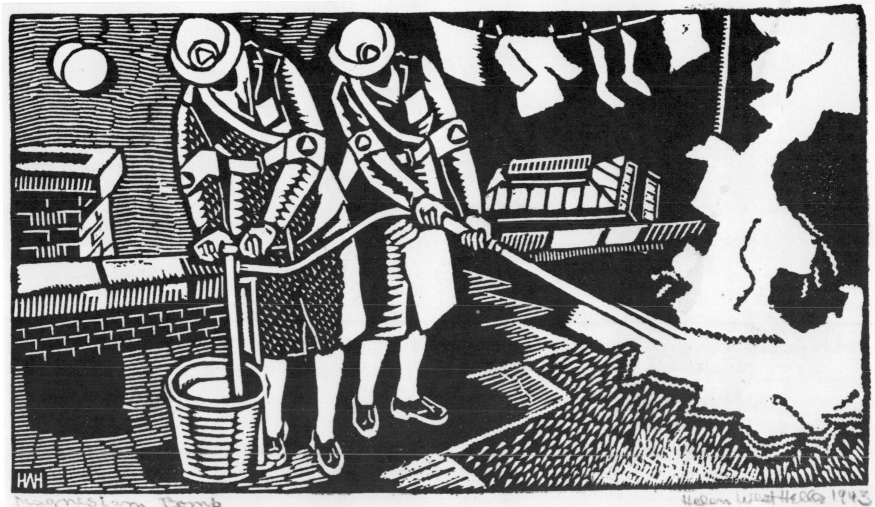

Fig. 15
Magnesium Bomb

Helen West Heller (1885–1955)

Woodcut, 1943 (11.7 x 21.2 cm)
*Signed on block with initials, signed
and dated in pencil*

*"I determine the composition and on
this place the large forms, then, on the
block, draw such detail as I can pre-
conceive. Then, between the tool and
the material, I begin thinking in the
wood." The artist goes on to explain
that she was particularly interested in
"conveying emotions through abstrac-
tions." (Helen West Heller to Reming-
ton Kellogg, April 9, 1949, Archives of
American Art)*

XX H477 A26
Fine Prints Collection
Prints and Photographs Division
Library of Congress

August Henkel
(1880–1961?)
Color silkscreen: *Victory Garden*

August Henkel was born in Philadelphia, Pennsylvania, on July 31, 1880. He studied at the Pennsylvania Academy of the Fine Arts with William Merritt Chase and Thomas Anshutz. Henkel, a painter and cartoonist, had moved to Queens Village, New York, by the early 1940s. He was one of the signers of a call for a congress of American artists in defense of culture in June 1941, jointly sponsored by writers and artists passionately opposed to Fascism. He was a member of the Artists League of America and the National Serigraph Society. His work is in the permanent collection of the Metropolitan Museum of Art, as well as the Library of Congress.

Sources

Who's Who in American Art: 1940–47, 1953, 1962.

Hoyt Howard
(dates unknown)
Silkscreen: *Johnny Rivers at Guadalcanal*

Hoyt Howard was active as a printmaker in Bethlehem, Pennsylvania, at the time of his submission to the "America in the War" exhibition.

Robert Jackson
(dates unknown)
Lithograph: *The Camoufleurs*

Robert Jackson was active in the Los Angeles, California, area at the time of the "America in the War" exhibition in 1943. He studied at the Chouinard Art Institute with Phil Paradise for a short while.

Hans Jelinek
(b. 1910)
Wood engraving: *The Last Walk*

Hans Jelinek was born in Vienna, Austria, on August 21, 1910. He studied at the Wiener Künstgewerbeschüle and the University of Vienna. In Europe he taught art and descriptive geometry, illustrated scientific books, and did research in the psychology of art before coming to the United States in 1938, when Austria was invaded by Hitler.

At first, Jelinek settled in Virginia, where he worked as a medical illustrator. At the time of the "America in the War" exhibition, he was living in Richmond. The work he submitted, *The Last Walk,* was the seventh print in a series of twelve entitled "The Story of Lidice." Along with *The Village, The Hangman, Assassin, Destiny, The Guards, Occupation, Execution, Departure, The Mother, The Fire,* and *The End, The Last Walk* told the story of a Nazi atrocity. Carlyle Burrows of the *New York Herald Tribune* wrote about these works, "There is no room in this artist for a compassionate narrative of human suffering, but only grim hatred of the brutal menace which devastated the little Czechoslovak village and its inhabitants." Another writer, in Fort Wayne, Indiana, said about *The Last Walk,* which won first prize in the relief category in the "America in the War" competition, "The inhumanity of war is revived in the woodcut winner *The Last Walk* by Hans Jelinek. His interpretation of a burdened weary people at the point of a bayonet is unforgettably significant." Jelinek has been compared with Pieter Breughel in his ability to pinpoint the vanities and cruelties of life which, in this case, he had observed firsthand.

In 1943 the New School for Social Research in New York City had a special exhibition of Jelinek's Lidice series and the following year that same institution showed his illustrations for *Down a Crooked Lane,* by Martha Byrd Porter. Following a 1945 one-man show at the Virginia Museum of Fine Arts in Richmond, Hans Jelinek moved to New York to teach woodcut and wood-engraving at the New School and soon also became an assistant professor at City College of New York. In 1973, he also began teaching at the National Academy School of Fine Arts.

In 1951, the Division of Graphic Arts of the Smithsonian Institution devoted a show to his woodcuts. An exhibitor in many group shows throughout his career in the United States and abroad, Hans Jelinek won awards from the Tiffany Foundation in 1947 and the Library of Congress in 1945. He was given the Paul J. Sachs prize at the fifteenth annual exhibition of Boston Printmakers in 1962.

Jelinek's work may be seen in such collections as that of the Museum of Modern Art, the Victoria and Albert Museum in London, the Philadelphia Museum of Art, the Boston Museum of Fine Arts, the Virginia Museum of Fine Arts, the Munson-Williams-Proctor Institute, and the Alabama Institute of Technology.

Sources

Freeman, Lorraine. [Review]. Ft. Wayne, Indiana, *News Sentinel,* October 2, 1943.

[Review]. *The Journal Gazette,* Ft. Wayne, Indiana, October 3, 1943.

Burrows, Carlyle. [Review]. *New York Herald Tribune,* December 5, 1943.

Ten Years of Drawings and Prints, 1940–1950, by Hans Jelinek. New York: New School for Social Research, January 4–25, 1951.

Ward, Lynd. *Hans Jelinek.* Society of American Graphic Artists, 1956.

Who's Who in American Art: 1940–80.

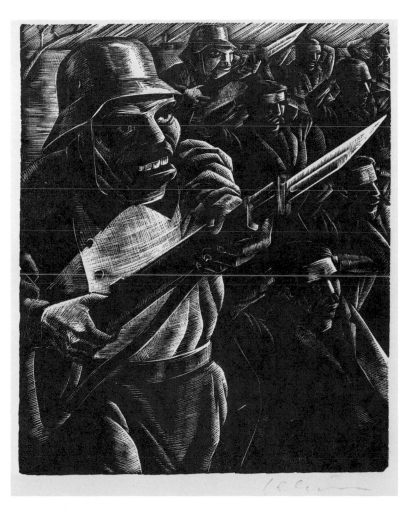

Fig. 16
The Last Walk

Hans Jelinek, b. 1910

Wood engraving, not dated
(12.6 x 10.2 cm)
Signed in pencil

"When in the beginning of the war the Czech village Lidice was brutally annihilated by the Nazis, I was horrified as well as desperate, feeling my own inability to do something about it. Then one night it came to me that an artist could also contribute to the bitter fight if only with a piece of wood and a graver. The same night I made all the sketches for a series of engravings illustrating the sad story of Lidice. It took many evenings and nights to finish the work. Nevertheless I couldn't stop working until I was through. Then I felt a little better.

"I have shown these prints in several exhibitions and I hope to publish them someday to make them fulfill their task to remind people that the unbelievable sufferings of so many people should not have been in vain, and also should not be forgotten. . . . I believe that a work of art can still be art and also carry a message to the people." (Hans Jelinek to Karl Kup, ca. 1944, New York Public Library)

XX J48 A3
Fine Prints Collection
Prints and Photographs Division
Library of Congress

Helen L. Johann

(b. 1901)

Linoleum cut: *Next of Kin*

Helen L. Johann was born in West Depere, Wisconsin, on May 30, 1901. She studied at Milwaukee State Teacher's College and received a bachelor of science degree from Columbia University. A teacher as well as a printmaker, Johann has been awarded six prizes from the Milwaukee Art Institute and a prize for her art at the Wisconsin State Fair (in 1957).

Johann has exhibited also at the Pennsylvania Academy of the Fine Arts, at the Oakland Art Gallery, with the Philadelphia and Buffalo Print Clubs, at the National Academy of Design, and in several Library of Congress group shows. She also showed at the large Artists for Victory-sponsored exhibition at the Metropolitan Museum of Art in 1942. The *New York Herald Tribune* (October 10, 1943) commented that *Next of Kin,* her submission to "America in the War," "reflects a cynical phase of the Detroit riots" of the war era.

Sources

Collins, J. L. *Women Artists in America, 18th Century to the Present.* Chattanooga: University of Tennessee, 1973.

Who's Who in American Art: 1940–47, 1953, 1959, 1962.

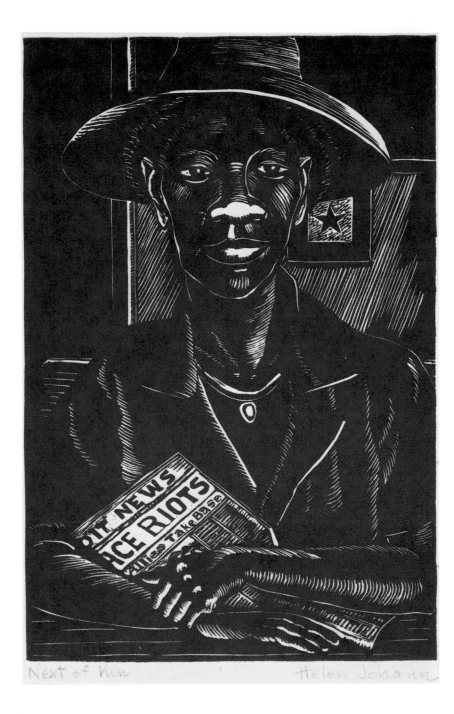

Fig. 17
Next of Kin

Helen L. Johann, b. 1901

*Linoleum cut, not dated
(21.7 x 14.1 cm)
Signed in pencil*

*XX J65 A1
Fine Prints Collection
Prints and Photographs Division
Library of Congress*

Mervin Jules

(b. 1912)

Color silkscreen: *Hostages*

Mervin Jules was born March 21, 1912, in Baltimore, Maryland. He studied at Baltimore City College and the Maryland Institute in his hometown, as well as for two years in New York at the New School and the Art Students League (with Thomas Hart Benton). Before moving back to New York at age twenty-five, he taught at the Baltimore Educational Alliance and had a work purchased by Duncan Phillips for the Phillips Collection in Washington, D.C.

After only a few months in New York, Jules was given his first one-man exhibition at the Hudson Walker Gallery. Critics noted the irony and disillusionment so evident in the socially conscious works in this show and pointed out how unusual they were for one so young. A champion of the oppressed against inhumanity and injustice, Jules exhibited a highly satirical painting, *Tomorrow Will Be Beautiful,* at the New York World's Fair in 1939–40. He was one of the signers of the call to a congress in defense of culture against Fascism in 1941 and a contributor to *Winter Soldiers,* a book issued in conjunction with that conference.

In the late 1930s and early 1940s, Mervin Jules worked on the Fine Arts Project of the W.P.A. in New York. He was one of the members of the innovative Silkscreen Group that founded the Workshop School on East Tenth Street in 1940. During World War II, he made posters encouraging Americans to buy war bonds and exhibited in the Artists for Victory British–American Goodwill Exhibition, as well as "America in the War."

Mervin Jules had a one-man show at the Weyhe Gallery in New York in 1941 and, that same year, had the first of a long series of solo shows at the A.C.A. Gallery. In 1942, he exhibited in the A.C.A.'s "Artists in the War" show, and his 1945 one-man show in Washington, D.C., at the Whyte Gallery, included many biting commentaries related to the war, such as *Hostages,* which was Jules's entry to "America in the War." In 1942 and 1945 he had two solo exhibits in Hollywood at the ACG Gallery.

Mervin Jules, in addition to being a painter and printmaker, has also been an art educator. Following his early teaching experience in Baltimore, he taught in New York at the Fieldston School, the Museum of Modern Art, the War Veteran's Art Center, and the People's Art Center. In 1946 he became associated with Smith College in Northampton, Massachusetts, where he taught until 1969. Since that time, he has been professor of art and chairman of the art department of the City College of New York, and he has spent many summers teaching at various other institutions, including the University of Michigan and the University of Wisconsin.

Mervin Jules has exhibited widely in group shows all over the United States, winning many prizes. Recent one-man shows include those at the Ferdinand Roten Gallery, Baltimore (1965), and galleries in Binghamton, New York (1971), and Florence, Massachusetts (1979). In 1967, Jules was awarded two important grants, the Asian–African Study Program Grant to Japan and the Alfred Vance Churchill Foundation Grant. In 1973 he received the City College Medal.

Jules's work may be seen in such collections as those of the Metropolitan Museum of Art, the Art Institute of Chicago, the Boston Museum of Fine Arts, the Portland Art Museum, Smith College, and the Tel Aviv Museum in Israel.

Sources

"Mervin Jules Showing Geese Paintings at the Hudson D. Walker Galleries." *Pictures on Exhibit* 1 (November 1937): 32.

Mervin Jules: Exhibition of Paintings. Essay by Ruth Green Harris. New York: A.C.A. Gallery, January 12–25, 1941.

Recent Paintings by Mervin Jules. Essay by Hudson D. Walker. New York: A.C.A. Gallery, September 27–October 16, 1943.

Jules. Essay by Victor D'Amico. New York: A.C.A. Gallery, January 22–February 10, 1945.

Riley, Maude. "Mervin Jules Paints with Heart and Mind." *Art Digest* 19 (February 1, 1945): 13.

"Exhibition A.C.A. Gallery." *Pictures on Exhibit* 10 (November 1947): 32–34.

Reese, Albert M. *American Prize Prints of the 20th Century.* New York: American Artists Group, 1949 (pp. 96, 245).

Recent Paintings: Mervin Jules. Essay by Oliver Larkin. New York: A.C.A. Gallery, October 15–November 3, 1951.

Who's Who in American Art: 1940–80.

Max Kahn
(b. 1904)
Color lithograph: *V . . .—Mail*

Max Kahn was born in Russia in 1904 and came to the United States in 1907. He settled in Peoria, Illinois, where he received a bachelor of science degree from Bradley College. Kahn returned to Europe to study art in Paris in 1928–29. There he was a sculpture student at the ateliers of Antoine Bourdelle and Charles Despiau. He also studied drawing with Othon Friesz in Paris and, later, lithography with Frances Chapin at the Art Institute of Chicago. Kahn worked on the W.P.A. FIne Arts Project in the Chicago area in the 1930s.

Max Kahn became a lithography instructor at the Art Institute of Chicago in 1944, where he remained on the faculty until 1959. From 1959 to 1969 he taught at the University of Chicago. He has also been an art instructor at the John Herron Institute, the Escuela Universitaria de Bellas Artes in San Miguel de Allende, Mexico, and the Oxbow Summer School of Painting, Saugatuck, Michigan.

Max Kahn is married to Eleanor Coen, another of the artists in the "America in the War" exhibition, and has had several joint exhibitions with her. He is one of the best-known printmakers from the Chicago area. He has won a large number of awards not only from Midwest institutions but also in exhibitions and competitions all over the United States. A specialist in color lithography, he has had quite a few one-man exhibitions since the 1940s, including shows at the Weyhe Gallery in New York, the Princeton Print Club, the Philadelphia Art Alliance, Pratt Institute, and the Fairweather-Hardin Gallery in Chicago. Kahn, who not only pulls his own prints but also grinds his stones and inks himself, has works in a large number of public and private collections all over this country, in Canada, and in Israel.

Sources

Schniewind, Carl O. *Color Lithos/Max Kahn.* New York: Wehye Gallery, March 6–27, 1946.

Peck, Janet. "Grease, Stone and Ink is Art in Right Hands—South Side Lithographer is Famed for Prints." *Chicago Sunday Tribune.* March 14, 1948, part 3, p. 95.

Reese, Albert M. *American Prize Prints of the 20th Century.* New York: American Artists Group, 1949 (pp. 97, 245).

"Coen and Kahn to Show Color Lithographs." *Philadelphia Art Alliance Bulletin* 30 (October 1951): 9.

"Forty-five works by Max Kahn Show Why He's Popular." *Chicago Daily News,* November 13, 1953.

Haydon, Harold. "Two Chicago Masters in Hometown Limelight." *Showcase, Chicago Sunday Times,* November 22, 1970, p. 14.

Hilda Katz

(b. 1909)

Linoleum cut: *Freedom from Want*

Hilda Katz was born June 2, 1909, in the Bronx in New York City. She studied art at the New School and at the National Academy of Design, which gave her two awards in 1933 and 1935. In 1938 she had the first in a series of over twenty-five solo shows throughout her career at the Morton Gallery in New York. In the 1940s and 1950s, she was an instructor at the Art Students League. In 1940 she exhibited in the U.S. pavilion of the Venice Biennale.

Hilda Katz was an active member of Artists for Victory during the war years. She not only exhibited in "America in the War" but also in the large Artists for Victory-sponsored exhibition at the Metropolitan Museum of Art in December 1942. In December 1944 she represented the Audobon Artists at Artists for Victory meetings.

Katz's contribution to "America in the War," a linoleum cut, *Freedom from Want,* came from her own series depicting the four freedoms outlined by President Roosevelt as a goal in a 1942 speech. It exhibits her typically bold, vigorous pattern quality, with emphasis on the symbolic value of dark tonalities. The entire "Four Freedoms" set is now owned by the Library of Congress, the Jewish Museum, the Brooklyn Museum, the National Museum of American History, and the Colorado Springs Fine Arts Center.

Throughout her career, Hilda Katz has been active in women's art organizations. She exhibited from 1937 to 1952 with the New York Society of Women Artists. Twice, in 1945 and 1947, she was given prizes by the National Association of Women Artists and, in 1946, she exhibited in an International Exposition of Women's Art and Industry, at the International Women's Club in England.

Katz has been included in group exhibitions all over the United States and abroad, garnering many prizes. Solo shows in the 1950s include, among others, exhibitions at the Bowdoin College Art Museum, the California State Library, the University of Maine, the Jewish Museum, and the Albany Institute of History and Art Print Club. The Albany Institute has been the recipient of an archive of Katz's paintings, drawings, prints, and documentary material related to her two careers. (In addition to her career as a painter, Katz, under the name Hulda Weber, has also been acclaimed as an author and poet whose work has been included in many poetry magazines and anthologies, winning many prizes, primarily in the 1960s. She has also written a number of short stories for children.)

In 1966 Hilda Katz was elected to the Executive and Professional Hall of Fame and in 1970 she was made a "Daughter of Mark Twain," in recognition of her outstanding contribution to modern art. In 1974, she was awarded an honorary diploma and the title letters N.D. (Nobel Designate) from the Accademia di Scienze, Letteri, Arti in Milan. She was chosen to submit paintings to the Smithsonian Institution's National Air and Space Museum collection of art inspired by space. Other examples of her work may be found in both private and public collections, including the Franklin Delano Roosevelt Collection, the Fogg Museum at Harvard University, three museums in Israel, and the National Museum of American Art.

Sources

"A Dramatic Talent." *New York Herald Tribune,* December 25, 1938.

Klein, Jerome. [Review]. *New York Post,* December 31, 1938.

Upton, Melville. [Review]. *New York Sun,* December 31, 1938.

J. L., "Hilda Katz: Paintings and Drawings by a Sensitive Observer." *Art News,* December 31, 1938.

Devree, Howard. [Review]. *New York Times,* January 1, 1939.

Etchings, Block Prints and Monotypes by the 3 K's: Marguerite Kumm, Hilda Katz, Gwyneth King. California State Library, May 1953.

"Hilda Katz in Albany." *Arts Digest* 29 (June 1, 1955): 20.

Linocuts by Hilda Katz, Young American Artist. New York: Jewish Museum, September 9–November 1, 1956.

Who's Who in American Art: 1940–80; *Who's Who in America:* 1968–79; *Who's Who in the World:* vols. 2, 3, 4.

Charles Keller

(b. 1914)

Color silkscreen: *Planners for Victory*

Charles Keller, a painter, sculptor, and printmaker, was born in Woodmere, New York, on October 4, 1914. In 1927 he moved to New York City and in 1936 received a bachelor of art degree from Cornell University in Ithaca, New York. From 1938 to 1940 he studied at the Art Students League. Around this time, he became involved with several politically active (and sometimes radical) art organizations such as the Young American Artists Association, sponsored by the American Artists Congress and the United American Artists. This group was, at first, opposed to U.S. involvement in the war. Keller was also part of the Labor Arts Youth Club of the Young Communist League.

Later, Keller was an active member of the Workshop of Graphic Artists which supplied war posters for Civil Defense and trade union purposes. He became director of the Victory Workshop and, in that capacity, was asked to represent Artists for Victory in a scheme to develop an art center in Greenwich Village. In 1942, Keller chaired a session, "Problems of the Young Artist," at the A.C.A. Gallery-sponsored symposium held in conjunction with their "Artists in the War" exhibition.

Charles Keller is an artist who has brought a deep social consciousness to his art throughout his career. During the 1940s, he worked as an assistant to Harry Sternberg on Treasury Department murals in Doylestown, Pennsylvania, and Chicago, Illinois; in the special exhibits department of the Museum of Modern Art; and at the Navy Training Aids Development Center, New York City. He has taught at Vassar College, the Storm King Boys School in Cornwall, New York, and Dutchess Community College in Poughkeepsie and in the extension program of Hofstra University in Hempstead, New Jersey.

In 1961 Charles Keller moved to Italy, where he lived and worked for about ten years, primarily in Rome. While there, he had one-man exhibitions in Rome, Allessandria, Turin, Milan, Sardinia, and Genoa. He has also had a solo show at the Drian Galleries in London in 1971 and four one-man exhibitions in New York City and New York State, one each in Hartford, Connecticut, and Princeton, New Jersey. A complete retrospective of his work was mounted at the Herbert F. Johnson Museum of Art at Cornell University in 1976.

Sources

Usiglio, Renata. *Charles Keller.* Turin, Italy: La Galleria d'Arte Botero, April 2–5, 1966.

Gianotti, Ezio. "La Pittura di Keller." *Diogene,* no. 45 (Milan) (June 1966).

Appel, Benjamin. "Ten Years in Rome." *Charles Keller, Paintings and Drawings.* Princeton, N.J.: Princeton Gallery of Fine Art, April 18–May 6, 1972.

Charles Keller. Paintings—Prints—Drawings—Sculpture. Retrospective Exhibition. Ithaca, New York: Herbert F. Johnson Museum of Art, Cornell University, May 26–June 27, 1976.

Mackin, Jeanne. "Art Meets Social Awareness." *Ithaca Journal,* June 5, 1976, section 3.

Dorothy Rutka Kennon

(b. 1907)

Aquatint and soft-ground etching: *Conchies*

Dorothy Rutka was born August 26, 1907, in Grand Rapids, Michigan. After attending the Grand Rapids public schools, she moved to Cleveland, Ohio, where she studied at the John Huntington Polytechnic Institute and graduated from the Cleveland Institute of Art in 1929. She traveled in Europe for seven months in 1931, after working for a short time as an illustrator and writer for the *Bystander Magazine*. She married Jack Kennon, political editor of the *Cleveland News*.

A member of the Cleveland Artists Union, Dorothy Rutka Kennon had her first solo exhibition at the Cleveland Print Market in 1939. Although gaining a reputation around this time as a fine portraitist, she also began to draw local attention in the late 1930s because of her socially conscious subject matter, concentrated on themes related to the condition of the poor during the depression. A writer for the *Cleveland News* commented, in 1938, that many people objected that Kennon's work was "not very pretty," and even termed it "propaganda," to which Kennon replied that her goal was "to show people as they are." At the time Kennon was working on the W.P.A. Fine Arts Project. The print she submitted to "America in the War" depicts conscientious objectors.

Kennon exhibited actively from 1929 through the mid-1960s in the annual area May shows held at the Cleveland Museum of Art, where she won many prizes. She has also been included in a number of Library of Congress group shows and large exhibitions in Philadelphia, Dayton, and Brooklyn. In 1946, a Kennon aquatint was selected as one of the one hundred best prints of the year by the Society of American Etchers in New York. In 1950, she was commissioned to paint a six-part mural depicting the life of St. James for the St. James Episcopal Church in her hometown. Additional solo shows of her work have been held at the Gallery 1030 and Ross Widen Gallery in Cleveland. Her work is owned by the Cleveland Museum of Art and the Cleveland Bar Association, among others. In 1965 Dorothy Kennon became Mrs. Philip Porter.

Sources

Bruner, Ray. "Art." *Cleveland News,* July 31, 1938.

"Cleveland Artist—No. 48: Dorothy Rutka Kennon." *Cleveland Press,* October 11, 1947.

Bruner, Louise. "Artists." *Cleveland News,* May 27, 1950.

Kirkwood, Marie. "Color in Motion Gives Life to Dorothy Kennon Exhibition." *Cleveland News,* March 15, 1958, p. 5.

Who's Who in American Art: 1940–41.

Hans Kleiber

(1887–1967)

Etching and drypoint: *In the South Pacific*

An Austrian by nationality, Hans Kleiber was born in Cologne, Germany, on August 24, 1887. He came to the United States in 1900 and moved from the mill towns of Massachusetts to Wyoming around 1906–7 in order to try to get into the U.S. Forestry Service. Largely a self-taught artist, Kleiber did study drawing and painting in New Jersey for a very short time before moving West.

Hans Kleiber began to draw and paint the nature subjects in which he became a specialist in 1923 while working as a timber cruiser, Forest Service ranger, and hunting and fishing guide in the Bighorn Mountain region. He constructed a makeshift printing press, read books on etching, and ordered supplies by mail in order to make his first prints.

Kleiber established a studio at Dayton, Wyoming, close to the outdoors and to the wildlife subjects that interested him most. He had his first one-man exhibition in the Print Gallery at Goodspeed's Book Shop in Boston in 1928 and his second—in what was to become a series of shows at that location—in 1930. A member of the California Printmakers, he won their Silver Medal in 1931.

A painter also, Hans Kleiber had a one-man exhibition of watercolors in 1951 at the Grand Central Galleries in New York. In that decade, he began to hand-tint some of his etchings with watercolor. He also painted in oils late in his career, in a somewhat Impressionistic style.

Sources

"Forester and Artist." *Boston Transcript* article reproduced in a Goodspeed's brochure, February/March 1928.

Jacques, Bertha E. *Hans Kleiber: Catalog* (1937).

Kettell, Russell Hawkes. "Hans Kleiber." *Hans Kleiber, Eight New Etchings.* Boston: Goodspeed's Book Shop, January 3–14, n.d.

Who's Who in American Art: 1936–37.

Fig. 18
In the South Pacific

Hans Kleiber (1887–1967)

Etching and drypoint, not dated
(17.4 x 30.5 cm)
Signed in pencil

XX K64 A2
Fine Prints Collection
Prints and Photographs Division
Library of Congress

Misch Harris Kohn

(b. 1916)

Color lithograph: *Survivors*

Misch Harris Kohn was born on March 26, 1916, in Kokomo, Indiana. He attended the John Herron Art Institute in Indiana from 1934 to 1939, earning a bachelor of fine arts degree and, inspired by the work of Kaethe Kollwitz, deciding to specialize in printmaking. In 1939 he studied color lithography in Chicago with Francis Chapin and Max Kahn. After a short stint in New York City, he returned to Chicago and became a part of the W.P.A. Fine Arts Project there. While on the W.P.A. for a year and a half, he produced paintings, wood-engravings, and color lithographs. He was one of the first in Chicago to do creative work in silkscreen, and he shared a studio for a time with Max Kahn and Eleanor Coen, whose prints are also included in "America in the War." Kohn's W.P.A. work, which primarily dealt with subject matter of social commentary, also included the illustration of a book, *Pursuit of Freedom.*

In 1942, Misch Kohn taught briefly at the University of Indiana and did defense work in a war plant in Chicago. In 1943, he traveled to Mexico to work at the Taller de Grafica Popular, where he came into contact with Alfredo Zalce, Pablo O'Higgins, Diego Rivera, Leopoldo Mendez, and Jose Clemente Orozco. Orozco, in particular, had a great deal of influence on his work. Kohn taught wood-engraving at the Taller before returning to Chicago in 1945, where he worked as an illustrator for *Fortune* and several book publishers.

The print expert Carl Zigrosser dates the emergence of Misch Kohn's mature style to the large wood-engravings he began to do in 1949, in the belief that wood-engraving could be approached as a highly creative, not just a reproductive, medium. At that time, Kohn was teaching at the Institute of Design in Chicago, the school founded by Laszlo Moholy-Nagy according to Bauhaus principles. Kohn organized the Graphics Workshop there and became head of the Visual Design Department in 1950, after the school affiliated with the Illinois Institute of Technology. Kohn remained there until 1972, when he became professor of art at the California State University of Hayward.

Misch Kohn took a year off from teaching in 1952–53 to live and work in Paris on a John Simon Guggenheim Memorial Foundation Fellowship. While there, he exhibited at the Salon du mai and with the Jeune Gravure printmakers. He was awarded a second Guggenheim in 1955 and a Ford Foundation grant for a retrospective in 1960. This exhibition, organized by Associated American Artists, traveled all over the United States. In 1961, he received another Ford Foundation stipend to work at the Tamarind Lithography Workshop.

Kohn has exhibited in numerous group shows throughout his career, winning many other important prizes. He has had a large number of shows devoted solely to his own art. A partial list would include the Art Institute of Chicago, the Taller de Grafica Popular, Indiana University at Bloomington, and the Philadelphia Art Alliance. His work is in collections at the Akron Art Institute, the Free Library of Philadelphia, the Bibliothèque nationale in Paris, the Museo de Arte Moderna in Rio de Janeiro, and the National Museum in Stockholm.

Sources

"Chicago Art Institute Exhibition of Prints and Drawings." *Pictures on Exhibit* 14 (November 1951): 58–59.

Selz, Peter. "Three-dimensional Wood Engravings: The Work of Misch Kohn." *Print* 7 (November 1952): 37–44.

"Misch Kohn to Show Wood Engraving." *Philadelphia Art Alliance Bulletin* 32 (March 1954): 5.

Prints: Misch Kohn 1949–1959. New York: Weyhe Gallery, October 6–November 4, 1959.

Peterdi, Gabor. *Printmaking: Methods Old and New.* New York: MacMillan & Co., 1959 (pp. 267, 270).

Zigrosser, Carl. *Misch Kohn* (New York: American Federation of Arts, 1961).

Spence, James Robert. "Misch Kohn: A Critical Study of His Printmaking." Ph.D. diss., University of Wisconsin, 1965.

Misch Kohn 25 Years. Washington, D.C.: Jane Haslem Gallery, 1974.

Who's Who in American Art: 1980.

Vincent LaBadessa

(dates unknown)

Lithograph: *U.S. Coast Guard*

Vincent LaBadessa was born in Philadelphia, Pennsylvania, where he studied art on a scholarship at the Philadelphia Museum School of Industrial Art. He graduated in 1930 and had his first one-man show of paintings that same year. LaBadessa did not have a solo show of prints until 1948, when he had a lithography show at the Philadelphia Art Alliance. Other one-man exhibitions of LaBadessa's work have included two at the Warwick Galleries in his hometown and an exhibition devoted to his paintings at the Chester County Art Association in West Chester, Pennsylvania, held in the late 1970s.

Vincent LaBadessa has also shown work in group exhibitions at the Pennsylvania Academy of the Fine Arts, the Philadelphia Museum of Art, the first and second Philadelphia Art Festival, and the Library of Congress, which awarded him a Joseph Pennell prize in the 1940s. He also won a purchase prize at the Carnegie Institute in Pittsburgh, and his work may be found in such other permanent collections as the Seattle Museum of Art and the Atwater Kent Museum in Philadelphia.

In addition to his career as a printmaker and painter, LaBadessa has also worked as a designer. To his credit are the "Italian in America" exhibit for the Italian Festival in Philadelphia in 1960, the Costume Gallery of the Philadelphia Museum of Art, the United States exhibit for the F.A.A. at the World's Fair in Montreal, and a number of interiors for Philadelphia commercial and business firms.

Sources

"LaBadessa's Prints in One-Man Show." *Philadelphia Art Alliance Bulletin* (May 1948): 5.

Richard Francis Lahey

(1893–1978)

Etching: *A Soldier's Farewell*

Richard Francis Lahey was born on June 23, 1893, in Jersey City, New Jersey. After becoming interested in an art career in high school, he attended the Art Students League in New York from 1912 to 1916, studying with Robert Henri, Kenneth Hayes Miller, George Brant Bridgman, and Max Weber. During World War I, for eighteen months, he served in the camouflage corps of the U.S. Navy in Washington, D.C., and in Paris. Later, in the Second World War, he did camouflage for battle ships.

Lahey's career got its first boost when he won the William H. Tuthill Purchase Prize at the Fifth Annual Watercolor Exhibition of the Art Institute of Chicago in 1925. By that time, he had worked as a caricaturist and free-lance artist for such periodicals as the *New York World Sun Magazine,* the *New York Times, Theatre Magazine,* and *Bookman.* In the mid-1920s, he collaborated with poet John Farrar on a Sunday column in the *New York Times Magazine* entitled "Seeing New York." He taught for one year at the Minneapolis School of Art (1921) and joined the faculty of the Art Students League in 1923, where he remained until 1935. In 1929, Lahey was given his first one-man show, at the Whitney Studio Galleries, predecessor of the Whitney Museum of American Art in New York City.

In the early 1930s, under the auspices of the Section of Painting and Sculpture of the U.S. Treasury Department, Richard Lahey painted a mural for the U.S. post office in Brownsville, Pennsylvania. In 1935, he left the Art Students League to become the fifth principal of the Corcoran School of Art, Washington, D.C., and he had a one-man show at the Corcoran Gallery of Art the following year. From 1937 to 1960, he was professor of art at Goucher College in Maryland and he also served as principal emeritus of the Corcoran School.

Other one-man exhibitions of Lahey's work include one at the D.C. Public Library, a series at the Kraushaar Gallery in New York, and shows at the George Washington University and the University of Georgia. Complete retrospectives of Lahey's work were held in 1944 at the Virginia Museum of Fine Arts and in 1963 at the Corcoran Gallery of Art. In the 1960s, Lahey was commissioned with his wife, the sculptor Carlotta

Gonzalez, to do a mural for the Hawaii Memorial in Honolulu, sponsored by the American Battle Monuments Commission.

An exhibitor in numerous group shows throughout his career, Lahey won a prize from the Pennsylvania Academy of the Fine Arts, several from the Society of Washington Artists, and an award from the Ogunquit Art Association. His work may be found in the Pennsylvania Academy of the Fine Arts, Goucher College, the Brooklyn Museum, the Detroit Institute of Arts, the Museum of Modern Art, and the U.S. Supreme Court.

Sources

"Richard Francis Lahey—Painter." *Index of 20th Century Artists* 3, no. 2 (November 1935): 107-9.

"Lahey Will Head Corcoran School." *Evening Star,* November 13, 1935.

"Lahey Paintings Put on Exhibit with Etchings." *Washington Star,* March 6, 1937.

Von Keller, Beatrice. "Richard Francis Lahey, May 20–June 1944." *Richmond, Virginia, Museum of Fine Arts, Virginia Artists Series,* no. 23 (1944): 93-96.

Reese, Albert M. *American Prize Prints of the 20th Century.* New York: American Artists Group, 1949 (pp. 110, 247).

"Corcoran Honors Richard Lahey." *Washington Star,* May 3, 1953.

"Lahey's Work, Shown at the Corcoran, Makes Popular, Interesting Exhibit." *Times Herald* (Washington, D.C.), August 9, 1953.

Richard Lahey. A Retrospective Exhibition. Essay by Hermann Warner Williams, Jr. Washington, D.C.: Corcoran Gallery of Art, April 2–May 5, 1963.

"Richard Lahey, Painter, Ex-Corcoran Principal." *Washington Post,* August 3, 1978.

Who's Who in American Art: 1940-47, 1962.

Anthony LaPaglia
(dates unknown)
Woodcut: *The Home Front*

Anthony LaPaglia was active in the New York City area at the time of his submission to the "America in the War" exhibition.

Pietro Lazzari
(1898–1979)
Drypoint: *Victory Gardens*

Pietro Lazzari was born in Rome, Italy, on May 15, 1898. He studied at the Scuolo Communale Arti Ornementali (1912–14), the Art Museo (1920–22), and the Belle Arti (1922–23), all in Rome, as well as at the Académie des Beaux-arts in Paris. Lazzari also studied decoration in Italy with Calcagnadoro and Bargellini from 1922 to 1925, and he worked on the decoration of the walls and ceilings of the Ministero della Marina in Rome. In addition, he assisted Depero and Marinetti in decorating the Cabaret del Diavoli built by Gino Gori. Lazzari won a prize from the Ornamental School and had a one-man exhibition at the Teatro Quirino in Rome in 1929.

After coming to the United States, Lazzari worked on the Public Works of Art Project in New York City in the mid-1930s. He participated in several national competitions sponsored by the Section of Fine Arts of the U.S. Treasury Department during the depression, winning commissions for post office decorations in Jasper, Florida, and Brevard and Sanford, North Carolina. Also a sculptor, Lazzari executed a bronze bust of Eleanor Roosevelt, which is in the collection of the Roosevelt Library in Hyde Park, New York.

Pietro Lazzari has participated in many one-man and group exhibitions in this country, beginning with his 1926 solo show at the New Gallery in New York City. He has been a part of exhibitions held in such diverse places as the Art Institute of Chicago, the Corcoran Gallery of Art in Washington, D.C., and the Betty Parsons Gallery in New York. Lazzari also exhibited abroad: in Venice in 1948 and at the Musée nationale d'art moderne in Paris in 1954.

During his career, Pietro Lazzari executed illustrations for both foreign and American publications, such as the Italian newspaper *Il Messagero* and the *New York World Sun Magazine.* He illustrated a book entitled *Washington Is Wonderful.* In 1950 Lazzari won a Fulbright Fellowship. From 1943–48 he was an instructor in art at American University, Washington, D.C., and he was head of the art department at Dunbarton College of the Holy Cross, 1949–50. He was also an instructor for the Graduate School of the U.S. Department of Agriculture.

Pietro Lazzari's work is in numerous public collections, including Howard University, the Honolulu Academy of Fine Arts, the Truman Library, and the San Francisco Museum of Art.

Sources

Who's Who in American Art: 1940–47, 1953, 1966.

Fig. 19
Victory Gardens

Pietro Lazzari (1898–1979)

Drypoint, not dated (18.9 x 11 cm)
Signed in pencil

"As for my husband's submission for the Artists for Victory show, he simply depicted the reality of the Victory garden as we were then experiencing it. We were new to Washington then, and living in a small tourist 'home' in East Falls Church. The premises belonged to a retiree from the postal service. He spent long hours in his vegetable garden. One day my husband found him shelling his home-grown peas. The drypoint Victory Garden *was thus inspired." (Evelyn Lazzari to Ellen G. Landau, February 27, 1982)*

XX L432 A1
Fine Prints Collection
Prints and Photographs Division
Library of Congress

Joseph LeBoit

(b. 1907)

Woodcut: *Herrenvolk*

Joseph LeBoit, a painter and printmaker, was born in New York, New York, on November 23, 1907. He studied at the College of the City of New York, where he earned a bachelor of arts degree, and at the Art Students League, with famed Regionalist painter Thomas Hart Benton. Joining the Graphic Division of the New York W.P.A. Fine Arts Project in 1938, he became part of its innovative silkscreen unit. LeBoit had a one-man exhibition at the A.C.A. Gallery in 1946 and worked in the forties as a staff artist for the periodical *PM*.

With the outbreak of World War II, Joseph LeBoit became a politically active member of the New York art community. In 1941 he was elected corresponding secretary of the Artists Societies for National Defense.

Present at the January 1942 organizational meeting of the Artists Council for Victory, he became one of the directors of Artists for Victory, Inc., when these other organizations merged to form it.

Elected corresponding secretary of Artists for Victory, Inc., in March 1942, LeBoit also served as chairman of the standing committee on promotions and programs. In this capacity, he served as director of the "America in the War" exhibition and was responsible for the brochure announcing the competition, the formulation of the rules and regulations governing the show, the suggested topics for artists' submissions, and the arrangement of the show's presentation at twenty-six museums all over the country.

Joseph LeBoit also exhibited in the A.C.A. Gallery's 1942 "Artists in the War" exhibition, and he delivered the conference report in a symposium associated with that show. He was an active union member of the United American Artists.

Another example of LeBoit's work is in the collection of the National Museum of American Art of the Smithsonian Institution.

Sources

LeBoit, Joseph and Hyman Warsager. "The Graphic Project: Revival of Printmaking." *Art Front* 3 (December 1937): 9.

Who's Who in American Art: 1940–47.

Alicia Legg

(b. 1915)

Aquatint: *Hopeful*

Alicia Legg was born in 1915. She studied at the Art Students League in New York with Robert Brackman. She also learned printmaking techniques from Harry Sternberg and Will Barnet, two other artists in the "America in the War" exhibition. In the early 1940s, Legg had her work in local exhibitions near Hackensack, New Jersey, her home, winning a prize at the Montclair Museum.

During the 1940s, Alicia Legg began working in the library of the Museum of Modern Art in New York City. She eventually worked her way up to a position as associate curator in the department of painting and sculpture, a position which she still holds today. In recent years, she took part in a course given at the New School in New York City entitled "Behind the Scenes with the Art People" (1978) and, in her curatorial capacity, she has lately edited a number of important Museum of Modern Art publications, among them *The Sculpture of Matisse* (1972), *Painting and Sculpture in the Museum of Modern Art with Selected Works on Paper: A Catalog* (1977), and *Sol Lewitt* (1978). She has not practiced as an artist herself for many years.

Beatrice S. Levy

(1892–?)

Aquatint (color): *River of Blood*

Beatrice S. Levy was born in Chicago, Illinois, on April 3, 1892. She studied at the Art Institute of Chicago, and with Charles Hawthorne and Vojtech Preissig. She had her first solo exhibition in New York in 1916 and had a one-person show in Boston, at Goodspeed's Book Shop, in 1924. In 1932, the Division of Graphic Arts of the Smithsonian Institution gave Levy an exhibition of etchings, drypoints, and prints in color. The most recent exhibition devoted to her work took place at the University of New Mexico in 1957.

Beatrice Levy has taken part in numerous group shows at such institutions as the Art Institute of Chicago, the Pennsylvania Academy of the Fine Arts, and the Chicago Society of Etchers. In 1932 and 1933, her works were selected for Fifty Prints of the Year. Among the many other group exhibitions in which she has taken part are several Pennell shows at the Library of Congress, and a traveling ceramic exhibit in Yokohama, Japan.

In the 1920s, Levy experimented extensively with different methods of making color aquatints, using three plates for each impression. A painter and teacher as well as a graphic artist, for a year and a half during World War II she did war work as a draftsman.

Beatrice Levy's works are part of the permanent collections of such museums as the Chicago Municipal Collection, the Bibliothèque nationale in Paris, the Art Institute of Chicago, the Smithsonian Institution, and the La Jolla, California, Art Center. In the early 1960s Levy moved from the Chicago area to La Jolla.

Sources

Mechlin, Leila. [Review]. *The Washington Star,* February 17, 1922.

"The Robert Rice Jenkins Prize to Beatrice Levy for 'Jackson Park Beach Nocturne,'" *Chicago Art Institute Bulletin* 17 (March 1923): 29.

"Notes about Artists." *Chicago Evening Post,* December 27, 1927.

Collins, J. L. *Women Artists in America, 18th Century to the Present.* Chattanooga: University of Tennessee, 1973.

Who's Who in American Art: 1940–47, 1953, 1962, 1966.

Margaret Lowengrund

(1905–1957)

Lithograph: *The Atlantic Charter*

Margaret Lowengrund, a painter and printmaker, was born in Philadelphia, Pennsylvania, on August 24, 1905. Her father was a sculptor. Lowengrund studied at the Pennsylvania Academy of the Fine Arts, the Philadelphia Graphic Sketch Club, and the Art Students League of New York with Joseph Pennell. She traveled to Europe in the 1920s, where she studied at the London County Council School of Arts and Crafts with A. S. Hartrick, a friend of Pennell's, and in Paris with Polish painter Leopold Gottlieb and French abstractionist André L'Hôte.

Lowengrund exhibited at the Salon d'automne in Paris in 1928. While in England, she did sketches for the *London Daily Express* and the *London Graphic and Bystander.* Two of her lithographs were purchased by Campbell Dodson for the British Museum while she was still a student. Hartrick once remarked that, "Joe Pennell sent [Lowengrund] to my workroom in London as an example of American wit, strength and truth. I found Margaret Lowengrund a genuine artist from the very beginning." (Archives of American Art, Washington, D.C.).

In the 1930s and 1940s, Lowengrund, now the wife of newsman Joseph Lilly, was active in the American Artists Congress, the Artists Union, and An American Group. Her work was chosen for Fifty Prints of the Year in 1932, 1934, and 1937. Three of her paintings of aircraft industry subjects were purchased during World War II by the Office of Emergency Management (O.E.M.) from an O.E.M.-sponsored competition to record defense and war activities.

Margaret Lowengrund taught at the American Artists School of New York and ran a workshop in color lithography at the New School. She was commissioned by the Grace Lines to do a series of paintings in Peru and by the Royal Netherlands Line to do similar work in Venezuela. She also painted murals for the New York Labor Temple and sketched for Paramount News at the first and second sedition trials in New York City. (Paramount News made a movie on the subject of her court drawings.) For many years, Lowengrund did a daily column for the *New York Post* entitled "Sketches about Town." She also drew for the *Philadelphia Ledger* and illustrated an edition of Sinclair Lewis's *Main Street,* edited by Carl Van Doren.

During her varied career, Lowengrund held several important positions in the New York art world. She was an associate editor of *Art Digest,* 1948–50, and registrar and assistant director of the National Academy of Design School of Fine Arts, 1950–51. She also served as codirector of the Pratt Contemporary Graphic Art Center, which she founded with several partners. From 1951 until her death, Margaret Lowengrund was director of the Contemporaries Gallery.

Among the solo exhibitions to Lowengrund's credit are shows at the Kleeman-Thorman Galleries, New York (1928), the Baltimore Museum of Art, the Smithsonian Institution's Division of Graphic Arts (1954), the Grace Horne Galleries in Boston, and the A.C.A. Gallery. The National Association of Women Artists named a memorial prize after her.

Sources

[Review, Kleeman-Thorman Galleries Exhibition]. *New York Evening Post,* November 10, 1928.

"Exhibition, New York." *Pictures on Exhibit* 6 (April 1945): 37.

"Mrs. Lowengrund, Lithographer Here." *New York Times,* November 21, 1957, p. 33.

Who's Who in American Art: 1937, 1953.

Louis Lozowick
(1892–1973)
Lithograph: *Granaries of Democracy*

Louis Lozowick was born on December 10, 1892, in Ludvinovka, the Ukraine. He moved to Kiev in 1904 and attended the Kiev Art School until he emigrated from Russia to the United States two years later. Here he studied at the National Academy of Design, 1915–17, with Leon Kroll and Emil Carlsen. He also graduated Phi Beta Kappa from Ohio State University in 1918. During World War I, he served in the armed forces in Europe.

After the war, Lozowick stayed in Berlin, where he became involved with the Novembergruppe of artists and did his first lithographs. He met Constructivist El Lissitzky there and on a trip to Russia became acquainted with other Russian revolutionary artists, Kasimir Malevich, Ivan Puni, and Vladimir Tatlin. Lozowick attended the Freidrich-Williams Gymnasium and the Free Academy in Berlin and began the urban studies concentrating on skyscrapers, bridges, and machinery, influenced by Cubism and Constructivism, for which he has become famous. He had two one-man exhibitions in Berlin, in 1922 at the Twaddy Gallery and the following fall at Alfred Heller's. Before leaving Europe, he also attended classes at the Sorbonne.

Louis Lozowick returned to the United States in 1924 and became involved in innovative stage design, doing sets for Georg Kaiser's *Gas,* presented at the Goodman Theater in Chicago. His lectures on modern Russian art were published by the Société anonyme in 1925, and he exhibited with that avant-garde group the following year. A little later, he published a book on *Modern Russian Art* and, in 1930, was coauthor of *Voices of October,* a study of the place of art in revolutionary Russia. After his fourth visit to Russia in 1932, he wrote a study of the Far Eastern Soviet Republics.

Lozowick had his first one-man show in the United States in 1926 at J.B. Neumann's New Art Circle. The show concentrated on subjects related to cities and machine ornamentation, done in a Precisionist style. In 1927, Lozowick wrote the introduction to the Machine Age Exposition at Steinway Hall and two years later began to exhibit at Weyhe Gallery. He continued to exhibit in Europe as well, most notably at the famous "New Objectivity" show in Mannheim in 1925. In 1928,

there were exhibitions devoted solely to Lozowick's work in Paris and at the Museum of Western Art in Moscow.

On the executive board of the radical publication *New Masses* beginning in 1926, Lozowick was also active in the American Artists Congress in the early years of the Depression. He wrote an article on revolutionary art for the Artists Union publication, *Art Front,* in which he advocated that artists become critics of the status quo and aim their art at the working classes. In 1933–34 he joined both the graphic and mural divisions of the W.P.A. and painted a mural for the U.S. post office in New York City.

During the war years, Lozowick remained politically active. He was one of the signers of the call to artists to assemble in defense of culture against Fascism in 1941 and exhibited in the show that was held in conjunction with this congress. He was a discussant on the congress's panel, "A Fascist World and Freedom of Expression." Again in 1942 he was a featured speaker on a panel concerning the arts in wartime sponsored by the Congress of Soviet American Friendship.

Louis Lozowick moved to South Orange, New Jersey, in 1943. From the 1940s through the 1960s, he participated in many group exhibitions, including the seminal "American Realists and Magic Realists" at the Museum of Modern Art in 1943. The Division of Graphic Arts of the Smithsonian Institution held a one-man show of his work in Washington, D.C., in 1950. There were a number of solo presentations of his work in the last two decades of his life, as well as an important series of posthumous exhibitions.

In addition to his publications on Russian art, Lozowick wrote *A Treasury of Drawings, 100 Contemporary American Jewish Painters and Sculptors,* and a book on the art of William Gropper. He was a contributor to such magazines as *The Nation, Menorah Journal, Theatre Arts,* and *Transition.* His work may be seen in the collections of the Museum of Modern Art, the New York Public Library, the Museum of Western Art in Moscow, and the National Museum of American Art, Washington, D.C., which has an in-depth selection of his graphic oeuvre.

Sources

Lozowick, Louis. "Lithography: Abstraction and Realism." *Space* 1 (March 1930): 31–33.

Abstraction and Realism: 1923–43, Paintings, Drawings and Lithographs of Louis Lozowick. Essay by William C. Lipke. Burlington, Vt.: Robert Hull Fleming Museum, University of Vermont, 1971.

Louis Lozowick: Lithographs. Essay by Elke M. Solomon. New York: Whitney Museum of American Art, 1972–73.

Obituary. *New York Times.* September 10, 1973, p. 24.

Singer, Esther Forman. "The Lithography of Louis Lozowick." *American Artist* 37 (November 1973): 36–40.

Louis Lozowick. Lithographs and Drawings. Newark, New Jersey: Newwark Public Library, 1972–73.

Louis Lozowick. Drawings and Lithographs. Essay by Janet A. Flint. Washington, D.C.: National Collection of Fine Arts, 1975.

Louis Lozowick's New York. New York: Associated American Artists, January 5–31, 1976.

Louis Lozowick: American Precisionist Retrospective. Essay by John Bowlt. Long Beach, Calif.: Long Beach Museum of Art, 1978.

Louis Lozowick (1892–1973). Works in the Precisionist Manner. New York: Hirschl and Adler Galleries, Inc., 1980.

Abel Franklin McAllister

(b. 1906)

Wood engraving: *Convalescent Craftsmen*

Abel Franklin McAllister was born September 9, 1906, in Herrington, Kansas. He studied with Edmund Giesbert and went to graduate school at the University of Chicago. A member of the Renaissance Society of the University of Chicago, he received honorable mention in the Union League Club of Chicago's competition for young Chicago artists in 1929.

At the time of the "America in the War" exhibition, Abel McAllister was still a resident of Chicago. From the inscription on his submission, *Convalescent Craftsman*—"American Red Cross Arts and Skills Program in Military Hospitals"—it can be inferred that he was involved in Red Cross hospital work during World War II.

Sources

Who's Who in American Art: 1937.

John Ward McClellan

(b. 1908)

Lithograph: *The Imprisoned Outcasts*

John Ward McClellan was born in 1908. At the time of the "America in the War" exhibition, he lived in Woodstock, New York, and had attained the rank of corporal in the U.S. armed services.

During his career as an artist, John Ward McClellan participated in a number of group shows, including one at the Library of Congress, which purchased one of his works through its Joseph Pennell fund, and another at the Isaac Delgado Museum of Art in New Orleans, which included McClellan in its 54th Annual, held in 1955. The only one-man show by McClellan which is documented was held in 1938 at the Grant Studios in New York City. Critic Howard Devree of the *New York Times* lauded McClellan's "powerful draftsmanship."

Sources

Devree, Howard. [Review, Grant Studios Exhibition]. *New York Times,* December 18, 1938.

Florence White McClung

(1896–?)

Lithograph: *Home Front*

Florence White McClung was born July 12, 1896, in St. Louis, Missouri. She studied at Southern Methodist University, where she earned bachelor's degrees of arts and science in education, at Texas State College for Women, at Colorado College, in Taos, New Mexico, and with artists Adolph Dehn, Alexander Hogue, Frank Reaugh, Richard Howard, and Frank Klepper. She herself was an instructor in drawing, painting, batik, and art history at Trinity University, Waxahachie, Texas, from 1928 to 1942.

McClung has been given numerous solo exhibitions in Texas, Louisiana, and Alabama, and she also had a one-person show in England in 1946. Notable among the many group shows in which she participated in the 1930s and 1940s are the Pan-American Exposition in Dallas, Texas (1937), and several shows each at the National Academy of Design, the Library of Congress, and the San Francisco Museum of Art.

Florence McClung was awarded prizes for her art by the Dallas Alliance of Art, the National Association of Women Artists, and in the competition Pepsi-Cola sponsored, organized by Artists for Victory, in 1942. Her work may be seen in the permanent collections of such museums as the Metropolitan Museum of Art, the Dallas Museum of Fine Arts, the Mint Museum of Art, and the Isaac Delgado Museum in New Orleans.

Sources

Collins, J. L. *Women Artists in America, 18th Century to the Present.* Chattanooga: University of Tennessee, 1973.

Who's Who in American Art: 1940–47, 1953, 1962.

Alexander Samuel MacLeod

(1888–?)

Lithograph: *Havoc in Hawaii*

Alexander Samuel MacLeod was born April 12, 1888, on Prince Edward Island in Canada. After studying at McGill University, he came to the United States in 1910 and studied at the California School of Design. During World War I, he was an engineer with the American Expeditionary Forces in France, doing mapping and panoramic sketching.

In 1921 Alexander MacLeod moved to Honolulu, where he became one of Hawaii's best-known artists. In 1928 the Honolulu Academy of Arts gave him a comprehensive exhibition of paintings and prints. He also had a one-man show at that same institution in 1931 (comprising war sketches from France, 1917–18) and 1940. Other solo showings in the 1930s and 1940s included one at the California Palace of the Legion of Honor in San Francisco, three at S. & G. Gump Galleries, Waikiki, one at Stanford University, another at the Vancouver Art Gallery, a show at the University of Hawaii, and his only one-man exhibition in the East, at the Ferargil Galleries in New York in 1934.

During World War II, MacLeod again worked with the U.S. Army Engineers, eventually becoming head of the Graphic Presentation Section, Adjutant General Division, Fort Shafter. An article in the *London Studio* (May 1945) notes that MacLeod was at the site of the bombing of Pearl Harbor, with his watercolors, at the same time as the first photographers arrived. MacLeod published his own graphic account of the Japanese attack in *The Spirit of Hawaii: Before and After Pearl Harbor* (New York: Harper and Brothers, 1943). A painting by MacLeod of a bombed hangar at an army airfield was purchased by the Office of Emergency Management out of a competition to record defense and war activities, held at the beginning of the U.S. involvement in World War II.

MacLeod has exhibited at museums and with art associations all over the United States. Just a few of the group shows to his credit include those held at the Museum of Modern Art, the Pennsylvania Academy of the Fine Arts, the New York World's Fair (1939–40), and the San Francisco Museum of Art. He also exhibited lithographs in 1942 at the National Art Gallery in Sydney, Australia.

Works by Alexander Samuel MacLeod may be seen in the permanent collections of many museums, for instance, the National Gallery of Art, the Honolulu Academy of Arts, and the Seattle Art Museum. MacLeod has also illustrated several other books with Hawaiian subject matter, including three written by Clifford Gessler and one by Erna Fergusson.

Sources

Gessler, Clifford. "The Art of A.S. MacLeod." *Studio* 93 (May 1927): 334–36.

"Hawaiian Painter Wins Honolulu Prize." *Art Digest* 2 (September 1928): 20.

"MacLeod of Honolulu Has N.Y. Show." *Art Digest* 8 (July 1, 1934): 24.

MacLeod, Alexander Samuel. "The Fisherfolk of Hawaii's Shores." *Asia* 41 (September 1941): 490–91.

MacLeod, Alexander Samuel. "Hawaii in Wartime, Sketches." *Asia* 42 (July 1942): 412–13.

Hall, W.S. "A.S. MacLeod, of Hawaii." *Studio* 129 (May 1945): 161–64.

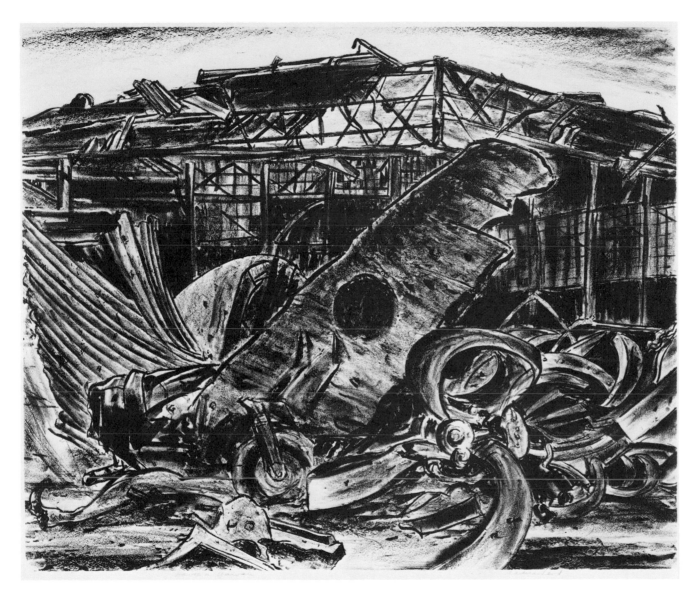

Fig. 20
Havoc in Hawaii

Alexander Samuel MacLeod, b. 1888

Lithograph, not dated
(43.6 x 35.4 cm)
Signed in pencil

XX M166 B7
Fine Prints Collection
Prints and Photographs Division
Library of Congress

J. Jay McVicker
(b. 1911)
Aquatint: *Arc Welder*

J. Jay McVicker, a painter, printmaker, and sculptor, was born October 18, 1911, in Vici, Oklahoma. He studied at Oklahoma State University, where he earned bachelor's and master's degrees in the arts. From 1941 to 1977, he himself taught at that institution. During part of this time, he served as chairman of the art department.

McVicker has had a number of one-man exhibitions throughout his active career. These solo showings, which began in 1940 and continue through the present, have been held at such locations as Esther's Alley Gallery in Bethesda, Maryland; the Fred Jones Memorial Gallery in Norman, Oklahoma; and the Division of Graphic Arts of the U.S. National Museum, Smithsonian Institution. At the time of the last-named (1945), McVicker was a lieutenant in the U.S. Navy.

J. Jay McVicker has won many artistic awards, including prizes from the Washington Watercolor Club, the Library of Congress, and the Wichita Arts Association. Some of the numerous group shows in which he has participated have been held at the National Academy of Design, the Downtown Gallery in New York City, the Salon des réalitiés nouvelles in Paris, the Galleria Origine in Rome, and the American/Japanese Print Exhibition in Tokyo. His work may be seen in over twenty major public collections all over the United States. The realistic subject matter of his prints, for the most part, strongly reflects life in the Southwest. His most recent paintings, however, done in acrylic media, are of the color-field type.

Sources

Reese, Albert M. *American Prize Prints of the 20th Century.* New York: American Artists Group, 1949 (pp. 141, 250).

"Prints of the Past as Fresh as Today." *Washington Post, Weekend* section, March 2, 1979.

Who's Who in American Art: 1940–47 through 1980.

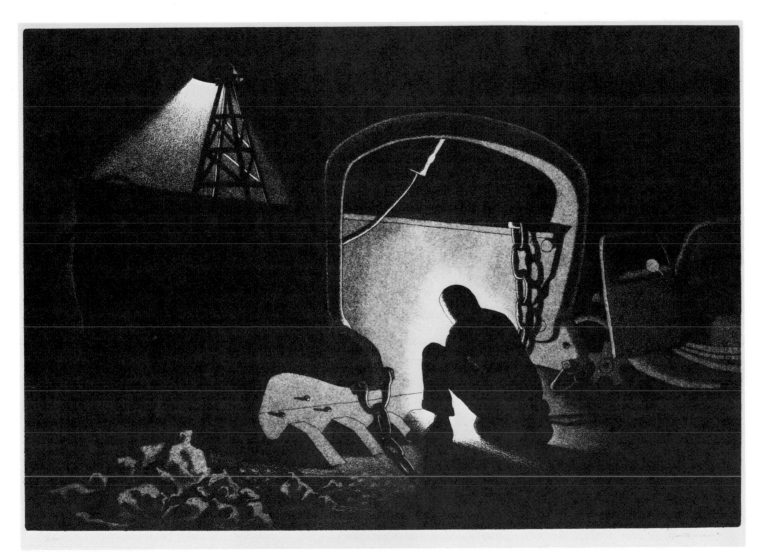

Fig. 21
Arc Welder

J. Jay McVicker, b. 1911

Aquatint, not dated (40.1 x 27.5 cm)
2/50, signed in pencil

"Regarding my print Arc Welder, _it_
was produced in the spring of 1943.
What is now the Stillwater Municipal
Airport was considerably enlarged at
that time to accommodate basic flight
instruction. Arc Welder _represents one_
of the many episodes that occurred
on a night shift of the construction
project." (J. Jay McVicker to Ellen G.
Landau, March 3, 1982)

XX M177 B3
Fine Prints Collection
Prints and Photographs Division
Library of Congress

Jack Markow

(b. 1905)

Lithograph: *Nazi Supermen*

Jack Markow, a painter, cartoonist, and lithographer, was born January 23, 1905, in London, England. He came to the United States at age two and grew up in New York City. He studied at the Art Students League and with Boardman Robinson, Richard Lahey, and Walter Jack Duncan, from 1922 to 1929. Markow had his first one-man show in 1937 at the A.C.A. Gallery in New York. Subsequent solo exhibitions of his work have been held at the School of Visual Arts, New York (1957), and the Hudson Guild Gallery (1958).

During the 1930s, Jack Markow worked in New York on the Fine Arts Project of the W.P.A. Each year from 1933 to 1938, one of his works was chosen for Fifty American Prints of the Year. Beginning in 1928, he began publishing cartoons in such prominent magazines as the *New Yorker,* the *Saturday Review,* the *Saturday Evening Post, Collier's, Life, Holiday, Argosy, True, Redbook,* and *McCall's.* He was an instructor in drawing and cartooning at the School of Visual Arts from 1947 to 1953. During part of this time (1951–53) he worked as cartoon editor of *Argosy.*

An active member of the Magazine Cartoonists Guild, Markow served on its executive board, 1968–72. He has written and illustrated several books on cartooning, including *Drawing and Selling Cartoons* (1955), *Drawing Funny Pictures* (1970), and *Drawing Comic Strips* (1972), as well as preparing the *Cartoonists and Gag Writers Handbook* for the *Writer's Digest* in 1967.

Among the group exhibitions in which Markow has participated are shows at the Pennsylvania Academy of the Fine Arts, the Art Institute of Chicago, the Philadelphia Sketch Club, the Princeton Print Club, the Whitney Museum of American Art, and the National Academy of Design. His prints and paintings are in the collections of the Metropolitan Museum of Art, the Brooklyn Museum, the University of Georgia, Hunter College, the Brooklyn and Queensboro Public Libraries, and the City College of New York.

Sources

Reese, Albert M. *American Prize Prints of the 20th Century.* New York: American Artists Group, 1949 (pp. 135, 249).

Who's Who in American Art: 1940–80.

Merritt Mauzey

(1898–1973)

Lithograph: *My Brother's Keeper*

Merritt Mauzey was born November 16, 1898, on a cotton farm in Clifton, Texas, the youngest of nine children. He grew up on a similar farm near Sweetwater, in the west Texas cattle country. For a short time, as a teenager, he took a correspondence course in cartoon illustrating from the Omaha Nebraska Fine Art Institute. Married at age eighteen, he became a sharecropper on a 160-acre cotton farm until 1921, when he went to Sweetwater to work a cotton gin.

In 1926, Mauzey moved his family to Dallas, where he did clerical work for a cotton export firm. In Dallas, he attended art classes at the public night school, where he studied etching with Frank Klepper and drawing with John Knott. He made his first print there in 1934, and in 1938 he became one of the charter members of the Lone Star Printmakers.

In the early 1930s, Mauzey sold some oil paintings to be used as illustrations in magazines and newspapers such as *Farm and Ranch* and the *Dallas Morning News.* He first exhibited his work at the Texas Centennial in 1936. He had his first solo show in New York in 1939 at the Delphic Studios and also exhibited at the New York World's Fair that year.

Mauzey was discovered in 1940 by Carl Zigrosser who, under the auspices of the Guggenheim Foundation, was engaged in making a national survey of printmaking. Around this time, Mauzey became interested in lithography. He had to work on transfer paper and send his designs to Philadelphia to be printed, since he had no access to a lithography press. This being unsatisfactory, he purchased instruction books, equipment, and stones, and in 1942 set up one of the first presses in Texas. After winning a Guggenheim Fellowship in 1947 to explore

lithography and make prints about Texas life, he took time off from his job at the Firestone Tire and Rubber Company in Dallas to study lithography, for several months each, under Lawrence Barrett at the Colorado Springs Fine Arts Center and George Miller in New York City. In the 1940s he had a number of one-man exhibitions of his lithographs, including a show organized by the Elisabet Ney Museum in Austin (1942) that traveled all over Texas and another at the Grand Central Art Galleries in New York (1947), as well as one at the Galeria de Art Mexicano in Mexico City.

Merritt Mauzey is best known for prints depicting aspects of the cotton industry, from planting to export, and for the series of children's books he wrote and illustrated in the 1950s and 1960s. These include *Cotton Farm Boy, Texas Ranch Boy, Oilfield Boy, Rice Boy, Rubber Boy,* and *Salt Boy.*

After retiring from Firestone in 1962, he traveled extensively all over the world. During his lifetime, Merritt Mauzey exhibited in numerous group shows, including six overseas tours, and won twenty-seven prizes. His one-man shows totaled more than thirty. A number of the museums which own his work have in-depth collections. These include the New Britain Museum of American Art, the National Museum of American Art, and the University of Houston. In 1972, a catalog was published of the Merritt Mauzey collection in the library of the University of Southern Mississippi.

Sources

Zigrosser, Carl. "Merritt Mauzey." In *The Artist in America: 24 Close-Ups of Contemporary Printmakers.* New York: Alfred A. Knopf, 1942.

Morgan, Ruth. "Sermons on Stone: The Lithographs of Merritt Mauzey." *Southwest Review of Literature* (Spring 1947): 163–69.

Reese, Albert M. *American Prize Prints of the 20th Century.* New York: American Artists Group, 1949 (pp. 138, 249–50).

Putcamp, Luise, Jr. "Sermon on Stones." *Town North Magazine,* 1953.

Mauzey, Merritt. "Lithography as a Fine Art." *Today's Art* 3, no. 9 (October 1955).

Tracy, Warren. *The Catalog of the Merritt Mauzey Collection in the Library of the University of Southern Mississippi.* Hattiesburg, Miss.: Univ. of Southern Miss., 1972.

Weaver, Gordon, ed. *An Artist's Notebook: The Life and Art of Merritt Mauzey.* Memphis: Memphis State University Press, 1979.

Who's Who in American Art: 1940–47, 1966.

Roderick Fletcher Mead

(1900–1972)

Copper engraving: *The Voice of Hope in the Dawn*

Roderick Fletcher Mead was born in South Orange, New Jersey, on June 25, 1900. He studied at the Yale School of Fine Arts, the Grand Central Art School, and the Art Students League. Mead studied painting with George Luks, W.C. Smith, and George Ennis and printmaking with William Stanley Hayter at Atelier 17 in Paris. In Europe, he became a member of the Société des indépéndents de Paris and exhibited in the Salon de mai and with other Atelier 17 artists at the Paris Exposition internationale de graveurs contemporains, as well as with this group in Brussels, Rome, and Honolulu and at several South American museums.

By 1943 Mead had moved from New Jersey to Carlsbad in the Pecos Valley of New Mexico. He has had one-man exhibitions at the California Palace of the Legion of Honor, the Columbus Gallery of Fine Arts, the Museum of New Mexico, the University of New Mexico, the University of Maine, the University of Arkansas, the University of Oregon, the Louisville Art Center, and the Bonestell and George Binet galleries in New York City. In the 1970s, the Museum of the Southwest and the Roswell Museum and Art Center both gave him complete retrospectives.

During his career, Mead was involved in a large number of group exhibitions and he was awarded prizes from the Société des beaux arts, Lorraine, France; the Northwest Printmakers; the Library of Congress; the Dallas Museum of Fine Arts; and Texas Western College. His work may be seen in the permanent collections of many museums in the United States as well as in Paris, London, and Tel-Aviv.

Sources

Morang, Alfred. "Roderick Mead, Painter with Clear Vision." *Palacio* 53 (May 1946): 125.

Reese, Albert M. *American Prize Prints of the 20th Century*. New York: American Artists Group, 1949 (pp. 142, 250).

"Roderick Fletcher Mead at the George Binet Gallery." *Pictures on Exhibit* 13 (April 1951): 20–21.

B.K. "Roderick Mead." *Art Digest* 25 (April 1, 1951): 19–20.

Reese, Albert M. "Roderick Mead." *New Mexico Quarterly* (1952): 70–74.

Roderick Mead 1900–1972: A Retrospective Exhibition. Midland, Texas: Museum of the Southwest, 1972.

Roderick Mead Retrospective. New Mexico: Roswell Museum and Art Center, December 12, 1973–January 9, 1974.

Who's Who in American Art: 1953, 1962.

Fig. 22
The Voice of Hope in the Dawn

Roderick Fletcher Mead (1900–1972)

Copper engraving, 1943
(20.2 x 25.1 cm)
3/40, signed and dated in pencil

XX M479 A3
Fine Prints Collection
Prints and Photographs Division
Library of Congress

Leo John Meissner

(1895–1977)

Wood engraving: *War Bulletins*

Leo John Meissner was born in Detroit, Michigan, on June 28, 1895. He studied at the Detroit School of Fine Arts with John P. Wicker. After serving in the American Expeditionary Forces in France during World War I, he studied painting on scholarship at the Art Students League in New York City, with Guy Pène du Bois and George Luks.

Meissner began his career as a printmaker in the early 1920s with linoleum prints. He began to specialize in end-grain wood engraving during the 1930s. He worked in New York as art editor of *Motor Boating Magazine* from 1927 to 1950, after which time he devoted himself entirely to his art. For more than forty years, he sketched and painted every summer on Monhegan Island, twelve miles off the coast of Maine.

Leo Meissner began exhibiting as an artist in 1924. During his career he had over seventy-five one-man shows. The first was held at the Print Corner, Hingham Centre, Massachusetts, in January 1929 and the most recent exhibition devoted to his work was held in May 1982 at the Bethesda Art Gallery in Bethesda, Maryland. The many prizes he was awarded include the Pennell purchase prize from the Library of Congress and awards from the Southern Printmakers and the Detroit Institute of Art. His work was included many times in Fifty Prints of the Year during the late 1920s and the 1930s.

The permanent collections in which Meissner's work can be found include those at the Metropolitan Museum of Art, the Currier Gallery in Manchester, New Hampshire, the Farnsworth Museum in Rockland, Maine, the Philadelphia Museum of Art, and the New York Public Library.

Sources

"Wood-engravings by Leo Meissner." *Milwaukee Art Institute Bulletin* 2 (March 1929): 8.

"Block Prints by Leo J. Meissner." *Akron Art Institute Bulletin* 1 (October 1929): 2.

"Leo J. Meissner." *Handbook of the American Artists Group.* New York, 1935 (p. 50).

Original Etchings, Lithographs and Woodcuts Published by the American Artists Group, Inc. New York, 1937 (p. 38).

Reese, Albert M. *American Prize Prints of the Twentieth Century.* New York: American Artists Group, 1949 (pp. 143, 250).

Paintings and Wood-engravings by Leo Meissner. Maine: Anderson Learning Center, Nasson College, March 14–April 4, 1965.

"Leo Meissner (1895–1977)." *Childs Gallery Print Letter,* no. 23 (June–August 1980): 1–3.

Who's Who in American Art: 1940–47.

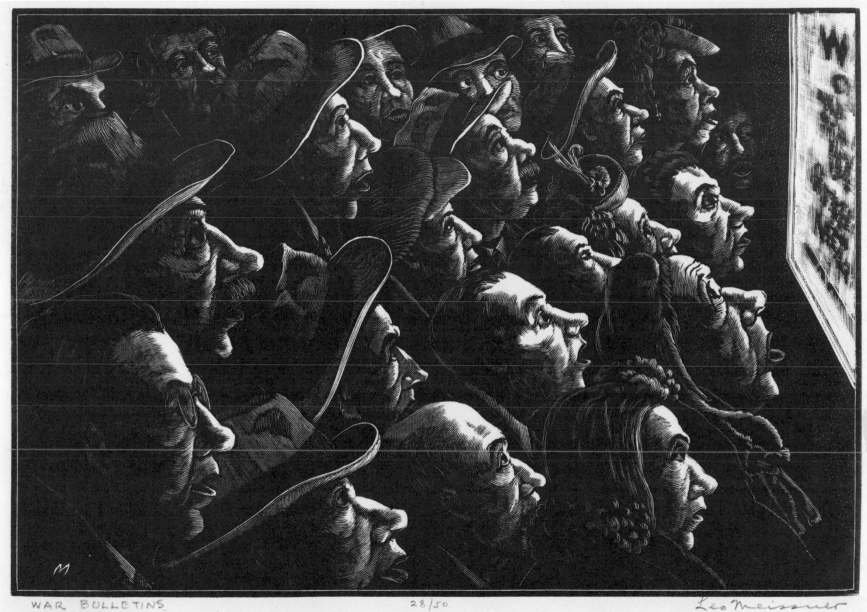

WAR BULLETINS 28/50 Leo Meissner

Fig. 23
War Bulletins

Leo John Meissner (1895–1977)

Wood engraving, not dated
(15.6 x 23.1 cm)
28/50, signed in pencil

XX M515 A2
Fine Prints Collection
Prints and Photographs Division
Library of Congress

Leon Gordon Miller
(b. 1917)
Linoleum cut: *Aggression*

Leon Gordon Miller was born in New York on August 3, 1917. He studied at New Jersey State Teachers College, where he earned a bachelor of science degree, at the Art Students League, at the Newark School of Fine and Industrial Art, at the Fawcett Art School, and with Bernard Gussow. Miller has been awarded two honorary doctorates in fine arts, from Baldwin Wallace College (1971) and Kean College in New Jersey (1973).

At the time of the "America in the War" exhibition, Miller was living in Philadelphia, Pennsylvania. During the war (1941–43), he served as chief designer in the Office of the Chief of Ordnance in Philadelphia and Newark. By 1947, he was teaching industrial design at the Cleveland Institute of Art, a post he retained until 1950. In 1948, he opened his own design firm, Leon Gordon Miller Associates, in Cleveland. In 1971, he also founded KV Design International, Ltd.

Leon Gordon Miller described himself in 1980 as "a multi-media artist engaged in painting, printmaking, sculpture and stained glass, working in a contemporary style and technique" *(Who's Who in American Art)*. He has written a book, *Stained Glass Craft,* published by MacMillan & Company in 1973, and was coauthor of *Light by Design* (published by General Electric, 1971).

Miller has been included prominently in several recent articles and books on interior design and contemporary synagogue art. He has been commissioned not only to do stained glass for religious purposes but also to create ceremonial sculpture and tapestries. For example, he designed the eternal light, menorah, ark, curtain, and other decorative items for the Temple on the Heights in Cleveland, Ohio. The Industrial Designers Institute gave Miller their Silver Medal in 1962, and he won a sculpture award in the Department of Housing and Urban Development's National Community Art Competition in 1973. Miller has also served on the board of the Pierpont Morgan Library Guild for Religious Art and Architecture.

During the 1940s and 1950s, Leon Gordon Miller participated in numerous group shows, including some at the Pennsylvania Academy of the Fine Arts, the Library of Congress, the Cleveland Museum of Art, and the Butler Art Institute. His first one-man show was held in 1948 at the Norlyst Gallery. Since then, he has had about fifteen such special exhibitions of his art. In addition to interiors and objects which he has designed in religious institutions, examples of Miller's work may be found in the Gertrude Stein Collection at Yale University and the Library of Congress.

Sources

"Color Trends in Stained Glass: III, Leon Gordon Miller." *Interior Design* 28 (May 1957): 94.

Kamph, Avram. *Contemporary Synagogue Art.* Union of American Hebrew Congregations, 1966.

Ball, V. *Art of Interior Design.* New York: Macmillan & Co., 1960.

Who's Who in American Art: 1953–80.

Gladys Amy Mock
(1891–1976)
Copper engraving: *Fighting Fire*

Gladys Amy Mock was born in New York City in 1891. She studied at the Calhoun School and at the Art Students League from 1909 to 1913, primarily with Kenneth Hayes Miller. In 1920, Mock was introduced to the medium of etching by William Ivins, Jr., curator of prints at the Metropolitan Museum of Art. In 1923, she studied printmaking with William Stanley Hayter and experimented with Letterio Calapai in color engraving.

Between 1918 and 1928, Gladys Mock served as New York representative to the *American Magazine of Art.* During these same years, she was in charge of sales service at the Bureau Office of the American Federation of Arts. In 1924, she married Pierce Trowbridge Wetter, a founding member of the corporation which formed the Washington Square Outdoor Art Exhibits (of which Mock became director in 1969). In 1959, she was elected first woman president of the Society of American Graphic Artists. She also served as president of the Audobon Association, 1959–60. Mock was directly involved in the Artists for Victory organization. Before its demise in November 1945, she was nominated head of its graphic arts committee.

Gladys Mock had a number of solo shows throughout her career.

These include exhibitions at the Delphic Studios, the Dudensing Galleries, the Elliot Museum of Art at Stuart, Hutchinson Island, Florida, the Bruce Museum in Greenwich, Connecticut, and the Thomas Waterman Wood Gallery, Montpelier, Vermont. Mock, who lived on Washington Square, maintained a summer studio in Montpelier for many years.

She also participated in numerous group exhibitions all over the country. She showed in Venice, Italy, and was included in a show sent abroad by the U.S. Information Agency from 1960 through 1962. She exhibited at the New York World's Fair, 1939–40, and among the numerous prizes she won was the Margaret Lowengrund Memorial Prize for Graphics, awarded by the National Association of Women Artists (1962).

Examples of Mock's work may be found in the permanent collections of such museums as the Pennsylvania Academy of the Fine Arts, the Todd Museum in Kalamazoo, Michigan, Kansas State College, the Metropolitan Museum of Art, the New York Public Library, the Georgia Museum of Art, and the Smithsonian Institution. The painter Isabel Bishop, her good friend for many years, recently noted that toward the end of her career, Mock, a traditionalist, turned to more experimental work, gaining as a result a great deal of new interest and power.

Sources

"Wins Prizes with Oils and Prints." *The Villager,* Greenwich Village, New York, August 11, 1949.

Exhibition of Prints by Gladys Mock. Stuart, Hutchinson Island, Florida: Elliott Museum, January 12–February 14, 1969.

"Distinguished Engraver's Show Will Open at Elliott January 13." *Stuart News.* January 9, 1969.

"Gladys Mock Etchings to Be Featured at Exhibit." *Times-Argus,* Montpelier, Vermont, November 4, 1971.

Collins, J. L. *Women Artists in America, 18th Century to the Present.* Chattanooga: University of Tennessee, 1973.

"Gladys Mock, 85, Artist, Modernistic Engraver." *New York Times,* October 31, 1976.

Who's Who in American Art: 1940–47, 1953, 1966.

Helen Morris
(dates unknown)
Lithograph: *Swing Shift*

Helen Morris was active as an artist in the Pueblo, Colorado, area at the time of her submission to the "America in the War" competition.

Ira Moskowitz

(b. 1912)

Lithograph: *War Worker*

Ira Moskowitz was born in a little town at the foot of the Carpathian Mountains, in what was formerly Austro-Poland, on March 15, 1912. He came to the United States in 1927 and studied at the Art Students League with Harry Wickey from 1929 to 1931. From 1935 to 1938 he traveled extensively in Europe, Africa, and Asia. By the early 1940s, he had settled in Santa Fe, New Mexico, where he began to specialize in western landscape scenes and American Indian subject matter.

In 1949, Ira Moskowitz illustrated a book, *Patterns and Ceremonials of the Indians of the Southwest,* which had a text by John Collier and an introduction by John Sloan. He showed lithographs and drawings from this book at Kennedy & Company that year. Other one-man exhibitions by Moskowitz include a show in 1937 sponsored by the Society for the Advancement of Judaism in New York; a show of Indian subjects in Old and New Mexico at Arthur H. Harlow & Company, New York; a presentation and sale organized by the Association of American Indian Affairs, Inc. in 1947; and shows at the Museum of Fine Arts, Houston, the San Antonio Museum of Art, and the New York City Natural History Museum. He established the Ira Moskowitz Graphic Art Club to sell his works in 1941. In 1975, a complete retrospective of Moskowitz's prints was organized by the Brooks Memorial Art Gallery in Memphis, Tennessee. This show was accompanied by a catalogue raisonné.

A participant in a number of group shows throughout his career, Ira Moskowitz was awarded a Guggenheim Fellowship in 1943 and a prize from the Library of Congress in 1945. His lithograph *War Worker* was chosen to take second place in the planographic division of the "America in the War" exhibition. Other examples from his oeuvre may be seen in the collections of the Whitney Museum of American Art, the Metropolitan Museum of Art, the Brooklyn Museum, the New York Public Library, the Carnegie Institute, the Albany Institute of History and Art, the Museum of Navajo Ceremonial Art in Santa Fe, and the Philbrook Art Center in Oklahoma.

Sources

"Exhibition, New York." *Pictures on Exhibit* 12 (November 1949): 48.

Reese, Albert M. *American Prize Prints of the 20th Century.* New York: American Artists Group, 1949 (pp. 147, 250).

Ira Moskowitz. New York: Shorewood Publishers, 1966.

Czestochowski, Joseph S., ed. *Ira Moskowitz Catalogue Raisonné, 1929–1975.* Memphis, Tenn.: Brooks Memorial Art Gallery, November 1–December 31, 1975.

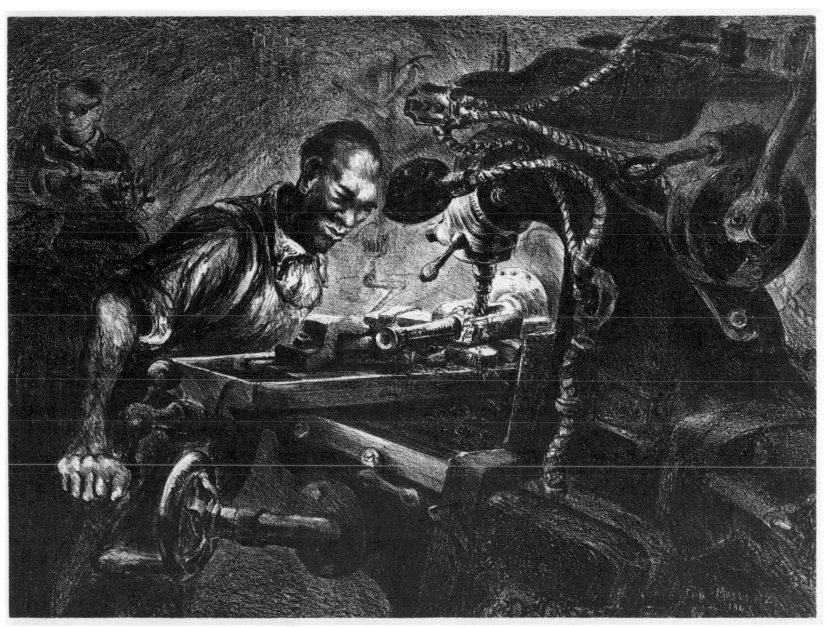

Fig. 24
War Worker

Ira Moskowitz, b. 1912

Lithograph, 1943 (25.5 x 35.1 cm)
Signed and dated on stone, signed in pencil

XX M911 B4
Fine Prints Collection
Prints and Photographs Division
Library of Congress

Fuji Nakamizo

(1889–?)

Etching: *Emblem of Strength and Courage*

Fuji Nakamizo, a painter, etcher, and lithographer, was born January 17, 1889, in Fukuiken, Japan. He came to the United States as a teenager. Nakamizo studied at the Art Students League in New York, at the Cooper Union Art School, and with Joseph Pennell, W. D. Dodge, and Frank DuMond. A specialist in portraits and figure and landscape compositions, Nakamizo executed a decorative mural for President Woodrow Wilson in 1919.

In the early 1930s, Fuji Nakamizo worked on the Public Works of Art Project in New York, predecessor of the W.P.A. His major subject matter at this time was animals, especially dogs, ducks, fish, and birds. This type of motif was continued in the work which he submitted to "America in the War," which prominently displays an American eagle looming large in the foreground, sitting on a tree branch surrounded by war planes.

Nakamizo participated in a number of group exhibitions all over the United States. These included shows at the Pennsylvania Academy of the Fine Arts, the National Gallery of Art, the National Academy of Design, the Houston Museum of Fine Arts, the Norfolk Museum of Fine Arts, the Portland Oregon Museum Association, the Santa Barbara Museum, the Philadelphia Print Club, and the Honolulu Academy of Arts. He also exhibited with the Society of American Etchers in 1945.

Sources

Who's Who in American Art: 1940–47.

Mildred Bernice Nungester

(b. 1912)

Lithograph: *Warsaw, London, Coventry, etc.—*

Mildred Bernice Nungester was born in Celina, Ohio, on August 23, 1912. She studied at Athens College, the Alabama State College for Women (where she earned a bachelor of arts degree), and the Colorado Springs Fine Arts Center (where she earned her master's degree). She also studied art at the Art Institute of Chicago, at the Art Students League in New York, and with J. Kelly Fitzpatrick and Boardman Robinson. In the 1950s, she taught art at Allison's Wells Art Colony in Way, Mississippi, and Millsaps College in Jackson.

Nungester, who became Mrs. Karl Wolfe, exhibited a poster design in Artists for Victory's war poster competition. She is responsible for murals at the St. Andrew's Episcopal Day School in Jackson, Mississippi, the Jacksonian Highway Hotel, and the Stevens Department Store in Richton, Mississippi. She executed a mosaic depicting the Stations of the Cross for St. Richard's Catholic Church, also in Jackson.

Mildred Nungester exhibited from the 1930s through the 1950s with, among others, the Corcoran Gallery of Art, the Mississippi Art Association, the Birmingham Museum of Art, and the Alabama Art League and at the New York World's Fair (1939–40). The McDowell Gallery and the Alabama Art League awarded her prizes in 1935, 1938, and 1940. Her work is in the permanent collections of the Montgomery Museum of Fine Arts, the Municipal Art Gallery, Jackson, Mississippi State College and the Alabama Polytechnic Institute.

Sources

Who's Who in American Art: 1937, 1953, 1962.

Seymour Nydorf
(b. 1914)

Lithograph: *Today, Europe;—Tomorrow, the World . . .*

Seymour Nydorf was born in Brooklyn, New York, on June 28, 1914. He studied printmaking at the Art Students League with Will Barnet. At the time of the "America in the War" competition, he was employed by the O.S.S. in Washington, D.C., as a graphic artist and designer. He later went overseas to the China-Burma-India war theater.

Nydorf, while stationed in Washington, D.C., helped the chairman of the art department at Howard University, Lessene Wells, to reconstitute an unused lithography press. He ordered stones from New York and made prints, including his entry to Artists for Victory, at Howard University.

After World War II, Nydorf's career moved in the direction of advertising art and design. He returned to New York City to work in this field and in 1949 his projected scheme for a butcher shop was featured in

Interiors magazine's ninth annual collection of "Interiors to Come." Part of his design was a mural, *From Farm to You,* added as an instructive as well as a decorative touch.

Seymour Nydorf has shown in a number of group exhibitions, with the Audobon Artists (who awarded him a prize), the National Academy of Design, and the American Watercolor Society. In 1966, he had a one-man exhibit of oil paintings in New York City. In recent years, Nydorf has returned to printmaking, concentrating on intaglio work and collography, the application of collage methods to graphics.

Sources

B.R. "Interiors to Come—Seymour Nydorf. Design Catches Up with the Butcher Shop." *Interiors* 108 (January 1949): 111–13.

Phil Herschel Paradise

(b. 1905)

Lithograph: *Inductees*

Phil Paradise was born in Ontario, Oregon, on August 26, 1905. He studied at the Chouinard Art Institute in Los Angeles with F. Tolles Chamberlain, Clarence Hinckle, Leon Kroll, Rico Lebrun, and David Alfaro Siqueiros. Beginning in 1931, Paradise himself taught at Chouinard, becoming its director, 1936–40. Later, in the 1950s, he taught at Scripps College, the California College of Arts and Crafts, and the University of Texas, El Paso. He has also served as director of the Gerry Peirce Watercolor School in Tucson, Arizona (1952–53).

Paradise first became interested in the medium of silkscreen when, as a teenager, he worked in a sign shop in Bakersfield, California. He paid for his tuition as a student at Chouinard by doing commercial lettering. In 1929, he designed and built his own intaglio press. Six years later, while living in Uruapan, State of Michoacan, Mexico, for five months, he began to approach serigraphy from a fine art, rather than commercial, point of view, because he did not have intaglio equipment available. In the period immediately preceding World War II, a number of his works were purchased by the Section of Painting and Sculpture of the U.S. Treasury Department.

From 1941 to 1948, Phil Paradise worked as a motion picture art director and production designer for Sol Lesser Productions, a division of Paramount Studios. During the war, he made propaganda posters for the American Red Cross. With James H. Patrick, one of the teachers on his staff when he directed Chouinard (and fellow participant in "America in the War"), Paradise built models for protective concealment, eventually leading to an appointment as chief camoufleur for the United Office of Civilian Defense. Under the auspices of this organization, Paradise and Patrick prepared a manual for the camouflage training of bombardiers and worked out a plan for the aerial concealment of the entire Pacific coast. During this period, Paradise also did editorial illustrations for *Fortune, True,* and *Westways* magazines. He served as president of the California Watercolor Society, 1939–40.

Phil Paradise has participated in numerous group exhibitions during his career, including many at which he was given prizes. These include, among others, the Los Angeles County Fair (1935 and 1937), the Philadelphia Watercolor Club (1943), the Pennsylvania Academy of the Fine Arts (1941), and the San Diego Fine Arts Association (1940). His lithograph *Inductees,* depicting the entry of new recruits into an army camp, was awarded third prize in the planographic division of the "America in the War" competition. He also won an award from the Pepsi-Cola Company in 1945.

Paradise has had a number of one-man shows, for example, at the Los Angeles County Museum in 1941. His work may be seen in the permanent collections of such institutions as the San Diego Museum, the Carville Marine Hospital in Louisiana, Kansas State University, and Cornell University. Primarily a painter and printmaker, Phil Paradise also worked in ceramics in the 1940s and for a time in the mid-1960s turned his concentration to sculpture. He worked with a blowtorch on metal salvage, as well as making bronzes with the lost wax method.

Sources

"In the Watercolor Group Phil Paradise Won the First Prize of $200 for His *Orchard* at Exhibition of Contemporary California Paintings at the Golden Gate." *San Francisco Art Association Bulletin* 7 (August 1940): 5.

"Virginia Paradise and Her Husband, Painter Phil Paradise, Are Collaborating Ceramists, Signing Their Work 'Ginia.'" *House Beautiful* 83 (November 1941): 82.

Penney, Janice. "California Artists and the War." *American Artist* 7 (November 1943): 32, 34.

Phil Paradise. An Exhibition of Paintings at the Los Angeles County Museum. Los Angeles, October 1941.

Johnson, Beverly. "Phil Paradise and His Works." *Los Angeles Times Home Magazine* (1967).

Lovos, Janice. "The Serigraphs of Phil Paradise." *American Artist* 33 (October 1969): 43–48, 81–82.

Fig. 25
Inductees

Phil Herschel Paradise, b. 1905

Lithograph, not dated
(19.5 x 37.2 cm)
18/50, signed in pencil
Printed by Paul Roeber

XX P222 A4
Fine Prints Collection
Prints and Photographs Division
Library of Congress

Harold Persico Paris
(b. 1925)
Colored woodcut: *They Suffer Too*

Harold Persico Paris, the youngest artist to exhibit in "America in the War," was born in Edgemere, New York, in 1925. He studied print-making with Stanley William Hayter at Atelier 17 and also studied art at the Académie der bildenden Künste in Munich. Paris has been awarded two important grants to pursue his work, from the Tiffany Foundation (1948–50) and the Guggenheim Foundation (1953–55). At the time of his submission to Artists for Victory, Paris, only seventeen years old, lived in Brooklyn, New York. Later, in 1945, he worked in Germany as an illustrator for the armed services publication *Stars and Stripes* and saw firsthand the horrors of the Nazi death camps. From 1954 to 1959 he lived in France. Most of his mature career has been pursued in Berkeley, California, where he moved to take a faculty position at the University of California in 1960.

Harold Paris had a number of one-man print exhibitions in New York City in the early 1950s, including one at the Argent Gallery and one at the Village Art Center in Greenwich Village. At the time, he was experimenting with making prints from lucite plates. Paris, however, is primarily known as a sculptor, and his name is usually linked with the Funk Art movement indigenous to California in the 1960s. With art historian Peter Selz, Paris wrote a seminal article, "Sweet Land of Funk," for *Art in America* in 1967.

The designation "Funk Art" had its etymology in a type of jazz characterized by mellowness and improvisation. In the art of Californians it frequently involves a mocking, paradoxical, Surrealistic, and antiaesthetic attitude, often deliberately emphasizing the ugly and whimsically grotesque. Paris's enigmatic Souls series, in which small objects cast in silicon, and sometimes painted phosphorescently, are enclosed in lit chambers of plexiglas, is an example of his approach to Funk. Much of the work of this and subsequent series seems to be preoccupied with death and suffering, as a result of his wartime experience in Europe. An exhibition at the Jewish Museum in New York City in 1976, "Kaddish for the Little Children," is another example of this facet of his sensibility.

Numerous one-man exhibitions of Harold Paris's sculpture have been mounted in California and elsewhere in the United States. His most recent print exhibition took place in 1970 at the Berkeley Art Center, where twenty-five years of his graphic career were surveyed. In 1972, Paris had a ten-year retrospective at the University Art Museum, Berkeley, entitled "Harold Paris: The California Years." This exhibition, which traveled throughout the nation in 1973, occasioned a number of important publications on his art.

His work may be seen in many major collections. A partial list would include the Museum of Modern Art, the Whitney Museum of American Art, the Philadelphia Museum of Art, the National Gallery of Art, the Hirshhorn Museum and Sculpture Garden, the Art Institute of Chicago, and the San Francisco Museum of Modern Art.

Sources

"Lucite Plates for Making Black and White and Color Prints." *Pictures on Exhibit* 13 (April 1951): 54–55.

The Prints of Harold Paris. New York: Argent Galleries, April 2–22, 1951.

McNulty, Kneeland. "Hosannah: The Work of Harold Paris." *Artists Proof* 1 (1961): 12–17.

Selz, Peter, Kneeland McNulty, Lawrence Dinnean, and Herschel Chipp. *Harold Paris: The California Years.* Berkeley, California: University Art Museum, 1972.

Selz, Peter. "Harold Persico Paris: The California Years." *Art International* 16 (April 20, 1972): 42–44, 56–57.

"Harold Paris' Art Rocks U.C. Museum." *Oakland Tribune,* May 7, 1972.

Hersham, Lynn. "Harold Paris' Berkeley Years." *Artweek,* May 20, 1972.

Who's Who in American Art: 1966.

Fig. 26
They Suffer Too

Harold Persico Paris, b. 1925

Color woodcut, not dated
(28 x 20.5 cm)
Signed in pencil

XX P229 A1
Fine Prints Collection
Prints and Photographs Division
Library of Congress

James Hollins Patrick

(1911–1944)

Lithograph: *This Is Our Enemy*

James H. Patrick was born in Cranbrook, British Columbia, on September 14, 1911. He moved to Los Angeles, California, at the age of five, attending public schools there. He was graduated from Hollywood High School in 1929 and went on to Chouinard Art School on scholarship. He was graduated from there in 1931. He subsequently taught figure drawing, still life, and watercolor landscape painting at Chouinard. During his student years there, Patrick studied mural painting under the revolutionary Mexican artist David Alfaro Siqueiros and was one of the students who assisted Siqueiros in painting a mural for the patio of the school.

With Millard Sheets, Patrick later painted three large frescoes for the South Pasadena High School, and he helped Leo Katz execute two murals for the Frank Wiggins Trade School in Los Angeles. Before World War II, Patrick worked as color director for the Charles Mintz Studio (the cartoon division of Columbia Pictures, Corporation), and he also worked as color director of final release prints for Technicolor Studios. He served as president of the California Watercolor Society and was an active member of the Foundation of Western Art. He also became a cover designer and illustrator for *Westways* magazine.

With the outbreak of World War II, James H. Patrick devoted much time and effort to making propaganda posters. He and Paramount Studios artist Phil Paradise (also a contributor to "America in the War"), worked out ideas on protective concealment in their spare time. *American Artist* magazine noted that the technical division of the United Office of Civil Defense saw their efforts and, as a result, hired Patrick and Paradise as civilian camoufleurs for the U.S. Army Air Force Bombardier Training Squadron. They were assigned by the Western Defense Command to plan aerial camouflage for the Pacific coast. The two also taught camouflage detection and collaborated on an Air Force manual on that subject.

James Hollins Patrick died of tuberculosis in 1944, at age thirty-three. During his relatively short career, he won many awards, including a purchase prize from the Library of Congress the year before his death. He participated in group exhibitions at the Corcoran Gallery of Art, the Art Institute of Chicago, the Pennyslvania Academy of Fine Arts, the National Gallery of Art, the American Watercolor Society, the Riverside Museum, the Carnegie Institute, the San Diego Fine Arts Gallery, and the Los Angeles and San Francisco Museums. A memorial show of his works was held in October 1945 at the Biltmore Art Galleries in Los Angeles.

Sources

Penney, Janice. "California Artists and the War." *American Artist* 7 (November 1943): 32.

W. K. B. "Fine Arts—and the Bombardier." *Westways Magazine* (1943): 5.

Millier, Arthur. "James Patrick." In *James Patrick Memorial Exhibition.* Los Angeles: Biltmore Art Galleries, October 1945.

Fig. 27
This Is Our Enemy

James Hollins Patrick (1911–1944)

Lithograph, not dated (23 x 37.6 cm)
Signed in stone
Printed by P. Roeber

XX P314 B1
Fine Prints Collection
Prints and Photographs Division
Library of Congress

Martin Petersen

(1870–?)

Etching: *Victory Gardens*

Martin Petersen, a painter and etcher, was born in Denmark in 1870. He studied at the National Academy of Design in New York and at the time of the "America in the War" exhibition resided in West Englewood, New Jersey.

Petersen was awarded prizes for his art in the 1930s, 1940s, and 1950s from the National Academy of Design, the New York Watercolor Club, and the Library of Congress. In 1938, the Society of American Etchers gave him their Frederick Talcott Prize (best by a nonmember). After receiving that prize, Petersen joined the group. His work was included in "Arte Grafico del Hemisferio Occidental" in 1941 and he had a one-man exhibition at H.V. Allison & Co. in New York in April and May of 1942.

In the late 1930s and 1940s, Martin Petersen worked on the W.P.A. Fine Arts Project in New York. He exhibited at the New York World's Fair. Examples from his oeuvre can be seen in the Newark, New Jersey, Public Library and the Boston Museum of Fine Arts, as well as the Library of Congress.

Sources

American Art Today. New York, 1939.

Reese, Albert M. *American Prize Prints of the 20th Century.* New York: American Artists Group, 1949 (pp. 160, 252).

Who's Who in American Art: 1940–47, 1953.

Leonard Pytlak

(b. 1910)

Color silkscreen: *They Serve on All Fronts*

Leonard Pytlak was born in Newark, New Jersey, on March 3, 1910. He studied at the Newark School of Fine and Industrial Art and the Art Students League of New York. A painter as well as a printmaker, Pytlak executed a mural for the Greenpoint Hospital in Brooklyn under W.P.A. auspices in the 1930s. He also worked on the Graphic Section of the Fine Arts Project in New York in 1938, becoming part of its experimental silkscreen unit. In 1941, he was awarded a Guggenheim Fellowship to explore new techniques in color lithography and serigraphy, the latter a relatively new fine arts application of the silkscreen medium. During the 1940s, Pytlak served twice as a president of the National Serigraph Society.

Leonard Pytlak was one of the signers of a call to American artists to convene a congress in defense of culture against the rising tide of Fascism in 1941. The following year, he participated in the A.C.A. Gallery's "Artists in the War" exhibition, and one of his works was purchased by the Office of Emergency Management out of their competition to record defense and war activities. Pytlak won second prize in the serigraphy division of the "America in the War" competition for a print depicting the important job done by mobile medical surgery units on the war front.

In the 1940s, Leonard Pytlak had a number of one-man shows of his work, which included an exhibition at the A.C.A. Gallery in 1942, a joint showing with Harry Shokler at Kennedy & Company, and solos at the Weyhe Gallery in 1944, the Graphic Division of the U.S. National Museum, Smithsonian Institution, in 1948, and the Serigraph Gallery in 1949. Throughout his career, he has exhibited in a large number of group shows, winning awards from the Metropolitan Museum of Art, the Philadelphia Print Club, the Philadelphia Color Print Society, the Seattle Art Museum, the National Academy of Design, and the Library of Congress. He created the Print of the Year for the National Serigraph Society in 1960.

In another facet of his career, Leonard Pytlak has been teaching drawing, painting, and silkscreen for the past twenty years. During the 1960s, he conducted a private studio for handicapped students from the New York State Rehabilitation Department. Most recently, he has been an instructor for the Craft Students League of the YWCA on Lexington Avenue in New York City. The Craft Students League Gallery gave him a complete retrospective of fifty years of creative work in printmaking in May 1982.

Other examples of Pytlak's work may be seen in the permanent collections of the Metropolitan Museum of Art, the Carnegie Institute, the Denver Art Museum, the New York Public Library, the Philadelphia Museum of Art, the Museum of Modern Art, the Brooklyn Museum, the Boston Museum of Fine Arts, and others.

Sources

Silkscreen Prints by Pytlak. Foreword by Carl Zigrosser. New York: A.C.A. Gallery, May 10–22, 1942.

Lansford, Alonzo. "Pytlak Serigraphs." *Art Digest* 21 (December 1, 1946): 15.

Berryman, Florence S. "Serigraphs by Pytlak at National Museum Employ Rich Colors in Simple Treatments." *Sunday Star,* Washington, D.C., November 3, 1948, pp. 5–6.

Reese, Albert M. *American Prize Prints of the 20th Century.* New York: American Artists Group, 1949 (pp. 165, 252).

Recent Serigraphs by Leonard Pytlak. New York: Serigraph Gallery, October 17–November 12, 1949.

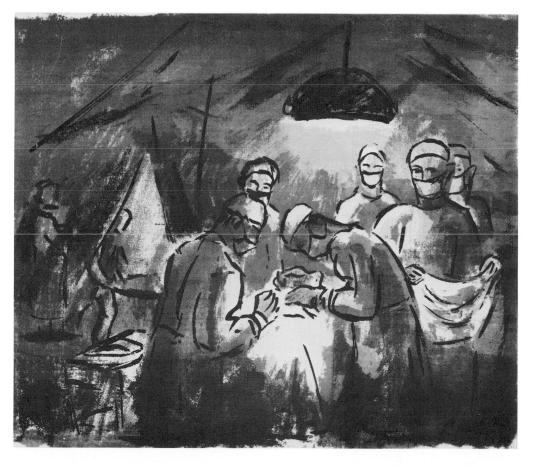

Fig. 28
They Serve on All Fronts

Leonard Pytlak, b. 1910

*Color silkscreen, not dated
(33.2 x 40.7 cm)
Signed in pencil*

*XX P999 B7
Fine Prints Collection
Prints and Photographs Division
Library of Congress*

Charles F. Quest

(b. 1904)

Woodcut: *Nearing the End*

Charles F. Quest was born in Troy, New York, on June 6, 1904. He pursued his art training at the Washington University School of Fine Arts in St. Louis from 1924 to 1929, and then he spent six months studying abroad. He returned to live in New York for a time, returning to St. Louis by 1944 to join the faculty of his alma mater. He retired from his professorship at Washington University in 1971.

During the war years, three of Quest's works were purchased by the Office of Emergency Management, as a result of its competition to record defense and war activities. His wood-engraving *Nearing the End* won honorable mention in the relief category of the Artists for Victory's "America in the War" exhibition. Although Quest had been making woodcuts since 1930, *Nearing the End* marked his first attempt at engraving an end-grain block. Quest has noted Goya and Daumier as strong influences on his work.

In addition to making prints, Charles Quest has also worked extensively as a painter, stone carver, sculptor, mosaicist, and stained-glass designer. He has been commissioned for a number of important murals, including the State of Missouri murals for the Chicago World's Fair in the 1930s, a mural for St. Mary's Church in Helena, Arkansas, and one for the Carpenter Branch Library in St. Louis. Two Episcopal churches in St. Louis gave him mural commissions (1934–35), and the Catholic Archbishop of that city asked him in 1959 to paint a replica of Diego Velasquez's *Crucifixion* of 1632–38 for the Old Cathedral. The preparation of this mural, completed in 1960, was featured in the *St. Louis Post-Dispatch* (Sunday magazine, September 18, 1960).

In 1951 Quest was invited by the cultural attaché of the U.S. Embassy in Paris to exhibit at the Petit Palais and then send his works on tour throughout France. Other touring exhibitions including Quest's work which were sent abroad were organized by the Boston Public Library, the Museum of Modern Art, the Philadelphia Print Club, and the U.S. Information Agency. Quest has exhibited in ninety-five museums and galleries throughout the world, winning fifty-three prizes and awards. He had his first one-man exhibition in Washington, D.C., in 1951, organized by the Division of Graphic Arts of the Smithsonian Institution.

A partial listing of other solo exhibitions of Quest's work includes the St. Louis City Art Museum; the Escuela Libre de Art y Galeria, Uruapan, Michoacan, Mexico; the St. Louis Artists Guild; the Springfield Museum of Art in Missouri; and the Mint Museum in Charlotte, North Carolina. The St. Louis Club, in St. Louis, Missouri, installed a permanent "Charles Quest Gallery" in 1968. Quest's work is in many other private and public collections in the United States, Paris, Israel, Stockholm, London, New Zealand, and Australia. Since his retirement, Charles F. Quest has lived in North Carolina. His most recent work continues to display a keen interest in social comment.

Sources

"Quest's Art Exhibit in Webster Groves." *St. Louis Post-Dispatch,* October 12, 1954.

"St. Louis Artist, Native Trojan, Will Revisit City." *Troy, N.Y., Record,* July 1, 1958.

McCue, George. "Replica of Famous Masterpiece for Old Cathedral." *St. Louis Post-Dispatch,* Sunday magazine, September 18, 1982, pp. 20–23.

Schweder, Mary. "In Quest of Humanistic Art." *Arts Journal* (March 1980): 23–24.

"Featured: Charles Quest." *Tryon* (N.C.) *Daily Bulletin,* March 11, 1980.

"The Last Peace Conference." *Tryon* (N.C.) *Daily Bulletin,* October 5, 1981.

Who's Who in America: 1952–81.

Who's Who in American Art: 1953–80.

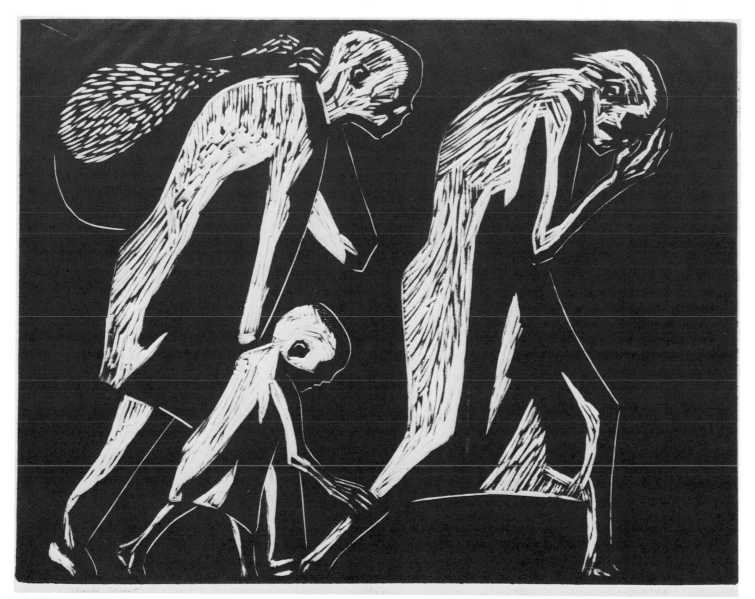

Fig. 29
Nearing the End

Charles F. Quest, b. 1904

Woodcut, 1943 (21.5 x 28 cm)
15/30, signed and dated in pencil

XX Q24 A1
Fine Prints Collection
Prints and Photographs Division
Library of Congress

Ruth Starr Rose

(1887–1965)

Lithograph: *I Couldn't Hear Nobody Pray*

Ruth Starr was born at Eau Claire, Wisconsin, on July 12, 1887. A graduate of the National Cathedral School in Washington, D.C., and Vassar College, she studied painting at the Art Students League in New York before marrying W. Searls Rose in 1914. After having several children, she returned to New York to study lithography in 1922. Some of Rose's teachers included Hayley Lever, Victoria Hutson Huntley, Harry Sternberg, and William Palmer.

As a young girl, Rose lived at Hope House, a historic fifty-room eighteenth-century mansion on the Eastern Shore of the Chesapeake Bay, near Easton, Maryland. Her lifelong love of sailing (she owned the famous cup-winning yacht *Belle McCrane*) and her concentration on the life, character, and spirituals of the Negro in her art, date to this formative period. Her contribution to "America in the War," *I Couldn't Hear Nobody Pray,* which depicts a black soldier with a walkie-talkie watching parachuters come down on a tropical island, reflects her predominant interests. Rose also exhibited in the A.C.A. Gallery's June 1942 "Artists in the War" exhibition a piece depicting war workers in Maryland.

Ruth Starr Rose has been included in a number of group shows throughout her career. Some of these were held at the National Academy of Design, the National Color Print Society, the Library of Congress, the Northwest Printmakers, and the National Association of Women Artists. She won awards for her art from the last and from the State of New Jersey, the Washington Area Printmakers, the Corcoran Gallery of Art, the New York Council of Art, Science, and Professions, the Virginia Printmakers, and the 1958 Religious Art Fair.

A resident of Alexandria, Virginia, by the 1950s, Ruth Starr Rose had a one-woman show there in 1952 at the Playhouse Art Gallery. This show was arranged by Prentiss Taylor, chairman of the gallery committee and another of the artists in "America in the War." Another show devoted solely to Rose's work was held in 1955 at the Dupont Theater Gallery in Washington, D.C. Howard University gave her a solo exhibition in 1956, and the George Washington University Library held a similar show of Rose's works the following year.

In the fifties, Rose was also asked to paint a mural for a chapel of the African Methodist Church in Copperville, Maryland. Her decoration was inspired by the Negro spiritual "Pharoah's Army Got Drownded." Rose's paintings and prints can be found in the permanent collections of the Metropolitan Museum of Art, Vassar College, the Philadelphia Museum of Art, Wells College, Williams College, Milliken College, Howard University, and the Norfolk Museum of Arts and Sciences in Virginia.

Sources

Original Etchings, Lithographs and Woodcuts Published by the American Artists Group Inc. Comment by Carl Zigrosser. New York, 1937 (p. 42).

"Noted Eastern Shore Artist Gives Four Paintings to Howard U." *Sunday Star,* Washington, D.C., May 17, 1942.

"Lyrical Lithographs." *Washington Star,* February 3, 1952.

"Rose at Mart." *Washington Star,* May 1955.

"Ruth Starr Rose Dead; Painter, Lithographer." *Washington Post,* October 26, 1965, p. 134.

Collins, J. L. *Women Artists in America, 18th Century to the Present.* Chattanooga: University of Tennessee, 1973.

Who's Who in American Art: 1937, 1953.

Karl Schrag

(b. 1912)

Etching and aquatint: *Persecution*

Karl Schrag was born on December 7, 1912, in Karlsruhe on Rhine, Germany, of a German father and an American mother. He was graduated from the Humanistisches Gymnasium. When his family moved to Switzerland in 1930, he studied in Zurich and at the Ecole des beaux arts in Geneva. In 1932, he went to Paris and took classes as the Ecole nationale supérieure des beaux arts, the Grande Chaumière, the Acadèmie Ranson (studying primarily with Roger Bissiere), and in the atelier of Lucien Simon.

In 1935, Karl Schrag went to live in Brussels, Belguim, and had his first one-man show there, at the Galerie Arensberg, in 1938. Soon after, with Hitler's invasion of the countries surrounding Germany, Schrag emigrated to the United States. In this country, he studied printmaking at the Art Students League of New York with Harry Sternberg. Although he had made his first print (a linoleum cut) at the age of fourteen, it was the experience with Sternberg that really activated this interest and, in 1939, his first showing in the United States was with the Society of American Etchers. Schrag's first one-man exhibition of paintings did not take place until 1947, at the Kraushaar Gallery. This was the beginning of a long series of solo exhibitions with that dealer.

In 1941, Karl Schrag did eighteen aquatints as illustrations for a deluxe version of Robert Louis Stevenson's *The Suicide Club,* published in a limited edition by Pierre Bères. This book was later chosen by the American Institute of Graphic Arts as one of the two hundred finest books published in a ten-year period. In the early 1940s, Schrag's work was, however, primarily concerned with social problems, and especially with the war in Europe. His *To Hell with Hitler* was singled out by critics when shown at the Philadelphia Print Club in 1942. In 1940 Schrag made *Persecution* (also called *Ecce Homo*), which he submitted a few years later to Artists for Victory. After the "America in the War" exhibition opened, he wrote a letter to the editor of *Art News,* which was published in November 1943, citing the exhibition as proof that, in his belief, "the graphic arts can be like a magic mirror in which the essence of time is reflected," more so than painting or sculpture. Schrag's prints of wartime subject matter were shown in a group at his one-man exhibition organized by the Division of Graphic Arts of the Smithsonian Institution in 1945.

The year previous, Karl Schrag had met Stanley William Hayter and had become associated with Atelier 17. This experience was catalytic for him, resulting in a change of focus. He moved away from social realism and toward a mystical interest in nature and a calligraphic linear style, similar to Oriental art. When Hayter returned to Europe after World War II, Schrag became director of Atelier 17 (1950–51). In the early fifties, Schrag also began teaching at Brooklyn College (1953–54) and the Cooper Union (where he stayed on the faculty until 1968).

Karl Schrag had a number of solo showings in the 1950s, not only in New York and other locations in the United States but also in Germany. A traveling retrospective of his work was organized as a result of a Ford Foundation grant in 1960, and a comprehensive retrospective of his prints since 1939 was held at the National Collection of Fine Arts in 1972. A catalogue raisonné of his graphic oeuvre was published in two parts by Syracuse University, in 1971 and 1980.

Other important awards won by Schrag for his art include two from the Brooklyn Museum, two from the Society of American Graphic Artists, one at the Fourth International Exhibition of Contemporary Art in New Delhi, India (1962), a Ford Fellowship at the Tamarind Workshop (1962), and a grant from the American Academy of Arts and Letters, given in 1966. Schrag has published a number of articles on printmaking and a portfolio of eighteen works, *By the Sea* (1965–66), and he has been featured in a film, *Printmakers U.S.A.,* produced by the U.S. Information Agency in 1961. His work may be seen in such collections as the Solomon R. Guggenheim Museum, the Hirshhorn Museum and Sculpture Garden, the National Museum of American Art, the Victoria and Albert Museum in London, and the Everson Museum of Art, Syracuse University.

Sources

Mellow, James R. "Schrag Exhibition at the Smithsonian." *Art News* 44 (November 1, 1945): 8.

Reed, Judith Kaye. "Subjective Schrag." *Art Digest* 24 (March 1, 1950): 14.

Burrey, Suzanne. "Karl Schrag: Movement Above and Below." *Arts Magazine* 30 (June 1956): 36–40.

Young, Vernon. "The Double Craft—Two American Painter-Printmakers (Peterdi and Schrag)." *Kunst Copenhagen* 1 (1958): 15–17.

Gordon, John. *Karl Schrag.* New York: American Federation of Arts, 1960.

Schrag, Karl. "Happiness and Torment of Printmaking." *Artist's Proof* 6, no. 9–10 (1966): 62–65.

Detailed Information Relating to Karl Schrag's Career as a Contemporary American Artist. Mountainville, N.Y.: Storm King Art Center, 1967.

Karl Schrag. A Catalogue Raisonné of the Graphic Works. Syracuse, N.Y.: College of Visual and Performing Arts, Syracuse University. Part I with a commentary by Una E. Johnson, 1972. Part II with a commentary by August E. Freundlich, 1980.

Cochran, Diane. "Karl Schrag: On Landscape." *American Artist* 40 (November 1976): 50–57, 93–95.

Schrag, Karl. "Light and Darkness in Contemporary Printmaking." *Print Review* 7 (1977).

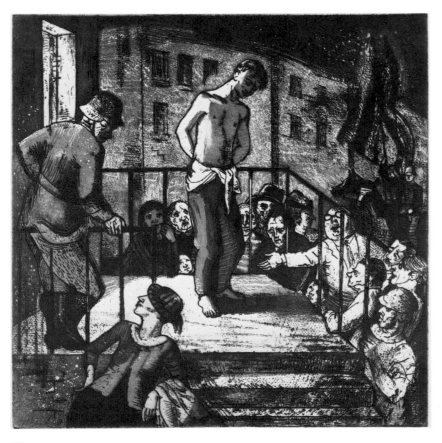

Fig. 30

Persecution

Karl Schrag, b. 1912

*Etching and aquatint, not dated
(30.4 x 30.4 cm)
Edition of 75*

"The work is one of the deeply etched, dark aquatint etchings with themes which are like somber meditations on those years. Persecution *shows symbolically both what America was fighting for and what it was fighting against. The isolated, dignified figure being shown to the ugly, almost monstrous crowd by the German soldier with the steel helmet represented to me everything of moral and spiritual value that had to be saved from total destruction. The print was also to give the assurance that in the end the spiritual strength of the victim would prevail— that all these surrounding criminal and vulgar powers could not succeed.*

"In some way I identified with that central figure. I was born and raised in Germany as the son of an American mother and a German father. In 1938, fearing war and the invasion of the countries adjoining Germany by the Nazi armies, I had left Belgium for America—to get away from persecution and the danger of death and seeking freedom for my faith and convictions." (Karl Schrag to Ellen G. Landau, March 14, 1982)

*XX S377 B2
Fine Prints Collection
Prints and Photographs Division
Library of Congress*

Mara Malliczky Schroetter
(dates unknown)
Wood engraving: *Worker and Soldier*

Mara Malliczky Schroetter was a printmaker active in the Chicago, Illinois, area at the time of her submission to the "America in the War" exhibition.

William Sharp
(1900–1961)
Etching and aquatint: *The New Order*

William Sharp was born June 13, 1900, in Lemburg, Austria. He studied there, in Cracow, Poland, and in England, France, and Germany (at the art academies in Munich and Berlin, 1918–20). During World War I, he served as a machine gunner for Germany on the Russian war front.

After the First World War, Sharp became a newspaper artist in Berlin. Increasingly, he criticized the rising National Socialist movement through his drawings. He even submitted pseudonymous drawings to anti-Nazi publications, which put him in great danger. When found out, he was threatened with being sent to a concentration camp, whereupon he fled to the United States (1934).

Working in this country as an illustrator, Sharp contributed drawings to the *New York Mirror,* the *New York Post, Life,* the *New York Times Magazine,* and *Coronet.* He worked on the artistic staffs of *Esquire* and *PM.* During his newspaper career, Sharp had many interesting assignments, not the least of which was covering the trial of Bruno Richard Hauptmann, accused of kidnapping the Charles Lindbergh baby. Sharp illustrated ten volumes for the Limited Editions Club, including such books as *The Diary of Samuel Pepys* and *The Brothers Karamazov.* Other publishers for whom he drew include the Illustrated Modern Library of Random House and the Heritage Press.

Early in his career, while still in Germany, William Sharp did a series of lithographs satirizing the German law courts. He repeated this Daumieresque idea in the United States, producing in 1937 twelve lithographs for a series based on his experiences as a news illustrator in the New York Supreme Court. These works, grouped under the title "The Administration of Justice," were shown at the Kennedy Galleries in New York. Other caricature series produced by Sharp in the 1930s include humorous looks at doctors, dentists, and the broadcasting profession.

After 1938 William Sharp began to devote more time to etching and aqautint, as opposed to lithography. Pathos and deeply felt sympathy for the socially deprived replaced biting satire as his main theme in the early 1940s. Sharp won second prize in the intaglio category of the "America in the War" competition for a work which exhibits this type of theme.

William Sharp, who won many prizes for his art throughout his career, had one-man exhibitions at the Weyhe Gallery, the PM Gallery, and Kennedy & Company, all in New York City. He also exhibited etchings and aquatints on the theme of Don Quixote and Sancho Panza at Knoedler's in the early 1940s. Sharp won a Joseph Pennell purchase prize at the Library of Congress in 1944 for one of the prints from this twenty-plate series. Examples of his work are in the permanent collections of the Library of Congress, the New York Public Library, the Art Institute of Chicago, the Carnegie Institute, and the Metropolitan Museum of Art. The Graham Gallery in New York gave him a posthumous show in 1972.

Sources

The Administration of Justice: Twelve Lithographs by William Sharp. New York: Kennedy and Company, 1937.

Devree, Howard. [Review of the Kennedy Exhibition]. *New York Times,* April 15, 1937.

"Life in the U.S. Courtroom: Lithographs by William Sharp." *Scribner's,* June 1937, pp. 49 ff.

Zigrosser, Carl. "William Sharp." *PM, an Intimate Journal for Production Managers* (February/March 1940): 16 pp. insert.

William Sharp: Etchings, Aquatints and Lithographs. Essay by Carl Zigrosser. New York: PM Gallery, January 12–February 5, 1940.

Reese, Albert M. *American Prize Prints of the 20th Century.* New York: American Artists Group, 1949 (pp. 183, 254).

"William Sharp, Illustrator, Dies; Magazine and Newspaper Critic." *New York Times,* April 2, 1961.

William Sharp. Comment by Daniel Schwarz. New York: Graham Gallery, February 5–26, 1972.

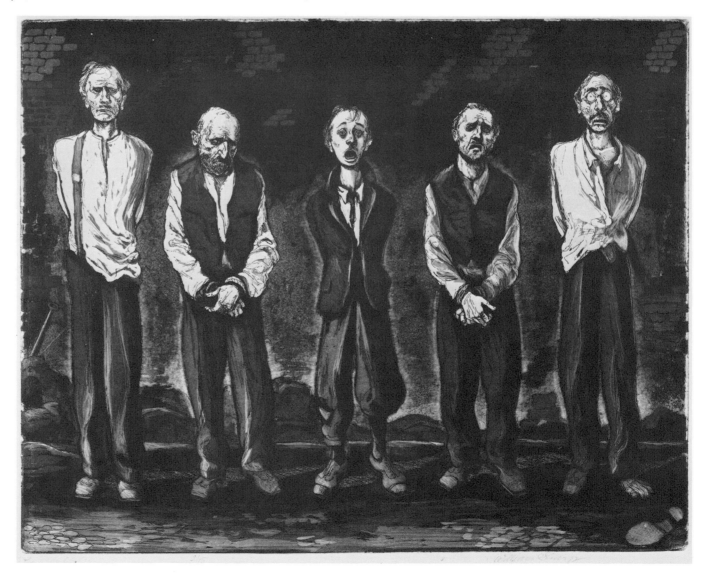

Fig. 31
The New Order

William Sharp (1900–1961)

*Etching and aquatint, not dated
(19.7 x 25.1 cm)
2/15, signed in pencil*

*XX S532 A2
Fine Prints Collection
Prints and Photographs Division
Library of Congress*

Harry Shokler

(1896–1978)

Color silkscreen: *Air Raid Drill*

Harry Shokler was born in Cincinnati, Ohio, on April 25, 1896. Rejecting a career in his father's fur business, he studied art at the Cincinnati Art Academy, the summer school of the Pennsylvania Academy of the Fine Arts, and the New York School of Fine and Applied Art. During World War I, Shokler served with the American Expeditionary Forces overseas. In the 1920s he painted academic portraits of such notable figures as Babe Ruth and Ty Cobb.

Harry Shokler was awarded a Freiburg Traveling Scholarship in 1929, which he used to go to Paris and take classes at the Académie Colorossi. He also traveled extensively on this trip abroad. First, he went to Concarneau on the Brittany coast, where he came under the liberating influence of the landscapes of resident artist Jerome Blum. Shokler painted, for a time, on the Côte d'Azur, and then lived for a year in Kairouan, Tunisia, where he met his wife, the only American in residence there. Shokler also visited Italy and Germany, returning finally to Paris where he had a one-man exhibition of paintings at the Galerie de Marsan.

Harry Shokler had over fifty solo exhibitions throughout his career, including shows at the Fifteen Gallery, the Schneider-Gabriel Galleries, the Grand Central Art Galleries, the Serigraph Galleries, and Kennedy & Company in New York City, as well as the Baltimore Museum of Art, the Syracuse Museum of Fine Arts, the Princeton Print Club, and the Traxel Galleries in Cincinnati. Shokler had six one-man shows at the Southern Vermont Art Center.

During the early years of the depression, Harry Shokler worked on the Public Works of Art Project, predecessor of the W.P.A. He was a member of the experimental silkscreen group which founded the Workshop School on East 10th Street in 1940. Beginning in 1934 he and his wife would spend part of the year near Londonderry, Vermont, where he taught oil painting for the Southern Vermont artists and became a fellow of the MacDowell Colony in Peterborough, New Hampshire.

In 1942, Harry Shokler participated in the A.C.A. Gallery's "Artists in the War" exhibition and in 1943 he had a joint showing with Leonard Pytlak, another of the artists in "America in the War." The following year, the International Print Society commissioned a special edition of prints by Shokler, and in 1946 Shokler wrote the *Artists' Manual for Silkscreen Printmaking,* which was published by the American Artists Group. Shokler lectured extensively on serigraphy and taught it at Princeton University and Columbia University, among others.

Harry Shokler won many awards for his art over the years and exhibited in numerous group shows all over the United States. While in Europe early in his career, he showed in the Paris Salon. Examples of his work are part of the permanent collections of the Metropolitan Museum of Art, the Philadelphia Museum of Art, the Carnegie Institute, the Library of Congress, the Syracuse Museum, the Newark Museum, the Cincinnati Public Library, the Princeton Print Club, the Munson-Williams-Proctor Institute, and the Dayton Art Institute.

Sources

"Paintings on View at the Schneider-Gabriel." *Pictures on Exhibit* 2 (January 1939): 11, 33.

"Late Afternoon (Silkscreen Print)." *Pictures on Exhibit* 4 (March 1941): 25–26.

Paintings and Silkscreen Prints by Harry Shokler. Essay by Anthony Volonis. New York: Schneider-Gabriel Galleries, March 17–29, 1941.

"Exhibit by Harry Shokler." *Syracuse Museum Quarterly Bulletin* (April–June 1943).

"Heights Can't Resist Print of Penny Bridge." *Brooklyn Eagle,* February 28, 1947, p. 15.

Reese, Albert M. *American Prize Prints of the 20th Century.* New York: American Artists Group, 1949 (pp. 185, 254).

Namsfield, Ruth. "Vermont Artist Swaps Art for Materials to Build His Studio." *Boston Sunday Post,* June 26, 1949, p. 40.

Harry Shokler Retrospective Exhibition of Paintings and Serigraphs 1920–1971. Essay by Dahris Martin Shokler. Manchester, Vt.: Southern Vermont Art Center, July 15–30, 1972.

Henry Simon

(b. 1901)

Lithograph: *The Three Horsemen*

Henry Simon was born November 10, 1901, in Poland. He came to the United States in 1906, settling in Chicago, Illinois, and he became a naturalized American citizen twenty years later. Simon, a painter, printmaker, muralist, photographer, and designer of electric signs, received his art training at the school of the Art Institute of Chicago.

From 1927 to 1934 Henry Simon painted theatrical posters and stage sets for Chicago theater groups. From 1938 to 1942, he worked on the Illinois Federal Art Project of the W.P.A., in both the mural and easel divisions. During the Spanish Civil War, he contributed drawings to *New Masses* magazine, and he had his first one-man exhibition of lithographs at the Weyhe Gallery in New York in 1939, a showing selected by Carl Zigrosser. That same year Simon installed two murals made under W.P.A. auspices in the Cook County Hospital.

In the early 1940s Simon won several mural commissions, which resulted in decorations for the Liberty Ship, U.S.S. *Hayes* (1941), and the Treasury Department Section of Painting and Sculpture-sponsored wall designs for post offices in Osborne, Ohio (1941), and DeQueen, Arkansas (1942). Also in 1942, under Illinois W.P.A. project sponsorship, he painted two tempera-on-gesso panels for McKenry College, which are now in the Wells High School in Chicago.

From 1944 to 1945 Henry Simon served as art director for the Hull House in Chicago. In the mid-fifties he began his career as an electric sign designer, which lasted until 1971. For reference material in this new career, he began photographing existing neon signs. This led to his decision to take pictures of street scenes and people to use in his paintings. By 1963, when he attended photography classes at the Horwich Community Center in Chicago, he began to develop his interest in photography as an art form, not just as a visual aid. In 1973 he had his first one-man show of photographs at the Chicago Art Institute. It comprised shots of Chicago scenes with particular concentration on store window mannequins and merchandise fused with their reflections to achieve abstract effects.

Throughout his career, Henry Simon has exhibited his paintings and prints in many group presentations. Some of these have been sponsored by the Art Institute of Chicago, the Weyhe Gallery, the American Federation of Arts, the International Print Society, and the Spertus Museum of Judaica. In 1942 he exhibited a lithograph in the large Artists for Victory exhibition at the Metropolitan Museum of Art. His awards have included two honorable mentions (in addition to his commissions) from the U.S. Treasury Department and three recent prizes, given in 1981–82, from the Jewish American Art Club. After a Surrealist period in the 1960s, Simon's most recent work, done in oil, pastel, and mixed media, is abstract.

Sources

Davey, Alice Bradley. [Review]. *Chicago Sun,* June 11, 1942.

Haydon, Harold. [Review of Chicago Art Institute photography exhibition]. *Chicago Sun Times,* March 30, 1973.

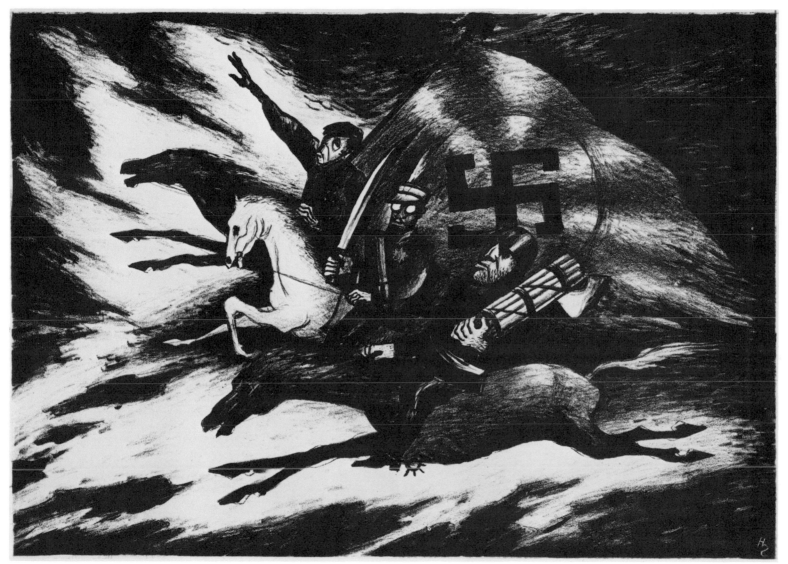

Fig. 32
The Three Horsemen

Henry Simon, b. 1901

Lithograph, not dated
(22.4 x 32.7 cm)
Signed with initials on stone, signed
in pencil

"The Three Horsemen *was inspired
by the four horsemen of the Apoca-
lypse who ride roughshod over the
land spreading death and destruc-
tion. The three horsemen in the litho-
graph are Hitler, Hirohito, and Musso-
lini. The symbol of the swastika
applies to all three. The Japanese
emperor is . . . used as a symbol of the
militaristic Japan of the Second
World War. Hitler's raised arm is the
'Heil Hitler' used by his followers as a
salute. Mussolini carries a symbol of
the Old Roman Empire."* (Henry
Simon to Ellen G. Landau, May 10,
1982)

Gift of the Artist
XX S5945 A1
Fine Prints Collection
Prints and Photographs Division
Library of Congress

103

Burr Singer
(b. 1912)
Lithograph: *Letters from Home*

Burr Singer was born in St. Louis, Missouri, on November 20, 1912. She has lived in Los Angeles, California, for most of her life, however. She studied at the St. Louis School of Fine Arts, the Art Institute of Chicago, the Art Students League in New York, and with Walter Ufer in Taos, New Mexico.

Singer is well-known in the Los Angeles area as a portraitist, and her commissions include paintings of Dr. Reiss and Dr. Davis, for the Reiss-Davis Clinic for Child Guidance in Los Angeles. During World War II, she worked as a volunteer sketch artist for the Hollywood U.S.O., doing pastel and charcoal portraits of servicemen, an experience which contributed to the idea for the print she submitted to the "America in the War" exhibition, depicting lonesome sailors reading letters from home.

Burr Singer's first solo exhibition was held at the Chabot Gallery, Los Angeles, in 1949. Since then, she has had more than twenty-five such shows, primarily at the Esther Robles Gallery, the Café Galleria, the Comara Gallery, and the Kramer Gallery, all in her home city, as well as one at the San Francisco Museum of Art.

Singer taught painting and drawing for twenty-five years and has won many prizes in group shows all over the country. She exhibited in both the New York and San Francisco World's Fairs. In 1972, Singer accompanied her husband, Harry I. Friedman, to Costa Rica, where she lived and painted for fourteen months. Examples of her work may be seen at the Warren Flynn School in Clayton, Missouri, the Beverly-Fairfax Jewish Community Center, and the Eaton Paper Collection, as well as at the Library of Congress. Her current work is primarily in watercolor and mixed media.

Sources

"Area Artist Burr Singer Will Move to Costa Rica." *Northwest Leader,* May 18, 1972.

Collins, J. L. *Women Artists in America, 18th Century to the Present.* Chattanooga: University of Tennessee, 1973.

Who's Who of American Women: 1958, 1961, 1964.

Who's Who in American Art: 1940 through the 1970s.

William Soles
(b. 1914)
Woodcut: *The Freedoms Conquer*

William Soles, a sculptor, teacher, and craftsman as well as a printmaker, was born in New York City on April 20, 1914. He studied at the Art Students League and with sculptor Alfeo Faggi. During the depression, Soles worked in the Graphic Arts Division of the W.P.A. Fine Arts Project in New York. By 1947, however, Soles had turned his attention primarily to sculpture.

Among the awards won by William Soles for his art are a St. Gaudens medal and the Keith Memorial Prize from the Woodstock Art Association, as well as second prize in the relief category of the "America in the War" competition. He once stated of his entry, *The Freedoms Conquer,* that he had tried to translate into graphic terms his feelings about the war as conflict. Soles believed strongly that a work of art should encompass some idea and be more than merely decorative (letter to Albert M. Reese, Archives of American Art, Washington, D.C.).

William Soles has shown in many group exhibitions, for example, at the Metropolitan Museum of Art, the Weyhe Gallery, Kennedy & Company, the Philadelphia Museum of Art, and the Library of Congress (in a Pennell memorial show). He had moved from New York City out to the active artists' colony in East Hampton, Long Island, by the mid-1960s, and has participated in numerous shows in that area at the Sigma Gallery, Guild Hall, the Southampton Gallery, and the Parrish Art Museum. Soles has been called upon to execute a number of ceramic murals for private homes. Another example of his prints is in the collection of the New York Public Library.

Sources

Reese, Albert M. *American Prize Prints of the 20th Century.* New York: American Artists Group, 1949 (pp. 190, 255).

Who's Who in American Art: 1966.

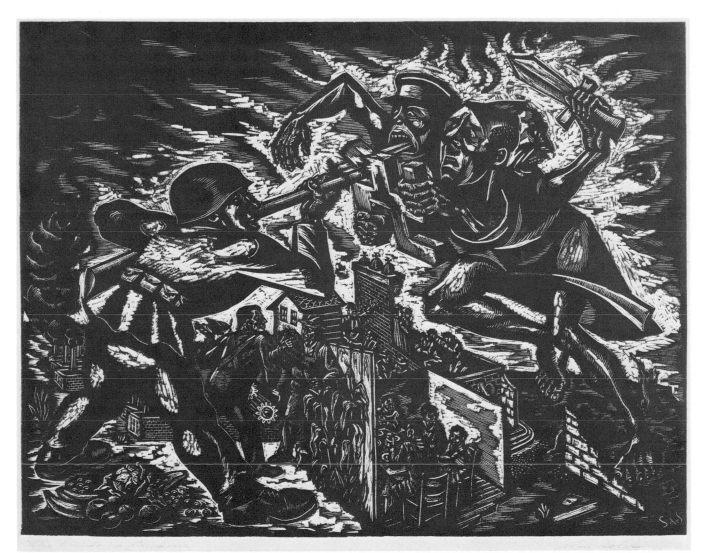

Fig. 33
The Freedoms Conquer

William Soles, b. 1914

Woodcut, not dated (23 x 30.4 cm)
Signed on block, signed in pencil

"Like everyone during the war, I was much concerned about its outcome, and our aims in it. Consequently, my prints of that period reflected that concern, and The Freedoms Conquer *was one of that group. I do not believe that one print can do very much, but it adds to the force of a belief if many artists battle away at an idea.*

"Of course, ideas, aims, and hopes alone do not make a good print. My feeling about the war as conflict I tried to translate into graphic terms, opposing black against white, form against form, diagonals piercing the dignity of verticals, destroying the peace of horizontals."

Moses Soyer

(1899–1974)

Lithograph: *War Workers*

Moses Soyer was born Moses Schoar on December 25, 1899, in Borisoglebsk, Government of Tambov, Russia. His twin brother, Raphael, and younger brother, Isaac, also became artists. All three were first exposed to art at the Tretiakoff Gallery in Russia in 1910 and were taught to draw by their father. Abraham Schoar was a Hebrew teacher and the liberal intellectual leader of their small Jewish community. In 1912 Abraham Schoar was ordered to leave Russia, and the family emigrated first to Philadelphia and then to the Bronx, in New York, where they settled.

The Soyer brothers were encouraged to draw and paint at home and often competed with one another. Moses and Raphael attended the Cooper Union and the National Academy of Design. Because their styles were so similar, they eventually decided to switch to different art schools. Moses then studied at the Beaux Arts Institute of Design and the Educational Alliance, whereas Raphael continued his art education at the Art Students League.

Around 1920, Moses Soyer discovered the weekend sketch classes at the Ferrer Club in Spanish Harlem. There he met George Bellows and Robert Henri, who criticized his work for him. Henri introduced Soyer to a lithograph by Daumier, in the *Liberator,* which was to have a profound effect on his art. Moses Soyer eventually specialized in the same kind of sad-eyed, psychologically soulful portraits that he saw in Daumier. *War Workers,* his entry to "America in the War," is evidence of this.

In 1926 Moses Soyer participated in his first group show, at J.B. Neumann's New Art Circle. The following year Neumann gave him his first one-man exhibition. In the 1920s, Moses Soyer also began his career as a teacher of art. He taught on the faculties of the Educational Alliance, the Contemporary School of Art, and the New School for Social Research. Later, in 1941, he would become director of the New Art School, which he and his brothers founded.

In the 1930s, Moses Soyer worked for the Public Works of Art Project and the Fine Arts Project of the W.P.A. He painted murals, under government auspices, for the Greenpoint Hospital in Brooklyn and the Municipal Building in New York City. He and his brother Raphael painted a set of complementary panels for the Kingsessing post office in Philadelphia, working separately on opposite walls. Moses Soyer had a one-man at the Kleeman Gallery in 1935 and three such solo showings at the Macbeth Gallery in the early 1940s. Beginning in the mid-forties, and until the end of his career, he was represented by the A.C.A. Gallery, which in 1944 published the first monograph on his work.

Moses Soyer continued to show in individual and group exhibitions from the 1950s through the 1970s. In 1964, he wrote *Painting the Human Figure,* and two years later he was elected to the National Institute of Arts and Letters. The A.C.A. Gallery orgnized a major retrospective of his work in 1972, which traveled all over the United States. Moses Soyer's work may be seen in such collections as the Metropolitan Museum of Art, the Museum of Modern Art, the Whitney Museum of American Art, the National Academy of Design, and the University of Kansas Museum.

Sources

Soyer, Moses. "Three Brothers." *Magazine of Art* 32 (April 1939): 201–7.

"Moses Soyer, Isaac Soyer, Raphael Soyer." *Current Biography* (1941): 809–13.

Smith, Bernard. *Moses Soyer.* New York: A.C.A.Gallery, 1944.

Willard, Charlotte. *Moses Soyer.* Foreword by Philip Evergood. Cleveland and New York: World Publishers, 1962.

Moses Soyer. Essay by Milton W. Brown. New York: A.C.A. Gallery, 1962.

Werner, Alfred, and David Soyer. *Moses Soyer*. South Brunswick and New York: A.S. Barnes & Co., 1970.

Moses Soyer: Drawings, Watercolors. Foreword by George Albert Perret. New York: A.C.A. Gallery, 1972.

Soyer, Moses, and Peter Robinson. *Oil Painting in Progress*. New York: Van Nostrand Reinhold Co., 1972.

Moses Soyer. A Human Approach. Foreword by Martin H. Bush. New York: A.C.A. Gallery, 1972.

"Moses Soyer, 74, Dead; Traditional U.S. Painter." *New York Times*, September 3, 1974.

Raphael Soyer
(b. 1899)
Lithograph: *Farewell*

Raphael Soyer was born on December 25, 1899, in Borisoglebsk, Government of Tambov, Russia. His early life was identical to that of his twin brother Moses, already described. Raphael Soyer studied art at the Cooper Union from 1914 to 1917 and at the National Academy of Design from 1918 to 1922, primarily with George W. Maynard and Charles Courtney Curran. He also studied in the early 1920s at the Art Students League with Guy Pène du Bois and Boardman Robinson. In 1917 Raphael Soyer purchased a small press, which he set up in his family's apartment in the Bronx, so that he could begin making prints. He made his first lithograph in 1920.

Raphael Soyer first exhibited in the Salons of America in 1926, and he soon began to show work regularly at the Whitney Studio Club. His first one-man show was held at the Daniel Gallery in 1931. During the depression, Soyer worked in the Graphic Arts division of the W.P.A. Fine Arts Project and painted a mural, with his brother Moses, for the Kingsessing, Pennsylvania, post office. In 1933, Raphael was able to switch from making lithographs with transfer paper to working directly on the stone. During the depression, he concentrated on frequently poignant, socially conscious subject matter, emphasizing the psychological effects on people of the hard times. He began the street scenes, introspective nudes, and other female subjects for which he later became most famous. Important influences on his art were Edgar Degas and Thomas Eakins.

During the war years, Raphael Soyer and his brother were both signers of a call to American artists and writers to convene a congress in defense of culture against Fascism. He exhibited in the A.C.A. Gallery's "Artists in the War" show in 1942, and his lithograph *Farewell* won honorable mention in the planographic division of the Artists for Victory "America in the War" competition. This work was based on scenes he glimpsed at Pennsylvania Station of servicemen saying goodbye to family and friends.

Since his first solo showing at the Daniel Gallery, Raphael Soyer has

had a great many other one-man exhibitions: in the 1930s at Curt Valentin, L'Elan, and the Frank Rehn galleries; and in the 1940s at Weyhe, the Philadelphia Art Alliance, and Associated American Artists, where he also showed frequently in the 1950s and 1960s. In the 1960s he also showed at A.C.A., the Forum Gallery, and others. In 1967 the Whitney Museum of American Art gave him a complete retrospective, and a major monograph was published by Associated American Artists covering his entire career.

In 1968 the Division of Graphic Arts of the Smithsonian Institution had a special showing of Raphael Soyer's art, which they held in collaboration with the Washington Print Club, at the Museum of History and Technology. In 1977 the National Collection of Fine Arts gave him another retrospective of drawings and watercolors and in 1980, when, in honor of his eightieth birthday, Soyer gave his complete graphic oeuvre to the Hirshhorn Museum and Sculpture Garden, that institution also held a special show of his works and awarded him the James Smithson Founder's Medal. This award was followed in 1981 by the very prestigious Gold Medal of the American Institute of Arts and Letters.

Like his brother, Raphael Soyer was an art educator as well as a practicing artist. In 1930 he taught at the radical John Reed Club and, from 1933 to 1942, at his alma mater, the Art Students League. He was also on the faculty of the American Art School after World War II. From 1957 to 1962, Raphael Soyer taught at the New School for Social Research. In recent years, Soyer has published a number of books. These include *A Painter's Pilgrimage* (1967), *Homage to Thomas Eakins, Etc.* (1966), *Self-Revealment and Memories* (1969), and *Diary of an Artist* (1977).

Sources

Zigrosser, Carl. *The Artist in America: 24 Close-Ups of Contemporary Printmakers.* New York: Alfred A. Knopf, 1942 (pp. 55–61).

Raphael Soyer. New York: American Artists Group, 1946.

Reese, Albert M. *American Prize Prints of the 20th Century.* New York: American Artists Group, 1949 (pp. 191, 255).

Gutman, Walter K. and Jerome Klein, *Raphael Soyer, Paintings and Drawings.* New York: Shorewood Pub. Co., 1960.

Goodrich, Lloyd. *Raphael Soyer.* New York: Whitney Museum of American Art and Praeger Publishers, 1967.

Cole, Sylvan Jr., ed. *Raphael Soyer: Fifty Years of Printmaking 1917–1967.* Foreword by Jacob Kainen. New York: Da Capo Press, 1967.

Raphael Soyer, An Exhibition of Drawings and Watercolors. Athens: Georgia Museum of Art, University of Georgia, 1968.

Goodrich, Lloyd. *Raphael Soyer.* New York: Harry N. Abrams, 1972.

Canaday, John. "Raphael Soyer's Lonely World." *New York Times,* October 25, 1972, p. 41.

Flint, Janet A. *Raphael Soyer: Drawings and Watercolors.* Washington, D.C.: Published for the National Collection of Fine Arts by the Smithsonian Institution Press, 1977.

Fig. 34
Farewell

Raphael Soyer, b. 1899

Lithograph, undated (40.4 x 31.3 cm)
Signed on stone, signed in pencil
Printed by George Miller

"During World War II I spent many hours at the Pennsylvania Railroad Station in New York watching American soldiers going to war in Europe. I witnessed many moving scenes of soldiers bidding their mothers, wives, and sweethearts farewell, and I made several oil paintings and the lithograph of this subject." (Raphael Soyer to Ellen G. Landau, March 15, 1982)

XX S7318 B3
Fine Prints Collection
Prints and Photographs Division
Library of Congress

Benton Murdoch Spruance
(1904–1967)
Lithograph: *Souvenir of Lidice*

Benton Murdoch Spruance was born in Philadelphia, Pennsylvania, on June 25, 1904, of French and English ancestry. One of his forebears, named Esperance, came to America around 1700. Orphaned by his teen years, Benton Spruance was raised by his stepfather, who insisted that architecture was a more potentially lucrative field than fine art, so Spruance began his studies at the University of Pennsylvania in that field. Switching to painting there and then continuing to study painting at the Pennsylvania Academy of the Fine Arts (PAFA) in the mid-1920s, Spruance studied with George Harding and Roy Nuse, among others. When awarded two Cresson Traveling Fellowships from the PAFA in 1928 and 1929, Spruance had the opportunity to study with André L'Hôte in Paris.

In the 1920s, the PAFA did not teach lithography. While in Europe, Spruance began to frequent lithography workshops to learn the technique, especially that of Desjobert in Paris. There he watched artists such as John Carroll and Yasuo Kuniyoshi create prints from lithographic stones. Desjobert allowed Spruance to work there as well as to observe and, when he returned to Philadelphia, Spruance began to use the services of German-born lithographer Theodore Cuno, who also printed for Joseph Pennell.

In 1953, Benton Spruance acquired his own lithographic press and thereafter did all of his own printing, as well as mixing all of his own inks. Several years earlier, Spruance had received a Guggenheim Fellowship to explore lithography in color. Spruance, however, is probably best-known for his work in black and white. His prints of the thirties exhibited a socially conscious tendency which concentrated on the American scene, especially urban subject matter such as traffic, bridges, and skyscrapers. Unlike most American scene painters, however, Spruance's compositions were frequently organized with an abstract framework and were sometimes stylized into patterns independent of the objects depicted.

By the following decade, Spruance concentrated more on portraits, figures, and psychological studies. In the 1950s, his work took a more emotional turn, centering around biblical themes. This direction is foreshadowed in his entry to "America in the War," *Souvenir of Lidice,*

which won first prize in the planographic division and in which countless Pietàs and Crucifixions are evoked. Spruance's last great series, The Passion of Ahab, was inspired by a theological interpretation of Melville written by Lawrence Roger Thompson.

Besides practicing art, Benton Spruance was also a dedicated art teacher. In 1933 he became professor of art and chairman of the department at Beaver College in Jenkintown, Pennsylvania, and from 1934 to 1965 also taught at the Philadelphia College of Art, where he built up the department of printmaking. Both institutions awarded him honorary degrees.

Spruance participated in many group exhibitions throughout his career, garnering many awards. A partial list of his one-man exhibitions includes those at the Division of Graphics Arts of the Smithsonian Institution, the George Washington University, the Frank M. Rehn Gallery in New York, and the Associated American Artists. He had complete retrospectives at the Philadelphia College of Art in 1967, at the June 1 Gallery of Fine Arts in Washington, D.C., in 1972, and at Sacred Heart University in Bridgeport, Connecticut, in 1973. In connection with the June 1 Gallery exhibition, a symposium was held at the National Collection of Fine Arts entitled "Benton Spruance: A Lifetime in Service to Art." Spruance's work may be seen in such public collections as the Carnegie Institue, the National Gallery of Art, the Philadelphia Museum of Art, the New York Public Library, the Whitney Museum of American Art, and the Museum of Modern Art.

Sources

"Benton Spruance." *Original Etchings, Lithographs and Woodcuts.* New York: American Artists Group, 1937 (pp. 43–44).

"Intimate Glimpses: Lithographs by Benton Spruance." *Coronet* 6 (May 1939): 92–97.

Zigrosser, Carl. *The Artist in America: 24 Close-Ups of Contemporary Printmakers.* New York: Alfred A. Knopf, 1942 (pp. 80–90).

Reese, Albert M. *American Prize Prints of the 20th Century.* New York: American Artists Group, 1949 (pp. 193, 225).

"Benton Spruance, Visiting Artist." *Munson-Williams-Proctor Institute Bulletin,* January 1949, pp. 1, 4–5.

"Lithographer and Artist." *Washington Post,* December 8, 1967.

Benton Spruance, Lithographs 1932–1967. Essays by Lessing J. Rosenwald and Carl Zigrosser. Phila.: Philadelphia College of Art, 1967.

Benton Spruance: A Retrospective. Four Decades of Lithography. Washington, D.C.: June 1 Gallery of Fine Art, 1972.

Benton Spruance. Essays by John Canaday and William J. Fletcher. Bridgeport, Conn.: The Library Gallery, Sacred Heart University, March 9–April 1, 1973.

Who's Who in American Art: 1937.

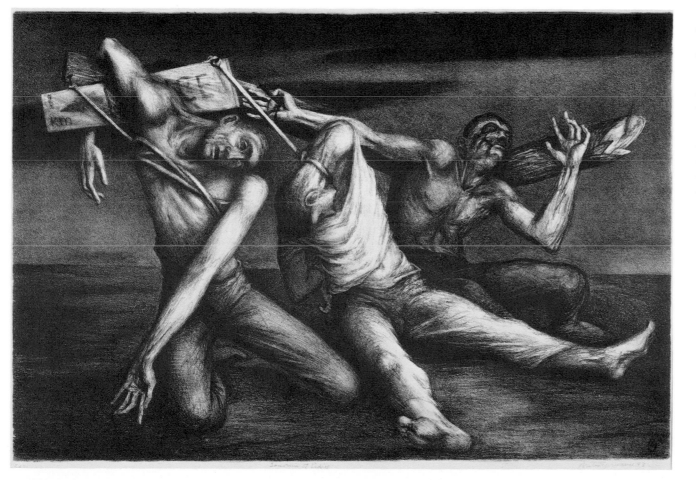

Fig. 35
Souvenir of Lidice

*Benton Murdock Spruance
(1904–1967)*

*Lithograph, 1943 (31 x 46.4 cm)
Signed with initials on stone, signed
and dated in pencil, edition of 35*

*XX S771 B6
Fine Prints Collection
Prints and Photographs Division
Library of Congress*

Harry Sternberg

(b. 1904)

Color silkscreen: *Fascism*

Harry Sternberg was born on July 19, 1904, in New York City. He grew up on the Lower East Side, the son of poor Jewish immigrants who wanted him to become a doctor, not an artist. He studied at the Art Students League with George Brant Bridgman and privately with Harry Wickey.

Sternberg first took up etching in 1927. In 1932 he had his first one-man exhibition at the Weyhe Gallery, which consisted of his work since 1928. During the depression, he was active in the organization of the American Artists Congress and taught for the W.P.A. While in the Graphics Division of the W.P.A. Fine Arts Project, he first experimented in serigraphy and offset lithography and was a member of the innovative silkscreen group that formed the Workshop School on Tenth Street. He painted murals for the Lakeview post office in Chicago, and the post offices in Sellersville and Chester, Pennsylvania.

In 1936 Harry Sternberg was awarded a Guggenheim Fellowship to study the coal and steel industries in the depression and actually lived among the miners and steelworkers in Pennsylvania. He showed drawings from this project at Frederick Keppel & Company in 1937. Sternberg was chosen in 1937, 1938, and 1939 for 100 Fine Prints of the Year.

Harry Sternberg was an instructor at the Art Students League from 1934 to 1968. He was on the faculty of the New School for Social Research, 1942–45, and he taught graphics as therapy at the Veterans Art Center of the Museum of Modern Art, 1944–48. During the war years, Sternberg was a very active and responsible member of the art community. In 1942, he had three exhibitions, in New York, Hollywood, and Richmond, Virginia, which he dedicated to victory, and from which he donated 10 percent of all proceeds to the Red Cross. He did three large aquatints with war subjects, praised by Carl Zigrosser as among the most impressive reactions to totalitarian war produced in this country.

Harry Sternberg was one of the signers of a call to American artists and writers to convene in defense of culture against Fascism. He exhibited in the A.C.A. Gallery's "Artists in the War," and his silkscreen *Fascism* won honorable mention in the serigraphy division of the Artists for Victory "America in the War" exhibition. Also in the forties, he illustrated two important antiwar pamphlets: "They Still Carry On! Native Fascists: How to Spot Them and Stop Them," published by the War Department, and "Eleven Fundamentals for Organization of Peace in Pictures," put out in 1944 by the Committee to Study the Organization of Peace, in New York.

In the 1950s, Sternberg continued to exhibit frequently. A.C.A., Garelick's Gallery, and the University of Minnesota all gave him complete graphic retrospectives. He taught in suburban New York and Connecticut until 1959, when he joined the faculty of the Idyllwild School of Music and Art in Los Angeles, where he stayed for ten years and where he shifted the emphasis in his art to landscape. The University of the South in Sewanee, Tennessee, gave him a retrospective in 1960, which included examples from the work of former students who had themselves become well-respected printmakers.

In the early 1960s, Harry Sternberg got involved in the direction of two movies, *The Many Worlds of Art* (1960) and *Art and Reality* (1961). He has written a number of books on art as well, including how-to books on serigraphy, etching, woodcut, and artistic composition and a book entitled *Realistic Abstract Art.*

Among the many prizes awarded Sternberg was a grant from the Institute of Arts and Letters in 1972. His more recent work has evinced something of a return to social commentary, and a catalogue raisonné of his oeuvre was published in 1975 by the Ulrich Museum of Art, Wichita State University. Examples of his work may be seen at the Ulrich, the Museum of Modern Art, the Victoria and Albert Museum in London, the Whitney Museum of American Art, the Cleveland Museum of Art, and many others.

Sources

"Sternberg Puts Forth Principles." *New York Times,* January 26, 1932.

"Harry Sternberg—Graver and Painter." *Index of 20th Century Artists* 3 (May 1936): 295–96.

Zigrosser, Carl. *The Artist in America: 24 Close-ups of Contemporary Print-makers.* New York: Alfred A. Knopf, 1942 (pp. 62–69).

"Sternberg's War Comment Wins Print Prize." *Art Digest* 16 (May 1, 1942): 21.

Sternberg, Harry. "War Art From the Bottom Up." *Magazine of Art* 36 (January 1943): 3–5.

Sternberg: 25 Years of Printmaking. New York: A.C.A. Gallery, 1953.

The Prints of Harry Sternberg. Essays by Hudson Walker and Malcolm M. Willey. Minneapolis: University Gallery, University of Minnesota, 1957.

Thirty Years of Graphics: Harry Sternberg. Essay by Carl Zigrosser. New York: Garelick's Gallery, 1958.

Suydam, Anne A. "Social Consciousness in American Graphic Art and Its Reflection in the Prints of Harry Sternberg 1929–40." Masters thesis, San Diego State College, June 1969. In the Harry Sternberg Papers, Archives of American Art, Washington, D.C.

Moore, James. *Harry Sternberg. A Catalogue Raisonné of His Graphic Work 1927–1975.* Wichita, Kansas: Edwin A. Ulrich Museum of Art, Wichita State University, 1975.

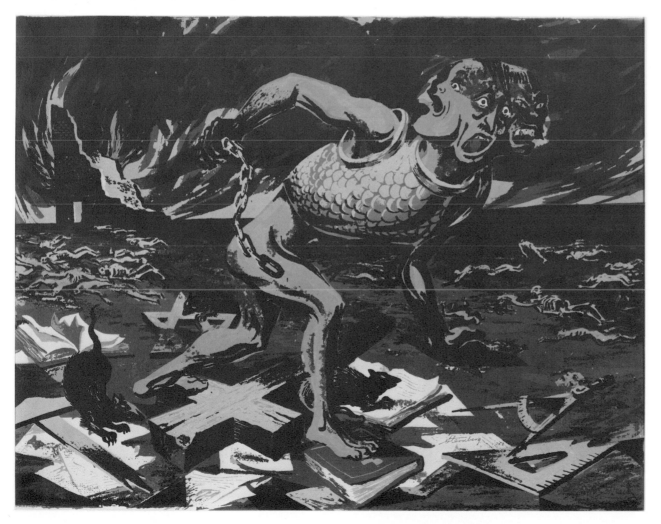

Fig. 36
Fascism

Harry Sternberg, b. 1904

*Color silkscreen, not dated
(39.5 x 52.5 cm)*

"An art which is healthy is a social art. . . . The content in a broad sense and the symbolism in a close sense should be about people and for people." The creator of this print had "Guernica, with the horror of the German bombing, in his mind. He wasn't thinking about whether people would like it or not. The symbolism is ugly because it was an ugly story." (Art Students League News 1, no. 8, December 1, 1948)

*XX S838 B4
Fine Prints Collection
Prints and Photographs Division
Library of Congress*

Agnes Tait

(b. 1897)

Lithograph: *The Survivors*

Agnes Tait was born June 14, 1897, in New York City. She studied at the National Academy of Design and later in France and Italy. In the 1920s a reviewer noted Tait's attachment, at that time, to the aesthetic ideals of the English Pre-Raphaelite group. In that decade, Tait painted many mural decorations for houses in New York and Palm Beach and participated in a show focusing on her and two other artists at the Dudensing Gallery (1928). Tait's decorative period was followed by a concentration on landscape and then on portraits. She had her first solo showing of portraits at the Ferargil Galleries in New York in 1933.

During the early years of the depression, Agnes Tait worked with both the easel painting and graphics sections of the Public Works of Art Project, predecessor of the W.P.A. Under federal auspices she executed murals for Bellevue Hospital and the U.S. post office at Laurinsburg, North Carolina. She also illustrated children's books, including *Peter and Penny of the Island* and *Heide,* in the 1940s.

By the time of the "America in the War" exhibition, Agnes Tait (then Mrs. William McNulty) had moved from New York City to Santa Fe, New Mexico. In 1958 she was given a large solo exhibition at the Albany Institute of History and Art. Tait has exhibited nationwide in numerous group shows, and examples of her work may be seen in the Metropolitan Museum of Art, the Library of Congress, and the New York Public Library. A member of the National Association of Women Painters and Sculptors, she was chosen to be included in "Fourteen American Women Printmakers of the '30s and '40s," a show organized by the Mt. Holyoke College Art Museum.

Sources

"Agnes Tait." *Handbook of the American Artists Group.* New York, 1935 (pp. 70–71).

"Agnes Tait." *Original Etchings, Lithographs and Woodcuts Published by the American Artists Group, Inc.* New York, 1937 (p. 44).

Jones, Hester. "Current Exhibition at the Museum of New Mexico." *El Palacio* 55, no. 6 (1948): 184–87.

Barlow, Heather. "Agnes Tait." *Fourteen American Women Printmakers of the '30s and '40s.* South Hadley, Mass. and New York: Mt. Holyoke College Art Museum and the Weyhe Gallery, 1973.

Who's Who in American Art: 1936–37, 1940–47, 1953.

Prentiss Hottel Taylor

(b. 1907)

Litho-tint: *Uprooted Stalk*

Prentiss Hottel Taylor was born in Washington, D.C., on December 13, 1907. He studied art at the Corcoran Gallery of Art and at the National School of Fine and Applied Arts with Isabel Sewell Hunter, Mary P. Shipman, Alexis Many, and Inez Hogan. He also worked with Charles Hawthorne during two summers in Provincetown, Massachusetts (1924–25), and with Ann Goldthwaite, Eugene Fitsch, and Charles Locke at the Art Students League in New York. Fitsch and Locke taught Taylor lithography, beginning in 1931.

Taylor's work in the 1920s was predominantly abstract but, when he took up lithography, he changed to a more conservative, realist style, emphasizing the American scene. In the 1930s, he spent four summers as a fellow at the MacDowell Colony in Peterborough, New Hampshire, strengthening this direction.

During the years when Prentiss Taylor lived in New York (1926 through the early 1930s), he followed, for a time, a childhood dream which was to design stage sets and costumes, working with Michio Ito, Stuart Walker, and others. In 1934 he worked on the Public Works of Art Project in that city. By 1936 he had moved to Arlington, Virginia, where he remains a resident.

Prentiss Taylor had his first one-man show in 1927, at the Arts Club in Washington, D.C., and another there in 1929. In the 1930s, he exhibited at the New York World's Fair and had several solo showings, including one at the Public Library of Washington, D.C., in 1938 and another at the Frank M. Rehn Galleries in New York that same year. He directed a class in lithography at Studio House in Washington in 1935 and illustrated a number of books, including *The Negro Mother* (1931), *Scottsboro Limited* (1932) by Langston Hughes, *Why Birds Sing* (1933), and *The American Herb Calendar* (1937). In 1938 and again in 1944, he was chosen for Fifty American Prints of the Year.

During the war years, Prentiss Taylor's work was included in a show of prints selected by Carl Zigrosser for the Office of War Information. One of his many one-man exhibitions at Whyte Gallery in Washington in the mid-1940s included a number of war subjects, some with Christian allusions similar to the Pietà theme of *Uprooted Stalk,* Taylor's entry to "America in the War."

Also in the 1940s, Taylor was commissioned to paint two murals, one in a private home and one in the Christian Science Headquarters in Washington, D.C. During the war, he began to teach art therapy at St. Elizabeth's Hospital and organized public showings of his patients' works. He remained there until 1954 and from 1958 to 1978 did similar work at Chestnut Lodge in Rockville, Maryland. President of the Society of Washington Etchers in these years, he had important shows at Howard University ("My First Ten Years at Lithography," 1942) and the Division of Graphic Arts of the Smithsonian Institution (1947).

In 1950 the United Nations Club did a seventeen-year survey of Taylor's career, and a forty-year survey was done in 1971 at the Franz Bader Gallery in Washington, D.C. In the 1950s, Taylor was involved with organizing and staging exhibitions at the Playhouse Art Gallery in Virginia and the American Institute of Architects. He taught for the Y.W.C.A. and American University. In 1961 Taylor was guest printmaker at The Tamarind Lithography Workshop. His most recent one-man show, at Bader Gallery, took place in 1981.

Public collections in which Prentiss Taylor's work may be seen include those at the Museum of Modern Art, the Phillips Collection, the New York Public Library, the National Museum of American Art, and Yale University.

Sources

Original Etchings, Lithographs, and Woodcuts Published by the American Artists Group. New York, 1937 (p. 45).

Salpeter, Harry. "About Prentiss Taylor." *Coronet* 5 (April 1939): 134–42.

My First Ten Years at Lithography. Prints by Prentiss Taylor. Essay by Adelyn D. Breeskin. Washington, D.C.: Howard University Gallery of Art, April 26–May 1942.

Reese, Albert M. *American Prize Prints of the 20th Century.* New York: American Artists Group, 1949 (pp. 198, 255).

"Taylor Strives for Space and Air." *Washington Post,* April 26, 1953, 3L.

"Taylor Art on Display at Bader." *Washington Star,* May 20, 1956.

Cohen, A. "Prentiss Taylor." *D.C. Gazette,* 1970.

Forty Years of Lithographs by Prentiss Taylor 1931–1971. Essay by Carl Zigrosser. Washington, D.C.: Franz Bader Gallery, April 21–May 8, 1971.

Who's Who in American Art: 1940–47, 1953.

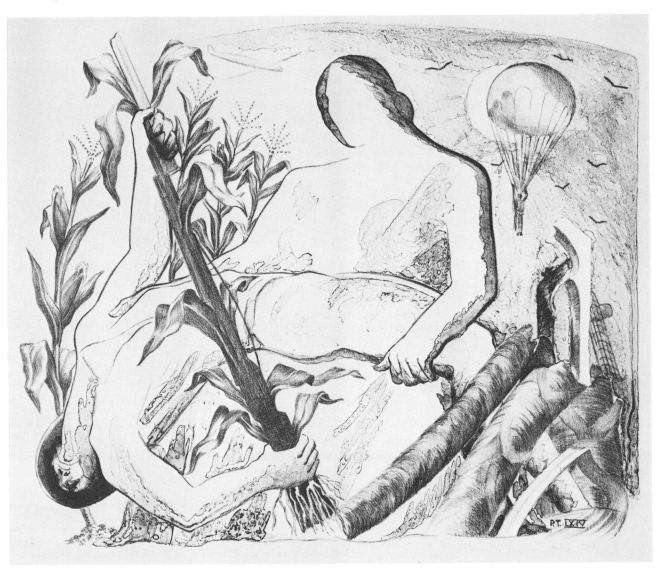

Fig. 37
Uprooted Stalk

Prentiss Hottel Taylor, b. 1907

Litho-tint, 1943 (26.2 x 31.6 cm) 34/35, signed with initials on stone, signed and dated in pencil

XX T243 A15
Fine Prints Collection
Prints and Photographs Division
Library of Congress

Harry Frederick Tepker
(dates unknown)
Lithograph: *Mountain Mortar Firing*

Harry Frederick Tepker was active in the Colorado Springs, Colorado, area at the time of his submission to the "America in the War" exhibition. In 1945, by then a private first class in the U.S. Marine Corps, he exhibited a watercolor depicting Tetere Beach, Guadalcanal, in "The War against Japan" exhibition. This exhibition, organized by the U.S. Treasury Department to stimulate the purchase of war bonds, was comprised of works executed by painters sent to the Pacific theater by the U.S. Marines, U.S. Navy, U.S. War Department, and *Life* magazine.

Tepker was apparently one of the few artists associated with the "America in the War" project who experienced active combat, though perhaps not before he submitted his print to Artists for Victory. After the war, Harry Frederick Tepker took part in two national exhibitions of prints sponsored by the Library of Congress, in 1950 and 1955. At that time he was a resident of California.

Sources

The War against Japan. Washington, D.C.: National Gallery of Art, 1945.

Fig. 38
Mountain Mortar Firing

Harry Frederick Tepker
(dates unknown)

Lithograph, 1943 (39.8 x 29.3 cm)
Signed and dated in pencil

"When it comes to courage, it is rightly taken for granted that no marine combat artist would be lacking. . . . Marines like PFC Harry F. Tepir know from experience the full meaning of the term 'Leatherneck.'"
(Forbes Watson papers)

XX T313 B1
Fine Prints Collection
Prints and Photographs Division
Library of Congress

Sophia Thanos

(dates unknown)

Linoleum block: *United Knockout Blow*

Sophia Thanos was active as an artist in the Oakland, California, area at the time of her submission to the "America in the War" exhibition. She participated in the 1947 National Exhibition of Prints sponsored by the Library of Congress.

Joseph S. Trovato

(1912–1983)

Woodcut: *Notice from the Draft Board*

Joseph S. Trovato was born in Guardaville, Italy, on February 6, 1912. He came to the United States in 1920, settling in Utica, New York. He studied at the Utica Art School and in the early 1930s in New York City, at the Art Students League and the National Academy of Design. In the latter part of that decade, he received a fellowship to the School of Related Arts and Sciences in Utica sponsored by the Munson-Williams-Proctor Institute. In the early 1940s, he continued his studies at the Munson-Williams-Proctor.

From 1933 to 1936 Joseph Trovato taught W.P.A. art classes and worked on the W.P.A. Mural Project, in addition to directing an art school connected with the Utica Conservatory of Music. In 1939 he became assistant to the director of the Munson-Williams-Proctor Institute, a position he retained until his retirement in 1982. His duties there included general museum administration and the organization and installation of exhibitions and preparation of their accompanying catalogs. Shows for which Trovato was responsible include the Armory Show Anniversary Exhibition (1963) and a memorial exhibition of the works of Charles Burchfield (1970).

From 1958 to 1969 Trovato also did curatorial and administrative work for the Edward W. Root Center at Hamilton College in Clinton, New York. He received an honorary doctorate in fine arts from that institution in 1963 and taught there as a visiting assistant professor of art, 1965–66. From 1974 to 1980 he taught at the School of Art of the Munson-Williams-Proctor Institute and in the spring of 1976 was also an associate professor at Kirkland College. Among his publications are *Portraiture: The 19th and 20th Centuries* (1957), *Learning about Pictures from Mr. Root* (1965), *George Luks* (1973), *The Olympics in Art* (1980), and an article in *Art in America* on the Armory Show (February 1963).

Trovato, in his career as a museum professional, has also worked as a field researcher for the Archives of American Art (1964–66), taping interviews with artists and administrators of the W.P.A. for a project entitled "The New Deal and the Arts." He served as a consultant to the New York State Council on the Arts, 1966–67, and he also served on many juries for exhibitions throughout upstate New York and in Pennsylvania.

In his capacity as an artist, Trovato has exhibited in a number of upstate New York group exhibitions. He had twelve one-man showings after 1950 at such locations as Colgate University, the Munson-Williams-Proctor Institute, Utica College of Syracuse University, the Albany Institute of History and Art, the Edward W. Root Center of Hamilton College, the Everson Museum of Art in Syracuse, the Kirkland Art Center in Clinton, New York, and Gallery II, Oneida, New York. His work is in the permanent collections of many of these same institutions and in numerous private collections.

Sources

"Paintings by Joseph Trovato." *Munson-Williams-Proctor Institute Bulletin* (October 1952): [4].

Paintings by Joseph S. Trovato. Essay by James Penney. Clinton, New York: Hamilton and Kirkland Colleges, January 11–February 11, 1976.

Who's Who in American Art: 1966.

Donald Vogel

(b. 1902)

Drypoint: *Swing Shift*

Donald Vogel was born in Poland on December 24, 1902. He came to the United States at the age of eight and received his early education in the New York City public schools. He studied art at the Parsons School of Design and earned both a bachelor of science and a master of arts degree from Columbia University. He later became an instructor in fine arts at the High School of Art and Design on Second Avenue.

A contributor to *Print Collector's Quarterly, La Revue moderne,* and other journals, Vogel has won awards for his art from the Munson-Williams-Proctor Institute (1943), the Northwest Printmakers (1943 and 1946), and the Library of Congress (1950). He was chosen to receive the third prize in the intaglio division of the "America in the War" competition for a drypoint depicting the change in shifts for defense work at the Peerless Coal Company.

Donald Vogel has exhibited in numerous other group shows throughout his career, at such places as the National Academy of Design, the Pennsylvania Academy of the Fine Arts, the J.B. Speed Museum, and the Flint Institute of Art. His work is in the permanent collections of the Seattle Art Museum, the Metropolitan Museum of Art, the Pennsylvania State University, the Munson-Williams-Proctor Institute, and the Society of American Graphic Artists.

Sources

Reese, Albert M. *American Prize Prints of the 20th Century.* New York: American Artists Group, 1949 (pp. 204, 256).

Who's Who in American Art: 1953–80.

Fig. 39
Swing Shift

Donald Vogel, b. 1902

Drypoint, not dated (17.8 x 22.8 cm)
18/40, signed in pencil

XX V878 A2
Fine Prints Collection
Prints and Photographs Division
Library of Congress

Sylvia Wald

(b. 1914)

Color silkscreen: *The Boys*

Sylvia Wald was born in Philadelphia, Pennsylvania, on October 30, 1914. She studied at the Moore Institute of Art, Science, and Industry there and, upon graduation, taught on the W.P.A. Federal Art Project in Philadelphia. In 1937 she moved to New York City, where she continued to teach for the W.P.A.

The following year, Wald was the winner of the A.C.A. Gallery's third annual competition for a first New York show, sponsored by the American Artists Congress. There were over two hundred competitors for this honor, which resulted in her first solo exhibition, held at the A.C.A. Gallery in May 1939 and comprising both painting and sculpture.

It was in conjunction with the A.C.A. show that Sylvia Wald first began to experiment with printmaking. The gallery asked her to reproduce two of her paintings by silkscreen, and she became fascinated with the possibilities of this multiple-copy and less expensive medium. Shortly after, she became associated with the innovative Silkscreen Group, which founded the Workshop School in New York in 1940. Later, during World War II, when she accompanied her husband, Dr. Alter Weiss, to an army base at Louisville, Kentucky, she worked on more fully developing her silkscreen style and technique, since she had no adequate studio space for sculpture or painting.

Sylvia Wald had another solo show of paintings and prints in the early 1940s sponsored by the New School Associates. She took part in an exhibition organized to accompany the American Writers and Artists Congresses' 1941 symposium, "In Defense of Culture," and was one of the illustrators of a book published as part of this exhibition, *Winter Soldiers,* which depicted through drawings the attempt of teachers to defend free public education. In 1942 she showed both a sculpture and an oil in the A.C.A. Gallery's "Artists in the War" exhibition. Her entry in the Artists for Victory graphic competition, *The Boys,* which depicts a group of black soldiers, probably reflects her wartime experience living on an army installation in the South.

Throughout her career, Wald has participated in numerous group exhibitions in the United States, Europe, Japan, Israel, and South America, winning many prizes. One-person showings, in addition to those already mentioned, include two each at the University of Louisville and the Serigraph Gallery, New York, and others at Kent State University, the Grand Central Moderns Gallery, the Briarcliff Public Library, and the Devorah Sherman Gallery in Chicago. The University of Louisville sent a show of Wald's works on tour from 1952 to 1956.

In the past decade, Sylvia Wald has actively participated in many women artists' shows, sponsored by such groups as Women in the Arts and the Women's Interart Center, Inc. She took part in the 1973 exhibition at the New York Cultural Center "Women Choose Women." Her work is in such public collections as the Museum of Modern Art, the Metropolitan Museum of Art, the Whitney Museum of American Art, the Solomon R. Guggenheim Museum, the Brooklyn Museum, the National Gallery of Art in Washington, D.C., and the National Gallery of Canada.

Sources

Sylvia Wald: Paintings/Prints during April. Essay by Herman Baron. New York: New School Associates, n.d. [probably early 1940s].

"Meet the Artist: Sylvia Wald of New York City." *Serigraph Quarterly* 4 (November 1948): 3.

"Sylvia Wald." *University of Louisville Allen R. Hite Institute,* no. 8 (April 1949).

[Review]. *New York Times,* February 24, 1954.

"Library to Exhibit Sylvia Wald's Prints." *Citizen Register,* Ossining, N.Y., June 4, 1965.

Collins, J. L. *Women Artists in America, 18th Century to the Present.* Chattanooga: University of Tennessee, 1973.

Who's Who in American Art: 1953–80.

Charles Banks Wilson

(b. 1918)

Lithograph : *Freedom's Warrior—American Indian*

Charles Banks Wilson was born in Miami, Oklahoma, on August 6, 1918. Part Cherokee and part Choctaw Indian, his native name "Tsungani" translates as "excels all others." Wilson, who grew up in a settlement of thirteen different Indian tribes, went to Chicago to study art at the Art Institute and, in 1938, took his first lithography class there. Some of his teachers include Francis Chapin, Louis Ritman, Boris Anisfeld, and Hubert Ropp. In 1941 he traveled to New York City with a recommendation from Regionalist painter Aaron Bohrod to Associated American Artists, for whom Wilson has since made many prints.

Since that time, Wilson's primary subject matter has related to Indian life. In the early 1940s, he wrote an article for *This Week* magazine about the Indian participation in World War II. Entitled "No War Whoops, But . . ." and illustrated with a lithograph depicting an American Indian in army uniform holding an American flag, this article pointed out that the U.S. armed forces, since Pearl Harbor, included about twelve thousand Indians and that the 180th Infantry from Oklahoma and Kansas had so many Indians that its motto was in Choctaw. The illustration for this article, *Freedom's Warrior,* became Charles Banks Wilson's entry to "America in the War."

A two-page spread in *Collier's* magazine devoted to his work gave a large boost to Wilson's career in the early 1940s and, in 1946, the Division of Graphic Arts of the Smithsonian Institution gave him a one-man exhibit in Washington, D.C. Another one-man exhibition was held in 1952 at the Philbrook Art Center in Tulsa, Oklahoma, and more followed at the Oklahoma Art Center, the Springfield Museum of Art, the University of Tulsa, the Gilcrease Institute, and the New York World's Fair (1964–65).

Beginning in 1948 (and until 1960), Wilson was director of the art department of Northeastern Oklahoma A. and M. College. In the mid-1950s he was commissioned by John D. Rockefeller, Jr., to paint a mural for Jackson Lake Lodge in the Teton National Park in Wyoming. Entitled *The Trapper's Bride,* this decoration presented a historical picture of the fur trade in the West.

The following year, Charles Banks Wilson helped famed Regionalist painter Thomas Hart Benton to obtain authentic Indian models for a mural on the subject of the St. Lawrence Seaway. He also assisted Benton with research for the latter's Truman Library mural and, in return, Benton taught Wilson how to work in the egg tempera method, which has been Wilson's primary medium since that time. Charles Banks Wilson has done several portraits of Benton, who became a great friend and artistic influence.

Another portrait by Wilson is that of Chief Whitehorn of the Osage Tribe. Many Indians have traveled thousands of miles to be painted by him. Wilson has done a life-size mural of the famous Chief Sequoyah for the Oklahoma State Capitol rotunda. It hangs with three others by him depicting Will Rogers, U.S. Senator Robert Kerr, and Indian athlete Jim Thorpe. Wilson's portrait of former House Speaker Carl Albert (1962) hung in the National Portrait Gallery before being transferred to the U.S. Capitol Speakers' Gallery.

In the 1970s Charles Banks Wilson was commissioned to paint a 110-foot long mural to hang in the Oklahoma Capitol under his four portraits. This new work depicts the state's history from 1541 to 1900, from the period of discovery up to the period of settlement. The project was featured in a three-part series in the *Orbit* magazine, published by the *Sunday Oklahoman* newspaper.

Wilson, an expert in the culture, ceremonials, and costumes of the Oklahoma Indians, has written several standard texts on this subject, including *Quapaw Agency Indians* (1947) and *Indians of Eastern Oklahoma* (1964). He designed the First Americans Series of Indian chief medallions for Josiah Wedgwood & Sons, Inc., of England. Wilson has done watercolors for *Ford Times* magazine and contributed articles to *Coronet, Colliers,* and the *Daily Oklahoman,* in addition to *This Week.* He has done the drawings for a number of books, many of which have won prizes, such as *Treasure Island* (1948) and *Henry's Lincoln* (1945). Wilson also made a color film, *Indians in Paint,* in 1955 and a television documentary, "Names We Never Knew," in 1974.

Among Wilson's awards are the Distinguished Service Cross and the first Governor's Award from the state of Oklahoma. He is in both the Oklahoma and the cowboy halls of fame and has won additional prizes for his art from such institutions as the Art Institute of Chicago, the Wichita Art Association, and the National Academy of Design. His work may be seen in such museums as the Metropolitan Museum of Art and the Thomas Y. Gilcrase Institution, which owns fifty-five examples.

Sources

Wilson, Charles Banks. "An Indian Party." *Collier's Magazine,* July 1942.

Wilson, Charles Banks. "No War Whoops, But" *This Week,* January 10, 1943, p. 5.

Sanford, Robert K. "Sure Painter of Indians and Mid-West." *Kansas City Star,* April 29, 1962, p. 6F.

Wilson, Charles Banks. "Painting Mural Portraits." *American Artist,* November 1969.

De Frange, Ann. "Murals Show 'Roots of Oklahoma.'" *Orbit Magazine, Sunday Oklahoman,* December 24, 1976, p. 3 ff.

Who's Who in American Art: 1940–80.

Fig. 40
**Freedom's Warrior—
American Indian**

Charles Banks Wilson, b. 1918

*Lithograph, not dated
(25.3 x 34.8 cm)
Signed on stone, signed in pencil*

"When the call for the first selective service registration went out, the bulk of the able-bodied men of the Navajo Indian tribe rode in to Gallup, N.M., on their horses, completely equipped with food, packs, and rifles. They were all ready to start fighting the man they call 'the mustache smeller' that very morning." (Charles Banks Wilson quoted in the New York Herald Tribune, *January 10, 1943)*

*XX W747 B3
Fine Prints Collection
Prints and Photographs Division
Library of Congress*

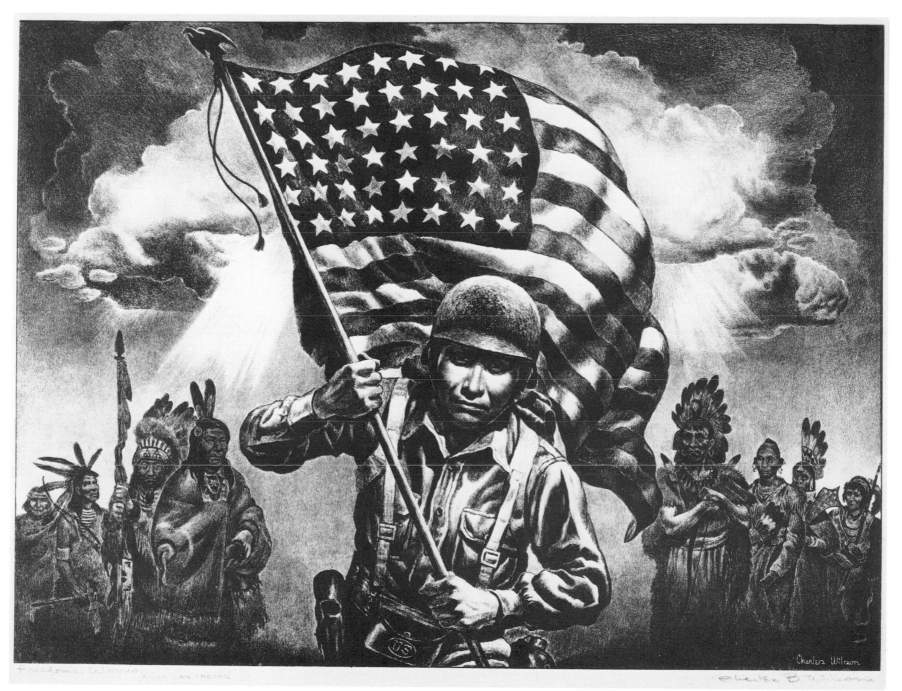

Freedoms Way ... American Indian

Charles Wilson

Charles B Wilson

Sol Wilson

(1896–1974)

Color silkscreen: *The Twelfth Day*

Sol Wilson was born in Wilno, Poland (now Vilnyus, Lithuania), on August 11, 1896. He first came into contact with printmaking in his father's lithography workshop in Russia, which specialized in printing bottle labels and the like. Wilson emigrated to the United States as a teenager and studied art in New York at the Cooper Union, the National Academy of Design, and the Beaux Arts Institute of Design. He encountered the teaching of George Bellows at the Ferrer School, and he considered Bellows and Robert Henri his most important pedagogical influences. Beginning in 1926 Wilson himself began teaching art at the New Haven Y.M.H.A. He subsequently taught at the American Artists' School (1936–40) and the School of Art Studies, New York (1945–49). Many of his former pupils have gained national reputations.

During the 1930s, Wilson worked on government art projects and painted murals for the Delmar and Westhampton Beach, New York, post offices. He exhibited in a number of group shows, including the New York World's Fair, 1939–40. In 1926 the first of a series of one-man shows of his work that continued throughout his entire career was held at the Babcock Galleries.

A winner of many prizes for his art, Sol Wilson submitted a silkscreen, *The Twelfth Day,* to the "America in the War" competition, and it took third prize in serigraphy. Its subject, survivors washed up on shore, was suggested to Wilson by news reports. He was also one of twelve prize-winners in the exhibition cosponsored by Artists for Victory and Pepsi Cola in 1944–45, and he won a purchase prize in the Section of Painting and Sculpture of the U.S. Treasury Department-sponsored American Red Cross competition in 1942. In 1950 he received a National Institute of Arts and Letters (NIAL) award. The chairman of the NIAL committee on grants, Leon Kroll, cited Wilson's "powerful sense of design in both form and color" and "emotional expression of a high order."

Sol Wilson, who once termed his own style "Expressionist Realism,"

switched from an emphasis on the human condition to an emphasis on nature—primarily landscape and seascape—in the 1950s. He had since 1927 been spending summers in New England, first at Rockport, Maine, near Cape Ann and then, beginning in 1947, at Provincetown, Massachusetts, on Cape Cod. Examples from his oeuvre may be seen at such museums as the Telfair Academy, the Butler Art Institute, the Whitney Museum of American Art, and the Bezalel and Ain Harod museums in Israel.

Sources

"Exhibit in New York." *Art News* 25 (November 20, 1926): 11.

Salpeter, Harry. "Immigrant's Rock Bound Coast." *Esquire,* February 1944, p. 81.

Gibbs, Jo. "Sol Wilson Places Sharper Accent on Man." *Art Digest* 19 (March 1, 1945): 15.

Reese, Albert M. *American Prize Prints of the 20th Century.* New York: American Artists Group, 1949 (pp. 213, 257).

Salpeter, Harry. "Sol Wilson: An Interview by Harry Salpeter." *American Artist* 14 (April 1950): 26–30, 73.

Genauer, Emily. "Blessing the Fleet." *This Week, New York Herald Tribune,* June 20, 1953.

Crotty, Frank. "Cape Cod Close-up." *Worcester Sunday Telegram,* October 6, 1957, p. 29.

Crotty, Frank. *Provincetown Profiles on Cape Cod,* 1958, p. 71.

Who's Who in American Art: 1940–47, 1953, 1966.

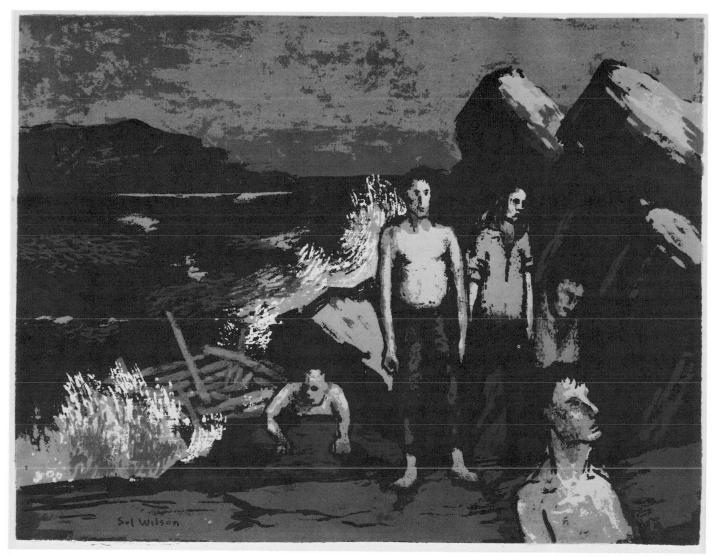

Fig. 41
The Twelfth Day

Sol Wilson (1896–1974)

*Color silkscreen, not dated
(30.5 x 40.8 cm)
Signed on screen*

*"This print was made during the war
and the theme was suggested by a
number of news reports of men hav-
ing been seen at sea on a raft . . .
many days and nights after their ship
had been destroyed. On the print the
broken raft is suggested behind the
men crawling up the rope." (Sol Wil-
son to Albert M. Reese)*

*XX W752 B1
Fine Prints Collection
Prints and Photographs Division
Library of Congress*

Lumen Martin Winter

(1908–1982)

Lithograph : *"Have Anudder on d'House, Doc"*

Lumen Martin Winter was born December 12, 1908, in Elerie, Illinois. The son of a mechanical engineer and inventor, he was named after a measure of light, the "lumen." He spent most of his early childhood on a ranch in western Kansas near Fort Larned, attending high school in Grand Rapids. At age thirteen, he was selling illustrations to *American Boy* magazine and, as a high school student, he worked as a political cartoonist for the *Grand Rapids Herald*.

Winter studied art at the Cleveland School of Art and took classes in anatomy from a nearby medical school. He then went to New York, where he studied at the Grand Central School, the Beaux Arts Institute of Design, and the National Academy of Design, with Ivan Olinsky, Hildreth Meiere, and Walter Biggs. He became friendly with Thomas Hart Benton and was influenced by his work.

After the stock market crash in 1929, Winter returned to the Midwest, attended junior college for awhile, and worked as a designer for a Cincinnati commercial art firm. But he soon returned to New York to work as a cartoonist and magazine and book illustrator. In the early 1930s, he studied still life with Arshile Gorky and met muralist Ezra A. Winter, whom he assisted on decorations for the Radio City Music Hall. This experience inspired Lumen Martin Winter to become a muralist.

Lumen Martin Winter had his first one-man exhibition at the Hackley Art Gallery in Muskegon, Michigan, in 1929. He exhibited his first large painting in New York at the Salons of America, held at Rockefeller Center, winning honors there. After several more one-man exhibitions in the Midwest, he was asked at age twenty-six by the principal of his former high school to paint a mural depicting the history of Michigan. The resultant work, installed in Union High, Grand Rapids, Michigan, was acclaimed in the *Literary Digest*.

In the late 1930s and early 1940s, Winter won three commissions for mural decorations from the Section of Painting and Sculpture of the U.S. Treasury Department. These were for the post offices in Fremont, Michigan, and Wellston Station, St. Louis, and the Hutchinson, Kansas, Federal Building. He painted posters to sell war bonds and served as an artist with the U.S. Signal Corps of the Air Force during World War II.

After the war, Winter's career as a muralist blossomed. In 1953 he did twelve paintings for the City of New York Tercentenary Celebration depicting Washington Irving's *Knickerbocker History of New York*. At this time he began to do some of his murals in mosaic as well as fresco. A sixty-foot-wide mosaic bas-relief of the *Triumph of Christ* was installed at the Roman Catholic Church of St. Paul the Apostle in New York in 1958. Winter supervised the work on this mural in the Pierotti Studios in Petrasanti, Italy. His most famous mosaic mural, two stories high and twenty feet long, was installed in the 1960s in the lobby of the AFL-CIO building in Washington, D.C. A detail from this mural, with Thomas Carlyle's motto "Labor is Life," was reproduced on a three-cent postage stamp issued by the U.S. Post Office.

In addition to the more than twenty painted and mosaic murals to Winter's credit, he received a number of major decorative sculpture commissions, including the thirty-foot bronze figure, *Our Lady of the Thruways,* at the crossing of the New York and New England throughways. Right before his death, Winter won a competition to provide an outdoor sculpture for the Kansas State Historical Society.

Lumen Martin Winter continued as an active printmaker to the end, creating limited editions for the firm of Jackie Fine Arts in New York City. His *White Stallion in Moonlight,* published commercially, has sold over a million copies.

Winter has had one-man exhibitions at the Galerie Internationale, Bonestell Gallery, Center Gallery, and Harry Salpeter Gallery in New York City, and at the Brown Gallery in Cincinnati, the Washington County Museum in Hagerstown, Maryland, and others. He has participated in numerous group shows and his work is in such important collections as those at the Vatican, the University of Israel, the White House, the U.S. Air Force Academy, and the Santa Fe Trail Museum in Larned, Kansas.

Sources

"History on a High School's Walls." *Literary Digest,* February 2, 1935, p. 24.

Kent, Norman, and Ernest Watson. "Lumen Martin Winter, Artist of Many Parts." *American Artist* 14 (May 1950): 35–36

"Mural for the East Brooklyn Savings Bank." *Pictures on Exhibit* 13 (May 1951): 14.

"Paulists Bless Vast Sculpture." *New York Times,* December 8, 1958.

Fabri, Ralph. "Lumen Martin Winter." *Today's Art,* 1966.

Winter, Lumen Martin. "A Mural Painter Discusses Watercolor." *American Artist* 30 (September 1966): 48–49, 70–72.

Winter, Lumen Martin. "A People's Art." *Kansas Quarterly,* Kansas State University, Manhattan, 1977.

Richardson, Jim. "For as Long as There Is a Kansas." *Kansas Magazine,* April 1978.

Beals, Kathie. "A Romance with Realism." Gannett Newspapers, *Suburbia Today,* January 3, 1982.

Who's Who in American Art: 1940–80.

Appendix 1

"America in the War" Exhibition List of Prizewinners

Intaglio
1st prize: Margot Holt Bostick
2nd prize: William Sharp
3rd prize: Donald Vogel
Hon. men.: Will Barnet

Relief
1st prize: Hans Jelinek
2nd prize: William Soles
3rd prize: Letterio Calapai
Hon. men.: Charles F. Quest

Planographic
1st prize: Benton Spruance
2nd prize: Ira Moskowitz
3rd prize: Phil Paradise
Hon. men.: Raphael Soyer

Stencil
1st prize: Robert Gwathmey
2nd prize: Leonard Pytlak
3rd prize: Sol Wilson
Hon. men.: Harry Sternberg

Appendix 2

Museums and Galleries Which Showed "America in the War"

The "America in the War" prints were shown in the following museums and galleries during the month of October 1943.

BROOKS MEMORIAL
ART GALLERY
Memphis, Tennessee

BUTLER ART INSTITUTE
Youngstown, Ohio

CAROLINA ART ASSOCIATION—
GIBBES MEMORIAL ART GALLERY
Charleston, South Carolina

CINCINNATI ART MUSEUM
Cincinnati, Ohio

CLEVELAND MUSEUM OF ART
Cleveland, Ohio

CORCORAN GALLERY OF ART
Washington, D.C.

CURRIER GALLERY OF ART
Manchester, New Hampshire

EVERHART MUSEUM OF
NATURAL HISTORY,
SCIENCE AND ART
Scranton, Pennsylvania

FINE ARTS GALLERY
San Diego, California

FORT WAYNE ART SCHOOL
AND MUSEUM
Fort Wayne, Indiana

KENNEDY GALLERIES
785 Fifth Avenue
New York City

LAYTON ART GALLERY
Milwaukee, Wisconsin

MUSEUM OF FINE ARTS
OF HOUSTON
Houston, Texas

WILLIAM ROCKHILL NELSON
GALLERY OF ART—
ATKINS MUSEUM OF FINE ARTS
Kansas City, Missouri

NORFOLK MUSEUM OF ARTS AND
SCIENCES
Norfolk, Virginia

PORTLAND ART MUSEUM
Portland, Oregon

PRINT CLUB
Philadelphia, Pennsylvania

SAN FRANCISCO MUSEUM OF ART
San Francisco, California

SANTA BARBARA MUSEUM
OF ART
Santa Barbara, California

SEATTLE ART MUSEUM
Seattle, Washington

SMITH COLLEGE MUSEUM OF ART
Northampton, Massachusetts

SWOPE ART GALLERY
Terre Haute, Indiana

VIRGINIA MUSEUM OF FINE ARTS
Richmond, Virginia

WICHITA ART ASSOCIATION
Wichita, Kansas

WILMINGTON SOCIETY
OF THE FINE ARTS
Wilmington, Delaware

WISCONSIN UNION
UNIVERSITY OF WISCONSIN
Madison, Wisconsin